Camcorder
Maintenance
and Repair

Camcorder Maintenance and Repair

Homer L. Davidson

TAB BOOKS

Blue Ridge Summit, PA

FIRST EDITION
SECOND PRINTING

Printed in the United States of America

Reproduction or publication of the content in any manner, without express
permission of the publisher, is prohibited. The publisher takes no responsibility
for the use of any of the materials or methods described in this book, or for the
products thereof.

Library of Congress Cataloging in Publication Data

Davidson, Homer L.
Camcorder maintenance and repair / by Homer L. Davidson.
p. cm.
Includes index.
ISBN 0-8306-1857-0 ISBN 0-8306-3157-7 (pbk.)
1. Camcorders—Maintenance and repair. I. Title.
TR882.D38 1989
621.388'337—dc20 89-4542
 CIP

TAB BOOKS offers software for
sale. For information and a catalog,
please contact TAB Software Department,
Blue Ridge Summit, PA 17294-0850.

Questions regarding the content of this book
should be addressed to:

Reader Inquiry Branch
TAB BOOKS
Blue Ridge Summit, PA 17294-0214

Roland S. Phelps: Acquisitions Editor
Katherine Brown: Production

Contents

Noisy • Image Not Clear and Sharp • Image Looks Overexposed • White Balance Drifts during Close-Ups • No Scene Appears In Viewfinder • Tape Transport Stops during FFWD or Record • No On-Screen Display • Input Key Switch Not Operating • Detection Indicators Inoperable • Power LED Is Not Working • Cassette Starts Loading but Shuts Off • Inserted Cassette Does Not Eject • Cassette Housing Does Not Move • Bent or Broken Cassette Door • Repairing Broken PC Board • Emergency Mode Loading/Unloading • Dew Sensor Indication • Removing a Jammed Cassette • Cassette Problems • No EVF Raster

Acknowledgments

Several manufacturers and electronic technicians have contributed electronic data for use in this book, and to them I offer many thanks. A special thanks is given to the RCA Corporation, Olympus, and Radio Shack for service literature and block diagrams used throughout the book. Without their help this book would have been impossible to write.

Introduction

This book was written for those who own a camcorder. The purpose of the book is to acquaint them with how the camcorder performs, and how to make simple repairs. Even if you know nothing about electronics, you can follow the text and block diagrams to keep your camcorder in tip-top shape. Extreme patience and care must be exercised when making camcorder repairs.

The first chapter illustrates the three basic camcorder formats, camera specifications, basic preparations, how to hold the camcorder, simple recording operations, and how to save the battery. Only a few tools are needed for the simple repairs in the book. How to check the diode, transistor, and IC components with the digital multimeter (DMM) round out the chapter. Chapter 2 elaborates on how to read and follow the instruction book. Special handling regarding outdoor care and moisture problems is thoroughly discussed. Safety and service precautions are found in this chapter, and throughout the book.

The different camcorder formats are found in Chapter 3. Basic operational functions are discussed. Video head differences, and how the circuits perform in several formats, are expanded upon in this chapter—including the VHS-VHS-C camcorder format.

Chapter 4 explains the 8 mm format, how the various circuits perform (with block diagrams), and the various operational control functions are given in detail.

Cleanup, lubrication, and battery care are thoroughly explained in Chapter 5. Chapter 6 covers videocassette selection. The camera system and VCR section are discussed in Chapters 7 and 8, respectively.

How to remove panels and components is given in Chapters 9 and 10. Knowing how the drum and cylinder motor operate and related problems are in Chapter 11, as well as the capstan, loading, iris, focus, control, and zoom motors and troubleshooting tips and notes. Simple adjustments you can make are in Chapter 12.

How to solve power, battery, recording, playback, viewfinder, video, and sound problems are given with simple repairs you can do in Chapter 13. Ac adapter problems are discussed in Chapter 14.

Throughout the book, you will find warning signs to alert you that the repairs are too difficult, you do not have the right tools, or to take the camcorder to the manufacturer's service or factory depot for repairs. Always use the exact factory parts for replacement.

A glossary of parts is found in Chapter 14.

1

Camcorder Fundamentals

In the past two years camcorder manufacturers have made great strides in the field of home entertainment electronics. Besides the VCR, the camcorder is the hottest electronic item going. Over 1.5 million units were sold in 1987, and sales over 3 million predicted for 1988. It is predicted that several different types of camcorders will soon be found in most households.

The camcorder is a combination of a camera and video recorder in one portable unit (Fig. 1-1). Some small camcorders only take the picture and will not play back. Most present-day camcorders will record both video and sound with playback features through a television set, television monitor or VCR machine. Many of the camcorders have electronic viewfinders that allow the operator to view the scene just taken, or play back into the Electronic View Finder (EVF).

DIFFERENT FORMATS

Basically, the camcorder started with the *VHS* and *Beta* models, like the videocassette recording industry (VCR). There are six camcorder formats, with two more coming up. Smaller versions of the *VHS*, called the *VHS-C* and *8 mm* camcorders were quickly added to the line. VHS is short for Video Home System and VHS-C is the compact version. The VHS and Beta camcorders are for mostly home use, while the

Fig. 1-1. The camcorder is a video camera and recorder in one unit. Here is a VHS RCA CPR300.

VHS-C and 8 mm camcorders are much lighter to carry around. Like all electronic products, shortly after the camcorder was placed in the home, great improvements were made, bringing forth the super S-VHS, S-VHS-C, ED Beta, and Super 8 mm.

VHS Format. The video home system (VHS) camcorder uses the same cassette as the VHS videocassette recorder (VCR) making this unit the most popular camcorder at the moment. The VHS cassettes are low in price, and play directly into the VHS-VCR (Fig. 1-2). Most VHS camcorders can be played back through the television set or video monitor. You can get up to two hours of recording in *standard play* mode (SP) with the VHS T-120 cassette (Fig. 1-3). Some camcorders record up to 6 hours in the *extended play* (EP) mode.

The early VHS camcorders used a *vidicon* or *saticon image pickup tube*. Today, you will find only a *Metal-Oxide-Semiconductor* (MOS) or a *Charge-Coupled Device* (CCD) in camcorders. Most VHS units have at least 250 resolution lines, with the average 250,000 pixel pickup features.

S-VHS Format. First, the VHS VCR format was improved with a *VHS HQ* (high quality) machine. The HQ recorder system employed sharper definition, truer colors, and less snow. Improved HQ circuits consisted of *White Clip*, *Luminance Noise Reduction*, *Chrominance Noise Reduction*, and *Detail Enhancement*. The super VCR machine provides higher resolution and *signal-to-noise ratio* (SN) with a wider bandwidth, providing greater detail in the picture. Today, these same HQ features are found in the VHS

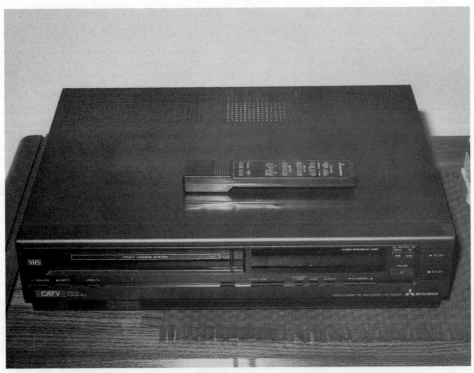

Fig. 1-2. The VHS format is the most popular since it can be played in a VHS-VCR.

Fig. 1-3. Four different videocassettes, VHS, Beta, VHS-C, and 8 mm.

camcorders. Remember, the super VHS-VCRs will play the conventional VHS cassette, but tapes or cassettes using the new (Super) system cannot be played on the older VCR machines.

The super (S-VHS) camcorders provide higher horizontal line resolution, showing greater detail in the picture. The standard VHS camcorder can have 240 to 250 lines while the super (S-VHS) has over 400 lines of resolution. The range in super VHS models varies from 200,000 to 400,000 pixels. The average luminance signal (brightness) is 3.4 megahertz in the conventional VHS camcorder and 5.4 megahertz with a 1.6 MHz to 7.0 MHz deviation of the super camcorder providing a higher range of picture performance. Your television set has only 330 lines of resolution, while the super S-VHS camcorder has over 400 lines providing a higher quality picture. The super S-VHS cassettes cannot be played in the conventional VHS-VCR, but the conventional VHS cassettes can play back on the super VCR machine.

VHS-C Format. The compact VHS-C camcorder is light in weight, and uses the small VHS-C cassette (Fig. 1-4). The VHS-C cassette cannot be played directly by the conventional VCR, but must be placed in the standard VHS size, plastic holder before inserting it into the VHS deck. Most VHS-C camcorders are made to play directly into the television set or color monitor with cables. Many VHS-C camcorders have electronic viewfinders for playback and image picture monitoring. The standard VHS-C cassette played in the SP mode has a duration of twenty minutes, and in extended play (EP) lasts a full hour. The VHS-C tape is the same width as the VHS cassette. The VHS-C camcorder averages 3½ lbs. in weight, compared to the VHS model of 5.5 to 6.8 lbs. Of course, the camcorder weight drastically increases when the battery or ac adapter is added to the back of the camcorder, in many models.

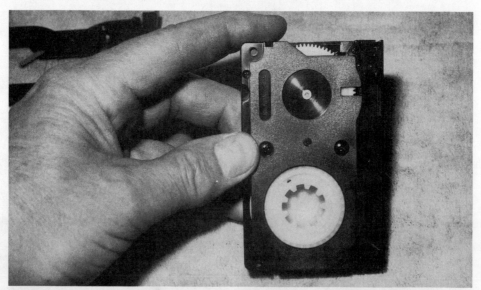

Fig. 1-4. The VHS-C compact videocassette is about ⅓ smaller than the VHS, and can be played back by the camcorder to the television set or monitor, or by placing it in a VHS adapter.

Super S-VHS-C Format. Since the VHS-C tape is the same size as the VHS cassette, the super circuits and format of the S-VHS camcorders are found in the super VHS-C format.

Beta Format. The Beta camcorder was one of the first on the market compatible with the Beta (VCR) recorder. The Beta camcorder will take the pictures using a Beta cassette, but has no playback features (Fig. 1-5). The recorded cassette must be played in a Beta machine, and is not interchangeable with the VHS camcorders or VCRs.

The Beta camcorder has a better picture quality, with about 280 lines of resolution compared to the 250 lines of the VHS machine. The owner of a Beta VCR may want to purchase a compatible Beta camcorder. The Beta cassette will play from 15 minutes up to 5 hours.

Super and ED Beta Format. The ED Beta camcorder is supposed to be marketed the later months of 1988 by Sony. The super Beta camcorder separates the chrominance and luminance signals for greater picture quality, has a higher frequency response than the Super-Beta system (1.2 MHz), or the ED Beta of 1.8 MHz frequency deviation. The ED Beta camcorder also provides *improved frequency response* and *signal-to-noise ratio* for greater audio recordings. The ED Beta horizonal resolution can be above 500 lines. The ED Beta camcorder has a special metal tape manufactured by Sony Corporation. The regular Beta tape can be played on the ED Beta VCR, but the ED Beta tape cannot be played on the conventional Beta machine.

8 mm Format. The 8 mm camcorder is made by the electronic manufacturers, but is designed by the different camera corporations. The 8 mm camcorder is of the small,

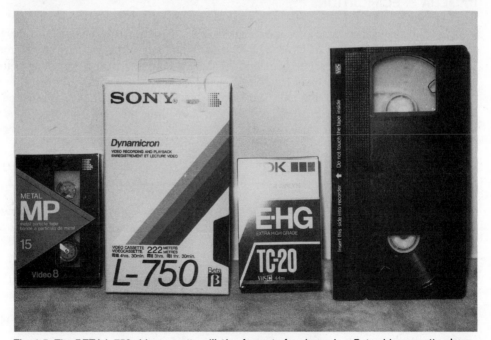

Fig. 1-5. The BETA L-750 videocassette will play for up to four hours in a Beta videocassette player.

light format, with a thinner tape and cassette. The 8 mm videocassette is coated with metal particles and operates from 15 minutes, up to 4 hours of record or playing time. The 8 mm cassette can only be played back through the electronic viewfinder, television set color monitor, or 8 mm VCR. This 8 mm cassette cannot be operated in the VHS-VCR or any other type camcorder.

The 8 mm camcorder has a smaller drum head diameter, with digital audio frequency modulation. The audio is recorded directly with the video signal and not on the edge of the tape like the VHS models. The horizonal resolution is between 300 to 330 lines. All 8 mm camcorders contain a Charge-Coupled Device (CCD) for higher resolution, higher color reproduction, low smear, quick start, and less weight. The *flying erase head* (FE) prevents color rainbow effects in the recording, and is mounted in the same drum or cylinder as the video heads.

Super or High Band 8 mm. The High Band 8 mm camcorder expands the bandwidth of the luminance frequency signal. The signal is expanded to 2 MHz wide and lies between the 5.7 and 7.7 MHz frequency, instead of the conventional 1.2 MHz width and 4.2 MHz to 5.4 MHz frequencies. The average 8 mm horizonal resolution is around 300 and is raised to more than 400 lines with the High Band models. The High Band 8 mm camcorder cassette cannot be played back in the present 8 mm VCRs or camcorders. The conventional 8 mm cassettes can be played back on the 8 mm High Band machine, but you cannot play the new High Band cassettes on the conventional machines.

CAMERA SPECIFICATIONS

Looking at the camcorder specifications will tell you what the unit will do, or which one to buy. Important features such as auto-focus, auto-white balance, power zoom, and high shutter speed should be noted. What is the lowest Lux rating for taking pictures indoors? Does the camcorder have a high speed shutter, and what is the lowest aperture setting? The weight of the unit, and battery power consumption should be noted for long battery life. Table 1-1 through Table 1-3 show three different camcorders and the manufacturers' specifications.

BASIC PREPARATIONS

Before starting out with a new camcorder there are a few basic steps to follow to prevent camcorder damage, to quickly place the unit into operation, and to take the best pictures possible.

Shoulder Strap. Attaching the shoulder strap makes the camcorder easy to carry, and prevents accidental dropping of the camcorder. A shoulder strap or brace can help steady the camcorder while taking outdoor pictures.

Minolta Model C3300 VHS-C HQ Camcorder

Lux rating—15

Exposure Control—Full automatic with AE lock

White Balance—Full automatic with lock

Viewfinder—Electronic B&W viewfinder

Pickup Device—CCD ½-inch solid-state image sensor

Format—VHS-C

Microphone—Unidirectional condenser type

Lens—9-54 mm F/1.6 6X power zoom

Weight— 3 lbs without batteries
 3½ lbs with batteries

Power Consumption—8.2 W maximum, 7.5 W normal

Battery—9.6Vdc

Table 1-1. Minolta's manufacturer specifications.

RCA CPR300 VHS Camcorder

Lux Rating—5

Auto focus—Yes

Auto White Balance—Yes

Power Zoom—8:1 ratio

High Speed Shutter—Yes

Pickup Device—MOS solid-state

Weight—5.5 lbs without battery

Scanning Lines—525 lines

Power Requirement—12 Vdc

Power Consumption—9.5 W normal

Record/Playback System—Four video heads

Table 1-2. RCA's manufacturer specifications.

Adjusting the Grip Strap. In some small camcorders the grip assembly must be attached to the camcorder body. The microphone assembly can be attached to this grip assembly. Place your right hand through the loop, and grasp the lens assembly or camcorder start-stop buttons. You should be able to operate the on/off, telephoto, T and W buttons with ease (Fig. 1-6). Snug up the Velcro strap over the right hand.

Eyepiece or Viewfinder Adjustment. In some models the electronic viewfinder must be remounted when carrying the camcorder in a case. Adjust the viewfinder to fit the operator's eye, by sliding the eyepiece slowly in either direction. Some electronic

Sony Model CCD-M8/M8U 8 mm

Video System—2 rotary heads-FM system

Cassette Format—8 mm

Tape Speed—(SP) 1.43 cm/sec.

Image Device—CCD (Charge-Coupled Device)

Lens—F 1.6

Minimum Illumination—25 lux

Weight— 2 lbs 3 oz without batteries
 3 lbs with batteries

Microphone—Electret Condenser Mike

Battery Pack—6Vdc

Power Consumption—5.2 W

Table 1-3. Sony's manufacturer specifications.

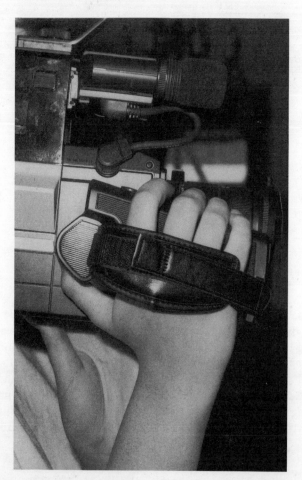

Fig. 1-6. Correctly adjusting the handgrip provides camcorder flexibility, in operation of recording, off/on, and telephoto buttons, depending on the unit type.

viewfinders have a focus eye adjustment underneath the eyepiece. Adjust this until the image is in focus, sharp, and clear (Fig. 1-7).

Battery Check. Make sure the battery is fully charged by checking the battery LED indicator (Fig. 1-8). Insert the battery pack on the rear of camcorder or inside the case. Do not throw the old batteries into the open fire as they may explode. Check the battery of the calendar/clock display. Always, carry a spare battery for long hours of shooting pictures.

How to Hold the Camcorder

Grasp the handgrip in your right hand. The handstrap helps to hold the camcorder firmly and is adjustable for comfortable operation. Your right hand is used to operate the off/on, record, pause, and power zoom buttons if placed on the handgrip assembly. Use the left hand to help support and steady the camcorder. You may want to purchase a shoulder strap assembly to support and hold the weight of the camcorder for easier operation with less jitter.

Another easy method to steady the camcorder is to back up against the wall. You can still shoot pictures at a fair distance if the camcorder is equipped with a telephoto lens. Take even steps when taking pictures while walking. Use a camera tripod whenever possible for steady shots (Fig. 1-9).

Fig. 1-7. Some camcorders have adjustment of the electronic viewfinder at the bottom edge of the eyepiece.

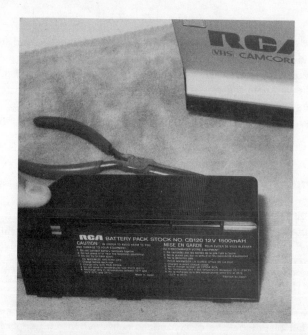

Fig. 1-8. This RCA 12 volt battery slides in grooves at the back of the camcorder when loading.

Fig. 1-9. When at all possible, use a camera or camcorder tripod to shoot pictures.

To ensure non-jittery shots, spread your feet outward and leave them there for different shots. Straight on, angle, or 180° pictures can be taken without moving one foot. When panning or following a subject (moving the camcorder in a horizontal line) it is best to do it from left to right to prevent blurry or jittery shots. Try to keep the subject or image centered in the viewfinder for more natural pictures.

SIMPLE RECORDING OPERATIONS

Know how the camcorder operates. Go over the service and operation manual several times. Mistakes made in operation can cause costly repair bills. In fact, you may be quite embarrassed after taking the camcorder to the repair shop, only to find out the camcorder works perfectly, and only improper operation was the culprit.

A. Connect power source: battery or ac adapter.
B. Press Power Switch: indicator light should light.
C. Press eject button: to open cassette holder.
D. Close door: insert cassette and close the door.
E. Select speed.
F. Remove lens cover.
G. Place switch in camera mode.
H. Press record button.
I. Press pause button: this button starts the recording operation in some camcorders.
J. Press pause button: to stop the recording.
K. Press the stop button.

To Save Power

To prevent extra battery wear and tear, shut the camcorder down in the following operations:

- Shut the power off when the camcorder is left in the stop mode for 3 to 5 minutes.
- Turn off the power switch when the camcorder is left in the Rec Pause mode for longer than 3 to 5 minutes.
- Prevent unnecessary power zoom, review, and auto focus when the battery is ready to wind down.
- You can protect the tape by releasing the tape tension if left in the Record-Pause mode by turning off the power switch.
- Protect the tape by shutting the power off, if left longer than 3 to 5 minutes in the (still) Play Pause mode.

HOOKUP CONNECTIONS FOR PLAYBACK

The VHS and VHS-C cassettes can be placed in the camcorder or VCR machine for playback. The VHS-C cassette must be placed in the VHS adapter before it can be played back in the VHS videocassette recorder (VCR). Super S-VHS cassettes can be played on the super S-VHS recorder, but cannot be played on the older VHS machines. You may, however, play the regular VHS cassettes in the super S-VHS VCRs. The VHS and VHS-C cassette can be played back through the television set and color monitor.

The VHS/VHS-C camcorders can be connected to the television set antenna terminals, if the television does not have a video/audio input jack, through the VHF RF adapter (Fig. 1-10). Connect the antenna wire cable to the RF adapter at the input terminal. Connect the output to the VHF antenna input terminal of the television set. The RF adapter output cable goes to the video/audio input/output jack on the camcorder. Check Fig. 1-11 for a 300 ohm hookup, and Fig. 1-12 for a 75-ohm cable connection.

The VHS and VHS-C camcorder can be connected directly to the television or color monitor with video/audio input jacks. Usually, these jacks are located at the rear of the

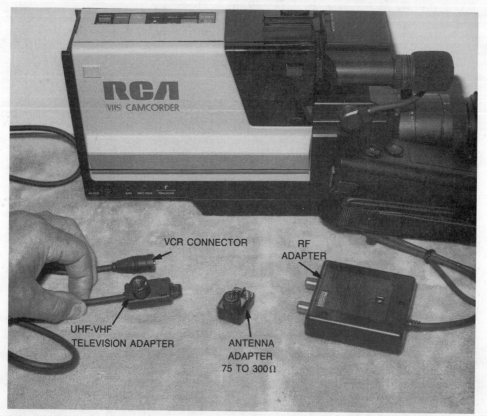

Fig. 1-10. Most camcorders provide connecting cables for playback through the antenna system or television.

set on a board that has several jack connections. The audio/video cable is connected to the camcorder video/audio input jack, and then connected to the same jack on the back of the set (Fig. 1-13). The audio connector is white, and the video connector is yellow. Some of the inexpensive VHS-C camcorders will only record, requiring the cassette be placed in a VCR recorder for playback.

The Beta camcorder records the picture and sound but must be played back through a Betamat VCR machine. Sony has a Beta camcorder that will record and play back its tapes. Check the manufacturers' service manual for new hookups.

The 8 mm camcorder may play back through an 8 mm VCR, television, and monitor. In some of the larger units, the picture is played through the electronic viewfinder. Some of the smaller camcorders have no playback features, and the 8 mm cassette must be played on the 8 mm videocassette recorder.

RECORDING FROM TELEVISION

If your television or color monitor has audio out and video out jacks, you can connect your camcorder and record from your television or color monitor with your camcorder. Connect the television or monitor cable, making sure the same color connectors are connected to the same audio or video jack. Place the red plug connector to the audio

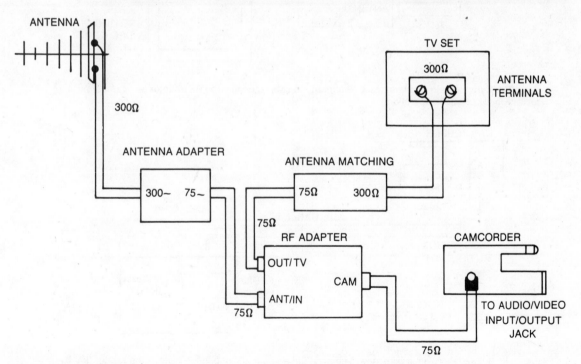

Fig. 1-11. If your antenna system has a 300-ohm flat cable, here is how to connect the camcorder to the television and antenna for playback.

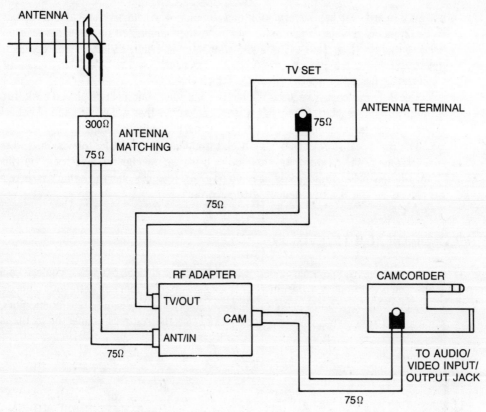

Fig. 1-12. If your antenna system has a 75 ohm round cable, connect the RF adapter and camcorder as shown for playback operation.

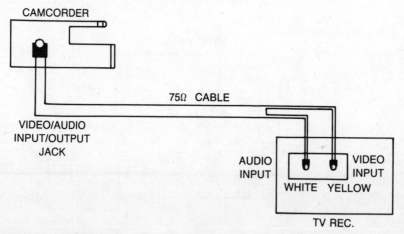

Fig. 1-13. If your television is fairly new, you may find audio and video input jacks at the rear of the set. Connect the white connector to the audio, and the yellow connector to the video input jack from the camcorder.

out on the rear of the television set, and the red connector to the audio in jack of the video/audio input adapter (Fig. 1-14). Next, place the white lead into the other video input jack of the television and adapter. The video/audio input adapter will plug into the camcorder audio/video input connector.

In some camcorders the viewfinder cable is removed and the video/audio input adapter is plugged into the same viewfinder jack. Now the program is tuned in on the television set for a normal picture. Insert the cassette and set the camcorder to the camera position of the playback/camera switch. Press the Record/Start/Stop button of the camcorder, you are now ready to record from the television. You will find some camcorders can be plugged directly into the television to record network programs.

VCR TAPE COPYING

The audio-video adapter cable packed with most camcorders is used to connect the camcorder to another videocassette recorder (VCR). Connect the white audio connector plug on the audio/video adapter cable to the Audio In jack in the back of the VCR (Fig. 1-15). Connect the yellow video connector plug on the audio/video adapter cable to the Video-In jack on the back of the VCR.

Plug the multi-pin-connector fitting on the other end of your audio/video adapter cable into the audio/video (AV out) jack on your camcorder. Do not force the plug. Line it up with the correct tabs, and slide the plug in. Your camcorder is ready to copy the tape from the camcorder to the VCR.

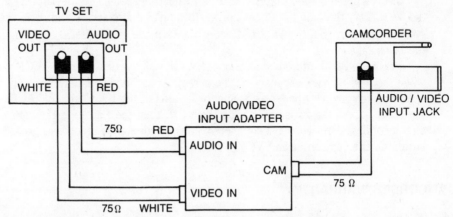

Fig. 1-14. Connect the white connector to the video out, and the red connector to the audio out at the rear of the television, and feed it to a video/audio input adapter to hook up the camcorder to record from a television program.

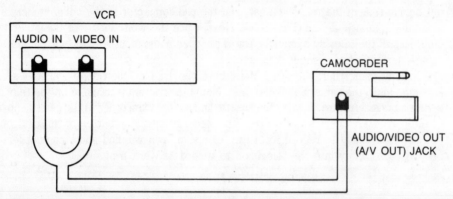

Fig. 1-15. The camcorder program can be recorded, or tape copying can be done from the camcorder audio/video output jacks, by cabling to the audio/video input jack of the VCR.

VIDEO EDITING

The camcorder can be connected to the VCR and television set for editing pictures, so you can rearrange the scenes, delete unwanted material, and combine material that was recorded on different videocassettes. Connect the audio/video output cord to the Audio and Video In terminals on the videocassette recorder (VCR) (Fig. 1-16A). Connect the other end of video/output cord to the video/audio input/output jack of the camcorder. Connect a video/audio output cable from the VCR to the color television set for monitoring.

Insert a pre-recorded cassette into your camcorder, and insert a blank cassette into the VCR. Play the tape in the camcorder to a point a few seconds prior to the scene you want to copy. Set the VCR to Record/Pause mode at the desired starting point on the blank tape.

Press the Play button to start playback on the camcorder. Start the VCR recording when the desired scene appears on the screen or in the viewfinder. You may want to use the electronic viewfinder as a monitor instead of the television set. At the end of the scene, press the Pause button on the VCR, then the Pause on the camcorder to stop recording. After you have completely finished editing the recording, press the Stop button on the camcorder and VCR.

CAMCORDER WARRANTY

The average camcorder warranty by the manufacturer covers any manufacturing defect in material or workmanship for one full year on parts, and 90 days labor. Do not attempt to repair any part of the camcorder during this time. It's wise to have the camcorder repaired through the first year of parts warranty. Take the unit to the manufacturers' authorized camcorder service center or dealer. Look in the yellow pages of your telephone book, or check the list of dealers listed by many manufacturers in the

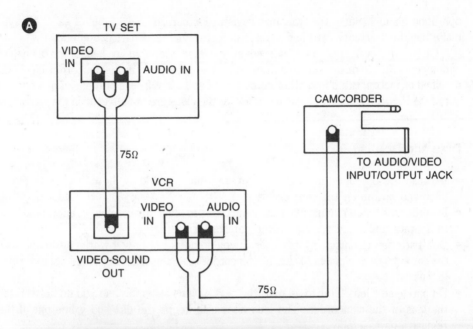

Fig. 1-16. (A) The audio/video output cord must be connected to the audio and video In terminals on the VCR. (B) Be real careful when taking voltage or resistance measurements on IC-CPU components; the many terminals are close together.

operation manual. Show the warranty registration card or have a bill of sale. Always, make out the warranty card and send it in for service and part protection.

Often, the warranty does not cover cleaning video/audio heads, or damaged components due to misuse or carelessness and no protection if the camcorder has been modified or incorporated into other components and camcorders purchased or serviced out of the U.S.A. Of course, small batteries for the clock are not covered in the warranty.

Do's and Don'ts

- Do read the operation manual over several times, and know how to operate every knob and button on the camcorder.
- Do order a service manual from the camcorder manufacturer to help understand how to operate and make repairs on the camcorder.
- Don't attempt to make certain repairs if you do not know how it works or do not have the correct test equipment. Take the camcorder to a camcorder depot or local electronic technician.
- Do purchase a lens filter to go over the regular lens assembly, so you do not scratch the lens of the camcorder. The lens filter also keeps the dirt and grime out of the regular lens assembly.
- Do connect the shoulder strap to the camcorder or purchase a separate one to prevent dropping the camcorder and causing extensive damage.
- Do purchase good quality tapes or videocassettes for your camcorder. Choose only top brands for quality pictures.
- Do keep the camcorder batteries charged. The Ni-Cad (nickel-cadmium) batteries should be thoroughly discharged before they are charged up.
- Do keep an extra battery on hand for emergencies, and for long hours of recording.
- Do not turn the ac adapter upside-down when a battery is attached to the camcorder. The battery may fall off and damage your feet.
- Do try the battery, ac adapter power supply or optional dc car cord when one of the units will not operate the camcorder. The trouble may be in the camcorder, if all three do not make the unit operate.
- Do store the videocassette in the upright position at room temperature.
- Do take a test shot of what you are planning to take a picture of, if you have an electronic viewfinder on the camera. Always advance the tape a few seconds to have a good beginning.
- Do not throw the battery away if it only furnishes power for a few minutes. Discharge the Ni-Cad battery completely and give it a good charge. You may be able to revive a so-called dead battery by doing this procedure several times.
- Do not place the dead battery in a fire, it may explode. Do not attempt to repair a defective battery.
- Do be careful when soldering around solid-state components. Use a 45 watt or less soldering iron, and do not leave the heat on the terminals for too long.

- Do be careful while working around, or taking voltages from ICs or CPU components (Fig. 1-16B).
- Do wear a static discharge wristband grounding device when working on the camcorder chassis.
- Do be careful when removing flat, small components from the pc board, so as not to pull up pc wiring or connecting circuits.
- Do remember that more than one diode or transistor may be located in one flat chip of the camcorder circuits.
- Do not squirt or spray lubrication on belts, tape heads, or pulleys to increase the tape speed. Keep all lubrication off of belts, rubber pulleys, and take rollers.

Required Test Equipment and Tools

You may have all the hand tools and test equipment you need. A good *volt-ohm meter* (VOM) or *digital multimeter* (DMM) is a valuable test instrument when repairing any electronic device. A 30 watt soldering iron or a battery operated soldering device is needed for clean solder joints. In addition to the regular bench or shop tools, a special, small screwdriver kit is handy for those miniature screws and bolts.

There are many electronic and mechanical repairs you can make on the camcorder as shown in this book (Fig. 1-17). Leave the most difficult electronic repairs and critical

Fig. 1-17. Many electronic and mechanical repairs you can do with only a few tools and a VOM or DMM.

adjustments up to the camcorder technician. Do not attempt to make electrical adjustments, unless you have the correct test equipment or knowledge to finish the job. Sometimes you can save a few bucks and headaches by letting the electronic technician do the most difficult camcorder repairs.

Purchase a good DMM, if you do not already have one. The DMM is the most accurate and most used test instrument found on the electronic technician's work bench. This meter will accurately measure small resistors, motor windings, capacitors, check diodes and transistors, and take critical voltage measurements (Fig. 1-18). Some digital multimeters will test electrolytic capacitors in or out of the circuit. Critical current measurements can be made with the DMM.

Nearly all fixed diodes found in the camcorder can be checked with the diode test of the DMM. A good diode will only give a reading in one direction. The LED indicator can be tested in the very same manner. Notice the resistance measurement of the LED. Infrared or light solid-state devices may be checked with the diode test of the DMM. Make sure no low ohm resistor, coil, or diode is in the circuit across the diode terminals, indicating a shorted or leaky condition.

You may find two fixed diodes inside of one flat component upon the pc board. Check the schematic for correct polarity. One or both diodes might be leaky inside the flat de-

Fig. 1-18. The DMM is used for the loading motor continuity measurement on the low ohm scale.

vice. Check each diode with the DMM in both directions (Fig. 1-l9). Replace the entire flat component even if only one diode is leaky or open.

Transistor junctions and leaky elements can be located with the DMM. Leaky or open conditions are the most common troubles related to the transistor. The normal transistor will have a resistance measurement in only one direction. The three elements of the transistor can be checked for open, normal, or leaky conditions. The base element is always compared with either the collector or emitter element (Fig. 1-20).

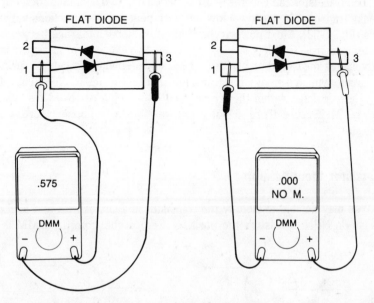

Fig. 1-19. There can be more than one fixed diode in a flat component. They can be checked the same as any diode. If one is defective, replace the entire package.

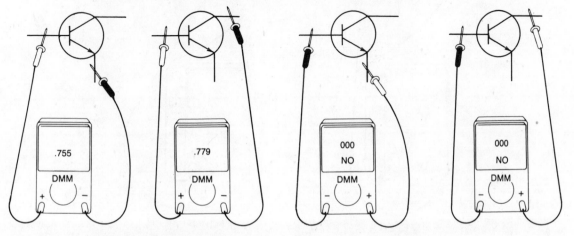

Fig. 1-20. For a normal NPN transistor test, place the positive (Red) probe to the base terminal, and then to the emitter and collector terminals of the transistor with the DMM.

The open transistor may not show a measurement between the base to collector or base to emitter terminals. Be very careful when making transistor tests. Make sure the test probes are on the exact element to be tested (Fig. 1-21). The transistor may be open from base to emitter or base to collector terminals or both. Usually, the open transistor measurement is only on two transistor elements. Another method is to check the bias voltage between the base and emitter terminals. A low .3 volts is measured across the PNP transistor while the NPN silicon transistor has a .6 bias voltage.

The transistor can become leaky between any two elements, or all three elements. A leaky transistor may show a low measurement in both directions with reversed test leads (Fig. 1-22). Most power type transistors show a leakage between collector and emitter terminals. Check both ways across any two elements of a leaky transistor. Usually, low voltages measured on all three transistor elements indicates a leaky transistor in the circuit. Simply remove the transistor and test it out of the circuit. The transistor may show leakage within the circuit, and after being removed test good. Replace it anyway. Make sure there is not a low resistance component across the suspected transistor.

Transistor Identification

You may be able to identify the transistor in a circuit with test lead polarity tests. Always on NPN transistors the positive (Red) probe from the DMM is placed in the

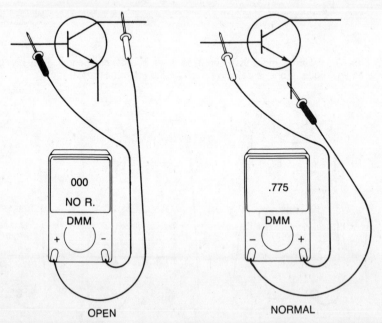

Fig. 1-21. When no measurement is found between the base and collector or the base and emitter, the transistor may be open in an NPN transistor. Make sure the transistor is not a good PNP type. Take another measurement.

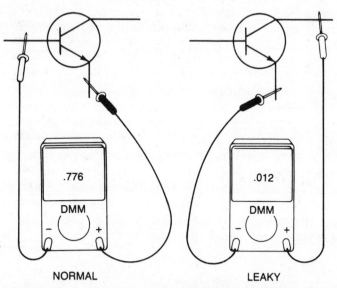

Fig. 1-22. A leaky transistor may show the same low ohm measurement between any two elements. Here the right NPN transistor is leaky between emitter and collector terminals.

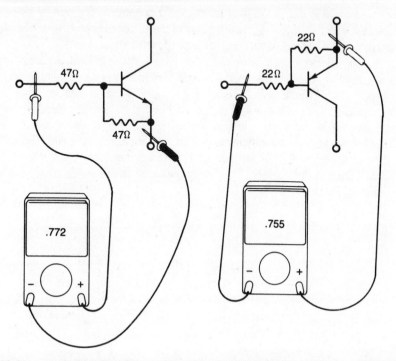

Fig. 1-23. You may find small resistors added to the base and emitter circuits in a digital transistor. Test the transistor with the DMM in the same manner. Remember, the measurements may have a high reading.

base terminal for normal transistor tests. The negative (Black) probe of the DMM is placed on the base terminal for normal transistor tests. If you do not have a schematic, you can easily tell if the transistor is NPN or PNP with base probe polarity.

Digital Transistor Package

You may find two different transistor polarities (NPN and PNP) with resistors in some flat components (Fig. 1-23). Usually, these resistors are quite low in value and will increase the resistance measurements between the two elements. A low resistance measurement between base and collector of an NPN transistor may indicate a leaky component. But, these components may be normal with resistors across the base and emitter terminals. Likewise, a low resistance measurement between the emitter and base of a PNP transistor may indicate a leaky transistor. Check the schematic for a resistor across the two elements inside the component.

Check IC Components with DMM

Critical voltage and resistance measurements on the suspected IC can indicate if the component is defective. You must have a schematic diagram or a voltage chart to indicate correct voltages on the terminals of the IC. Some camcorder manufacturers use voltage charts instead of marking measured voltages on the IC.

Often, a leaky IC will have a lower voltage at the critical working terminals. The most critical voltage test is on the supply terminal. Very low voltage on this terminal indicates the IC is leaky, or has an improper voltage source. Take a resistance measurement between the supply terminal and the chassis ground. A low resistance measurement under 1 kohm indicates a leaky IC. Remove the supply IC terminal from the board with solder wick material and a soldering iron. Make sure the supply terminal is free of the pc wiring. Take another resistance measurement between the removed terminal pin and the chassis. The low resistance measurement to ground indicates the IC is leaky.

2

Safety and Service Precautions

Like any new electronic product, certain steps in the safety of operation and servicing of the camcorder must be given special attention. After reading and learning how to operate the camcorder, you should know what you can and cannot do in taking video pictures. Remember when trying to maintain and repair the camcorder there are many components you should not touch, unless you can actually finish the job. Instead, call the electronic technician who services camcorders. Sometimes you will botch up the camcorder function, and end up having it cost a lot of money. There are a lot of maintenance and repairs you can do, but keep safety methods in mind at all times in the different operation and service procedures.

SAFETY POINTS YOU SHOULD KNOW

Here are simple safety precautions you should know before operating a camcorder: **Read Instructions**. Read and walk through the instructions before trying to repair a camcorder malfunction. Often the right button is not pushed or pressed when the camcorder will not operate properly. Go over each step of operation. Do not be afraid of the camcorder. Know how each function operates, and the camera will produce the best video pictures. Keep the instruction book close at hand. The safety and operating instructions should be retained for future reference.

Follow Instructions. All operating instructions should be followed in the camcorder operating manual. The manufacturer has gone to great lengths to provide safe, normal operating instructions for the camcorder. Sometimes shortcuts and time-saving methods can provide more danger than it's worth. Follow the camcorder operating manual to the letter.

Cleaning. Disconnect all power sources from the camcorder before cleaning it. When cleaning the cabinet or case, do not use benzyne, thinner, alcohol, thinner or other harsh detergents to avoid peeling, pockets or dull areas to the surface (Fig. 2-1). Do not use aerosol or liquid cleaners on the metal or plastic cabinet. Keep the camcorder away from volatile agents, and avoid contact with rubber or vinyl-coated products.

Gently wipe off dust and dirt marks from the cabinet and control panel with a soft, dry cloth. Lightly dust the control and plastic panels with a soft, light brush. If the dirt marks will not wipe off, moisten the cloth with a mild cleaning agent and dry the camcorder with a soft cloth. Gently wipe or blow the dust off from the lens area with a soft brush or lens cleaning paper. Regular camera-lens cleaning products are ideal for the camcorder lens assembly. Keep the camcorder in a protective case until it is placed in use to prevent dust and dirt from accumulating on the cabinet.

Special Handling. Do not drop the unit or subject it to shock or vibration. Do not hand the camcorder directly to someone to take a picture, lay it down and let it be picked

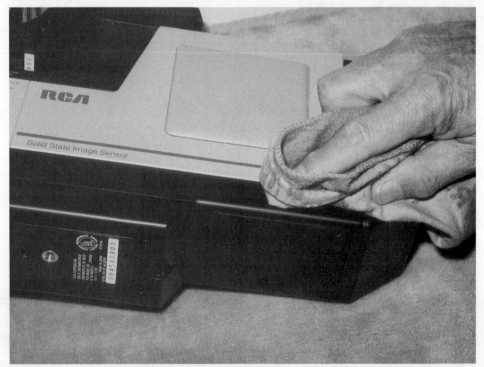

Fig. 2-1. Clean off the case with a soft cloth, and clean out slotted areas with cleaning sticks. Be careful not to scratch the metal or plastic areas.

up. The unit can be dropped when handed off. When it is dropped or knocked off the table, besides damaging the cabinet, lens assembly, or cassette door, circuit boards and the electronic viewfinder tube can be broken.

Do not aim the lens assembly directly at the sun or at extremely bright sources. Keep the lens cap on the unit when not recording, or after the power is shut off (Fig. 2-2). Choose adequate lighting equipment for better quality inside pictures. Sometimes neon or fluorescent lights do not provide good color recordings. Follow the manufacturers' operating manual on optional lighting equipment.

Water and Moisture Safety. Do not use the camcorder near water or where excessive moisture is found. For instance, near a bath tub, kitchen sink, laundry tub, wet basement or swimming pool. Keep the unit away from splashing water or spray when recording seashore and beach areas. Protect the camcorder when using it in sandy places, such as the beach. Do not record on wet or rainy days. If drops of moisture are spilled into the recorder, remove the covers and dry it out with a fan. Stop recording if there is lightning or a storm nearby.

Condensation. Do not use the camcorder in extremely cold and humid places, or when moving the unit from a cold to a warm place, such as taking the camcorder out of a cold car or off from the skiing slopes in the winter, and bringing it into a warm room. Often, condensation occurs gradually, and no indication may appear for the first 10 to 20 minutes.

As water vapor in the air condenses on the surface of a car window or window glass of a warm room, condensation may occur inside the camcorder. Damage can result to the tape, and video recording heads. A blinking dew indicator light may come on,

Fig. 2-2. Keep the lens cover on at all times until the camcorder is in use. Avoid camera flash units or extremely bright areas with the lens cap off.

automatically indicating moisture inside the unit (Fig. 2-3). In extreme cold areas, condensation will occasionally freeze up.

Let the camcorder warm up for at least an hour after bringing it in from the cold. If the dew light keeps blinking, make sure the videocassette is removed from the machine. Turn the unit off and remove the cassette. Wait another hour or until the dew light has stopped before attempting to record or play back.

Special Outdoor Care. Place the camcorder in its carrying case or place it in a plastic bag when using it outdoors in extremely cold areas to prevent condensation. Keep the unit out of steam, soot, dust, humidity, and sandy areas. Poor ventilation can cause the lens and cassette assembly to become moldy. Avoid extreme hot or cold places where temperature and humidity may exceed 32° to 105° F, and 30 to 80 percent humidity. Do not leave the camcorder lying in the sun, while closed up in the car. You may find a condensation preventive heater in some camcorders which functions with the power switch off, as long as the video ac adapter is used.

Ventilation. Poor ventilation can damage both the outside and inside of the camcorder. Slots and openings in the unit are provided for adequate ventilation and to ensure reliable operating by protecting against overheating. Do not block or cover these openings. Do not lay the vented side down on a bed, sofa, mattress, or clothing while operating the unit. Do not encase the camcorder or VCR recorder in tight fitting, built-in installations without proper ventilation. Clean dust and dirt out of the slotted areas with a sponge swab.

Accessories and Adapters. Shut off power to the camcorder before unplugging the video ac adapter. It is best to pull the plug from the ac outlet, if the unit is to be stored for a long period of time. Keep all long power cords and extensions wrapped up, so the camcorder and ac adapter are not pulled off from a table or resting place.

The camcorder, or heavy accessories, should not be placed on a light tripod, stand, or unstable cart. Sometimes they will be pulled off and cause serious injury to young people. Use a heavy tripod and bracket, products recommended by the manufacturer. After falling or dropping, the camcorder may not operate.

Power Sources. Always try to operate all video products from the power source marked on the label or in the operating manual. Do not try to operate the camcorder from a 220 Vac outlet. If you are not sure of the correct voltage, call the power company. If in doubt, operate the unit from the portable battery source. Some units have a commercial conversion plug for using the video ac adapter abroad. Most camcorders cannot be used

Fig. 2-3. Camcorders with a dew light will blink if moisture is inside the cassette area. The pen shows the location of CPR300's dew light.

in combination with a television in countries where the broadcast system or frequency is different.

Polarization and Ground. The ac adapter or power unit is equipped with a polarized ac male plug (Fig. 2-4). One of the blades or prongs is wider than the other, so it cannot be reversed. The ac male plug will fit into the wall receptacle only one way. Try reversing the plug if it will not fit. If the plug does not insert either way, try another outlet. You must have a polarized plug in the wall to plug the camcorder adapter into. Either change the female outlet or have the local electrician do it. Do not cut off the flange area of the male prong so it will fit into the female plug.

You may encounter two male prongs, with a round one which is at ground potential. If this is the case, plug the cord into a center-ground ac outlet. Sometimes the plug is not grounded and you cannot plug it into the wall. Obtain a ground plug, and insert it into the outlet, and ground the metal spade log wire to the metal screw on the outlet box. Do not cut off the round ground prong, especially while using the ac adapter outdoors.

Power Cord Protection. Never let the power cords lay where they can be walked on or tripped over. Check for areas the cord may be pinched, at the plug, receptacle, and near the ac adapter. If the covering becomes frayed and torn, simply cut it off and rewire it back into the plug or adapter. Solder up all connections. Double-check extension cords. Do not use light-weight extension cords, only use those with a heavy rubber covering. Do not overload wall outlets and extension cords, fire or electric shock is possible.

Lightning Damage. Do not take pictures with the camcorder outside with rain and lightning all around. Unplug the camcorder or VCR from the ac outlet, especially during a lightning storm. Do not leave the unit plugged into the outlet when you are not home. Power line surges and lightning damage can destroy camcorders and video equipment connected to the power line during summer storms. Keep the camcorder unplugged when not using it, or during storms.

Object Problems. Keep the camcorder in the case, up and away from youngsters who may stick small objects into the camcorder openings. Never push objects of any kind

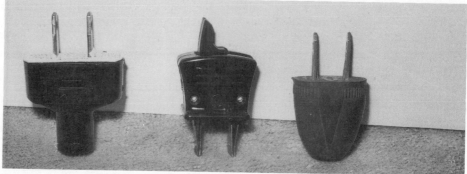

Fig. 2-4. Here are two different ac plugs, the camcorder plug is polarized, if broken, replace it with another polarized ac plug.

through openings or slotted areas of the camcorder or ac adapter. Metal screwdrivers, pins, needles, or metal knitting needles can short out components or become a shock hazard. Prevent drinking around the unit, which can be spilled down inside causing shorted components, gummed up belts and rollers, and burned circuit boards. Water spilled into the recorder is bad enough, but a coke or a cocktail really louses up the inside of a camcorder.

Replacement Parts. You can substitute many parts in a radio or television, but not in the camcorder. Most of the components are small, and the original part number should be used for replacement. There are many special parts installed for safety. Critical parts are marked with a star or triangle on the schematic diagram and circuit board diagram. Substituting universal parts can produce a fire or electric shock to the operator.

Safety Checks. There are many different safety checks to be made after you have completed servicing or repairing the camcorder, to make sure it is safe to operate. When servicing, observe the original lead dress of the components. Cut the same length of terminal wire on a resistor or capacitor. Dress or tie down long leads, exactly as they were originally placed with several other wires. Do not reroute the wires or just fold them up. Keep replaced wires out of the way of moving belts, wheels, and the capstan assembly.

Always replace protective devices, such as insulation barriers and paper shields, like they were originally. Replace metal shields on the pc board in the exact same order. Replace plastic insulators back over the wiring they were removed from. Last but not least, take a cold, and hot leakage test, to prevent electrical shock to you or the person who operates the camcorder. You may have used a larger screw than original, to hold the component in place, and it might be touching a hot wire or component lead terminal.

Cold Leakage Current Test. Make the cold test of the camcorder with a good ohmmeter (VOM or DMM). One that will measure above 10 megohms. Unplug the ac cord of the ac adapter of the camcorder, and connect a jumper wire between the two prongs (Fig. 2-5). Now plug the adapter cord into the ac adapter unit.

Take a resistance measurement with the ohmmeter, between the ac plug and each exposed screw, metal exposed parts, convertors, and metal controls. The VOM or DMM should be set at the 2 MΩ range. Most of the readings will have no measurement, or infinity, the lowest measurement should not be under one megohm. Double-check shields, the cassette assembly, and for missing fiber-insulating paper between components. Remember, if you have a piece of insulation left over after assembling the camcorder, go back and correct the situation.

Hot Leakage Current Checks. Usually, an isolation transformer is used, when working on the television or stereo amplifier chassis. The same holds true while servicing the camcorder; but, for this test, remove the isolation transformer from the ac plug. Insert the ac plug of the adapter directly into the ac outlet. The ac current measurement is made between exposed parts and the camera, to an earth ground (Fig. 2-6).

Parallel wire a 0.15 μF fixed capacitor across a 1.5 kohm, 10-watt resistor and connect to earth ground and the camcorder. Use alligator-clip cords for easy operation testing. Clip one end of the capacitor to the ground, and clip the other wire from the camcorder to the other end of the capacitor. Measure the ac leakage across the resistor with a good VOM or DMM.

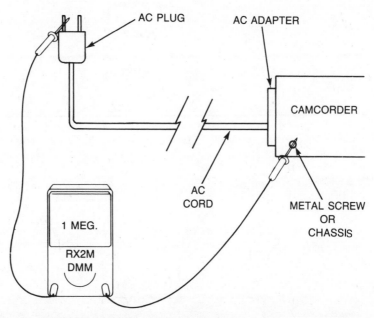

AC PLUG

AC ADAPTER

CAMCORDER

AC
CORD

1 MEG.

RX2M
DMM

METAL SCREW
OR
CHASSIS

Fig. 2-5. Take a cold leakage test with a good VOM or DMM from the camcorder to the ac cord. Jump the ac cord and measure resistance between plug prongs and metal areas of the unit.

to the other end of the capacitor. Measure the ac leakage across the resistor with a good VOM or DMM.

Check all the exposed parts of the camcorder and adapter. The adapter must be plugged into the camcorder for these tests. Touch the alligator clip to the cable connectors, handle, screwheads, metal cabinet parts, and screws. Record the lowest measurements. Since most ac adapter cords have polarity plugs the ac plug cannot be reversed. If you are using the extension cord without a polarized plug, reverse it at the ac receptacle and take other measurements.

The ac leakage current should never be under 0.5 milliamps. If the reading is lower it's possible a great shock hazard could result. Correct the situation at once. Remove the plastic covers, and take another measurement on the same object with the low reading. Try to isolate what metal part is touching, or if a piece of insulation is missing. Sometimes a longer screw is inserted, and is grounding out against a component that should be insulated. A quick meter test on each metal component should solve the leak. For difficult situations, remove the ac adapter and take low ohmmeter measurements between metal and grounded parts, until the leaks are found.

X-Ray Radiation. The electronic viewfinder is constructed somewhat like the television receiver. A high voltage is found on the small CRT. Like the television chassis, the high voltage is developed in the flyback transformer circuitry (Fig. 2-7). If the high voltage increases with a defective component in the horizontal output circuits, potential x-ray irradiation can result. Periodically check the HV with a high voltage probe or tester. Always, rotate the brightness and contrast control to determine if the voltage goes over

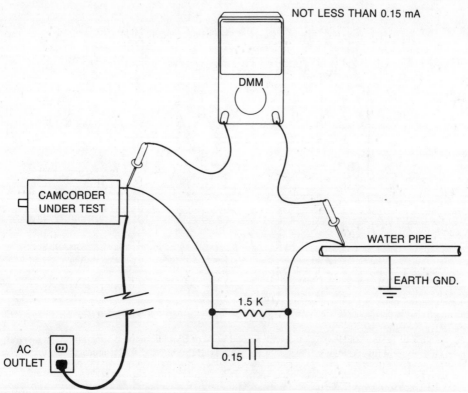

NOT LESS THAN 0.15 mA

Fig. 2-6. With the ac adaptor plugged into the outlet, take a hot leakage test from the camcorder to a cold water pipe. The leakage should not be more than 0.5 milliamps.

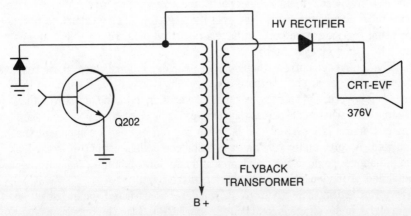

Fig. 2-7. Periodically check the electronic viewfinder tube for higher than normal voltage that may cause x-ray irradiation.

the high voltage setting. Most television shops have a high voltage probe to check excessive voltage. Do not try to check this voltage with a VOM or DMM.

CARE AND STORAGE PRECAUTIONS

Here are ten very important care and storage problems that may add many years of operation to your camcorder if followed carefully. Sometimes a few hints here and there, taking the time to do them, can save many and unnecessary repairs. Most camcorder problems are caused by improper care and not knowing how to operate the machine.

- Do not point the lens at the sun. The pickup device (MOS, CDD) can be permanently damaged by exposure to very bright lights. When not using the camcorder, shut it off and replace the lens cap.
- Do not use the camcorder near strong magnetic fields. Strong magnets, speaker magnets, and motors can cause noisy recordings. Keep the unit away from television and radio transmission antennas or towers. RF lines and distorted recordings can result.
- Always remove the videocassette from the camcorder when not in use, the tape, capstan, and idler pulley can be damaged.
- Clean the camera lens with a lens brush. The lens may become dirty or dusty while using it. Moisten the lens tissue with a drop of lens cleaning fluid to clean off stubborn marks. Start at the center of the lens and work towards the outside. Do not touch the lens surface with hands or fingers.
- Do not store the camcorder in places where the temperature exceeds 60° C (140° F). Always remove the unit from the car. Do not let it lay in the sun for a long period of time.
- Replace the videocassettes back inside their cases and store them in a cool, dry place.
- Keep all videocassettes away from extreme heat, sunlight, and furnace ducts. Do not leave them in the car glove-compartment during the summer months.
- Moisture can occur when cassettes from a warm car are brought inside during the summer, when air-conditioning is operating.
- Open up the plastic covers and cassette doors when the camcorder has accidentally gotten wet in a rain storm. Sometimes water or liquid is accidentally spilled on the unit. Wipe off all excess moisture and dry the camcorder off with a fan.
- A dirty tape head can cause blurred, poor recordings, and distorted sound. Use a wet or dry cleaning cassette to clean up the tape heads every 100 hrs. of use. If the camcorder is used a lot, you may need to clean it sooner, if the picture quality seems to go downhill.

SERVICE IDENTIFICATION DATA

The camcorder has many components with different sizes and shapes, like the latest television chassis, and compact disc players. The new miniature chip devices, digital

transistors, ES sensitive devices, multi-terminal IC processors, and surface-mounted components are found in the latest camcorders. When reading the schematic diagrams there are new connections, component identification, colored wiring, and colored circuit operation modes that should be identified. How to identify the new surface-mounted components, and how to remove and replace them is another story.

Board Connections. A direct connector, board-in connector, and direct connections are shown in Fig. 2-8. These connections are found throughout the camcorder schematic wiring, especially with motors, LEDs, sensors, and cables connected to the main circuitboards.

Component Protectors. The schematic symbols for a thermistor, thermal fuse, circuit protector, and posistor are shown in Fig. 2-9.

Chip Transistors and Diodes. The chip or surface-mounted transistor can appear as a PNP or NPN symbol on the schematic diagram. Look for the manufacturers' correct part number in the service manual (Fig. 2-10). The chip diode is also numbered, with connections on both sides. You can find a single, or two different diodes in one surface-mounted component. These different-numbered diodes can have different polarities at the terminals (Fig. 2-11). The zener diode is also found in a chip-mounted diode.

If either the transistor or diode terminals are not clearly marked you can check them out by using the diode test of the DMM. Place the red, or positive terminal to the base, and the negative, or black probe to either the collector or emitter terminal for a normal

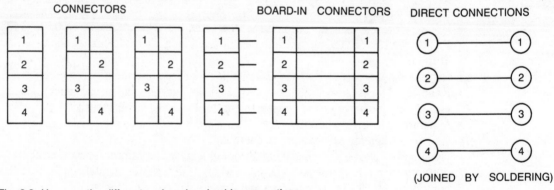

Fig. 2-8. Here are the different pc board and cable connections.

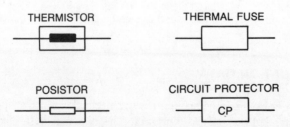

Fig. 2-9. Here are four different schematic diagram components that are found on the camcorder.

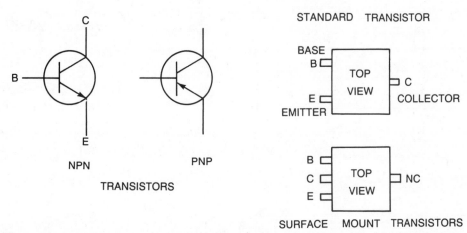

Fig. 2-10. The NPN and PNP transistors are found in surface-mounted parts that solder to the printed circuit wiring.

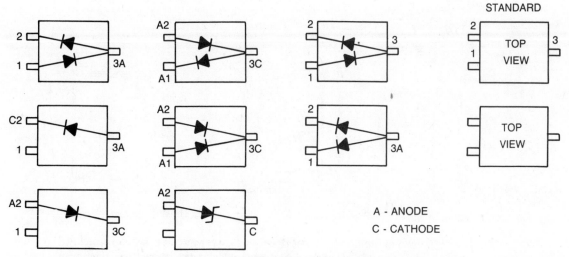

Fig. 2-11. There are many different diode hookups inside the surface mounted component. Notice the anode terminal is "A", while the collector pin terminal is "C". This diode component can be checked like any diode.

measurement of an NPN transistor (Fig. 2-12). Likewise, check the PNP transistor by placing the negative, or black probe to the base terminal, and the red probe to either the collector or emitter terminal. The diode can be checked by placing the red, or positive probe of the DMM to the anode or negative end, and the black probe to the positive or cathode end of the resistor.

Digital Transistors. The digital transistor may include built-in resistors. Both the PNP and NPN types are available. These digital transistor chips feature small size and high

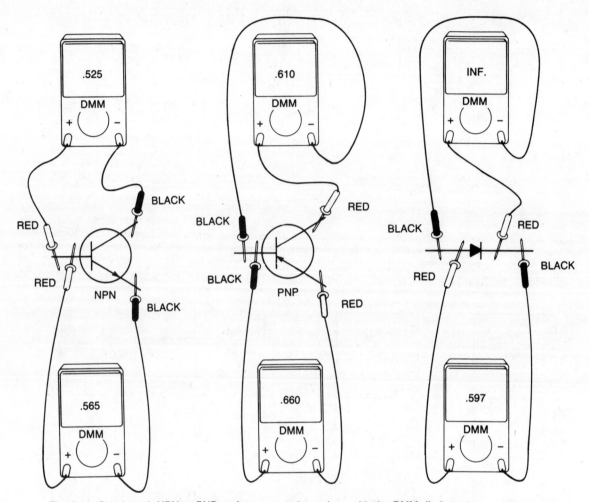

Fig. 2-12. Check each NPN or PNP surface-mounted transistor with the DMM diode test.

reliability. They are used in the inverter, interface, and driver circuits. When replacing a transistor, make certain that it is not of the digital-type, which may include base, emitter, and collector resistors within. A typical Mitsubishi digital transistor chart is shown in Fig. 2-13.

The UN2000 series of Cannon's VM-E2 model composite transistors with internal resistors are shown in Fig. 2-14. Check with the manufacturers' service literature, for the correct part number and digital transistor. When taking junction measurements on digital transistors, some terminals may have a low resistance across them, while in others a higher resistance measurement indicates a high resistance junction. If in doubt, replace these with the original part-numbered pieces.

Double Chip Resistors. A double resistor chip contains two resistance elements of different value in one chip. Notice how the chip terminals are marked. If the device is

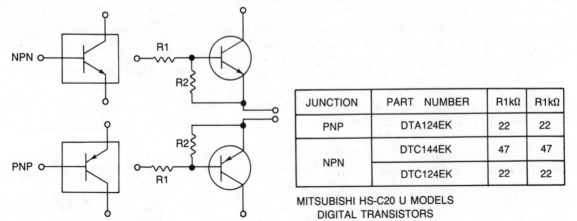

JUNCTION	PART NUMBER	R1kΩ	R1kΩ
PNP	DTA124EK	22	22
NPN	DTC144EK	47	47
	DTC124EK	22	22

MITSUBISHI HS-C20 U MODELS
DIGITAL TRANSISTORS

Fig. 2-13. In digital transistors, the bias resistors are mounted right inside the surface-mounted component. The chart shows the internal resistance of the Mitsubishi HS-C20U models.

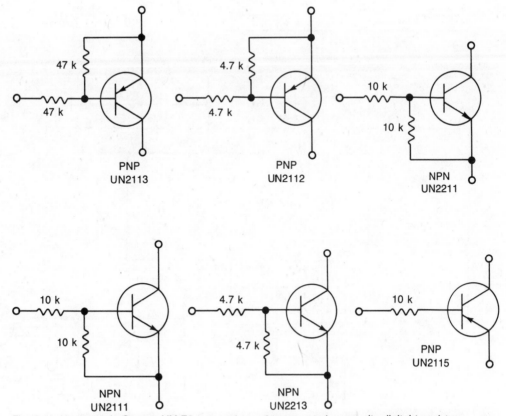

Fig. 2-14. Here are six Cannon VM-E2 camcorder surface-mounted composite digital transistors.

mounted upside-down, it will result in incorrect connections (Fig. 2-15). The correct resistance is measured between the terminal numbers indicated for the correct value. **Schematic Diagram Notes**. Components that are shaded, or have a safety mark, should be replaced with exact duplicates for added safety. Usually, resistance is noted in ohms, kilohms (kΩ) and Megohms (MΩ), while capacitors are either microfarads (µF) or picofarads (pF) (Fig. 2-16). Most resistors are of the 1/16 W type, unless otherwise specified.

Voltage measurements shown on the schematic are taken with a digital voltmeter (DMM). The voltages are taken with the iris closed and the lens cap on. These voltages are usually shown in *Red* while recording, and in *Black* in playback or playback/recording modes. Voltages listed on the schematic are typical values, and not absolute, exact, or standard.

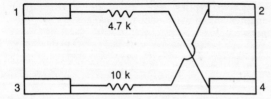

Fig. 2-15. The Zenith VM6150 camcorder contains a typical dual resistor with different resistances in one chip.

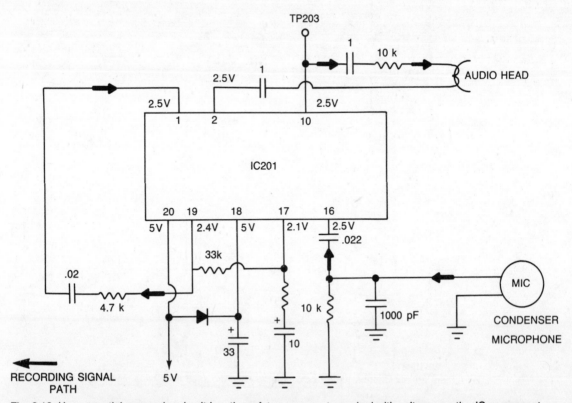

Fig. 2-16. Here a partial camcorder circuit has the safety components marked with voltages on the IC component.

Critical waveforms are taken with a 10:1 probe, unless otherwise indicated, waveforms are of a gray-scale, shot at a standard angle view. Many oscilloscope waveforms, and voltage test points are coded with a red dot.

The pc board drawings can have wiring on both sides of the board. Parts shown in black are mounted on the component side. Often, the pattern wiring on the soldering side is shown in a black mesh pattern. Parts with a blue coloring are mounted on the soldering side, while those in orange are the wiring pattern on the component side.

Schematic Color Information. Today there are many different colors found on the camcorder diagram. Recording voltages, and test point identification are found in red. Sometimes, variable controls and modules are outlined in red. Voltages marked in blue are found in the playback mode. The drum servo signal path may be noted with a solid blue arrow, while the capstan servo signal path is shown with a blue outlined arrow. Within the video section, the recording signal path may be shown with a solid blue arrow, and the playback signal path shown with a blue outlined arrow.

Electrostatically Sensitive Devices (ES). Integrated circuits, field-effect transistors, and semiconductor chip components can be damaged by static electricity. These sensitive ES devices must be handled very carefully when installing and soldering the many terminals. Your body should be grounded to the camcorder or adapter unit you are repairing with a wrist strap device. After all repairs are made, the wrist strap must be removed before turning the power on to the camcorder.

After removing any assembly of the camcorder, lay it on a conductive surface, such as aluminum foil or a copper sheet, to prevent electrostatic buildup. Ground the soldering iron tip to the conductive sheet and chassis, to solder or unsolder these ICs or chips (Fig. 2-17). It's best to use an anti-static solder removal device to prevent damage to the ES devices. Use a 30 watt pencil-type soldering iron on ES and chip terminals.

Do not use freon-spray chemicals, such as cleaning fluid or air, these can generate electrostatic charges. Keep the ES component inside its protective envelope, until it is ready to be installed. Sometimes these replacements are packaged with the leads shorted together in aluminum foil or conductive material. Touch the replacement device to the chassis where the component is to be installed. Do not let clothing touch the sensitive component. Your feet can create static electricity by walking across a carpeted floor. Sliding a chassis across a carpeted work bench will generate static electricity.

Replacing Chip Components. The required tools for removing and replacing leadless components are a 30-watt pencil soldering iron, tweezers, and some manufacturers recommend a blower-type hair dryer. Remember these chip components such as resistors, capacitors, transistors, and diodes cannot be used after they are removed. Replace them with new ones.

Follow the soldering techniques described:

- Do not apply heat for more than 4 seconds, you might destroy the new chip or pc wiring.
- Avoid using a rubbing stroke when soldering.
- Some chips are glued under the component besides being soldered at the terminals. Cementing the replacement is not necessary.
- Use care not to damage the new chip.

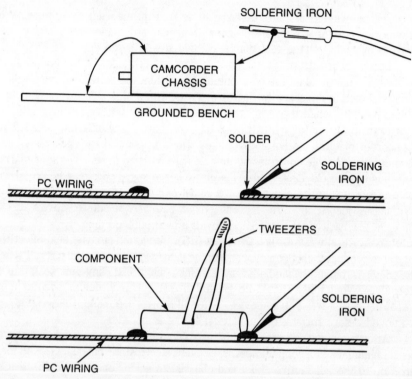

Fig. 2-17. Tin or place solder on the points where the surface component sets. Push downward, while melting each terminal with the soldering iron. Be careful not to damage the part or pc wiring.

- Do not use the removed chip, throw them away, off the bench.
- Do not bend or apply pressure on the transistor or IC terminals in the replacement.
- Do not use a large soldering gun and solder-wick to remove the defective component. The extra heat can damage or pull off the thin pc wiring.

To remove a defective resistor or capacitor, remove the solder at one end. Grasp the end of the component or lead and melt the solder at the other end. Remove the part with a twisting motion of the tweezers.

To remove a transistor or diode surface-mounted component, melt the solder at one lead then lift the lead upward with a pair of tweezers. Do this to each terminal until all are removed. Remove jagged or lopped over solder from the pc wiring. Clean off lumps of solder from the wiring with the soldering iron.

Replace all chip components, except semiconductors and IC processors, by preheating the part with a hair dryer for approximately two minutes (150° C). Tin or presolder the contact points on the circuit pattern or wiring (Fig. 2-17). Press the component down with tweezers and apply the soldering iron to the end terminal connections. Apply more solder over the terminal if it is needed for a good bond. Do not leave the soldering iron to for too long on the transistor or IC terminals. You will damage the internal junctions of the semiconductor.

3

VHS/VHS-C Camcorder Format

VHS and Beta were the first two formats used in the camcorder. Next, the VHS-C and 8 mm were designed for the compact camcorder. Most salesmen, and those in the know, expect the VHS will take over in the home, while the VHS-C and 8 mm camcorders (Fig. 3-1) with their light-weight format are ideal to take on vacation or trips. The VHS camcorder weighs 5.1 to 7.7 pounds, while the VHS-C weighs 1.7 to 4.8 pounds average.

VHS, VHS-C DIFFERENCE

The VHS and VHS-C camcorders use the same size tape, except it's in different type cassettes. The VHS plays for a longer period of time than the VHS-C compact cassette. Both tape formats play through the television set or color monitor. The VHS-C cassette is only ⅓ the size of the VHS, and must be placed inside a VHS adapter before being played back in the VCR machine. You will find that a VHS-C compact camcorder will only record, and has no playback functions. The VHS-C cassette must be placed in the VHS adapter and played through the VCR machine.

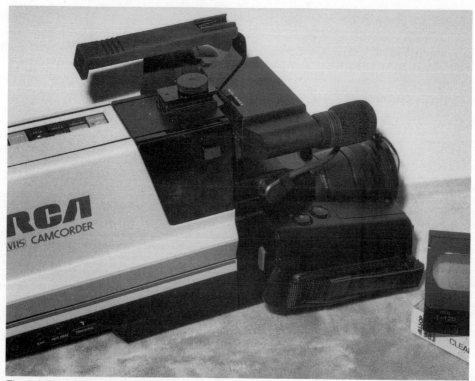

Fig. 3-1. The VHS format is the most common found in use today. Pictured is the RCA SPR300, which contains the latest solid-state features.

SUPER VHS

Super VHS has now entered the market, it also has a new sub-format called S-VHS. These camcorders deliver a higher quality picture on the SP and EP speed operations. Some super camcorders have now introduced stereo sound. At present, the S-VHS is not compatible with the older VHS system. You cannot play an S-VHS recorded tape on a standard VHS camcorder. You must play the S-VHS camcorder through the television set or monitor, just like the 8 mm camcorder, or purchase a separate S-VHS model VCR.

VHS, VHS-C CONTROL FUNCTIONS

There are many different operational functions employed in the VHS and VHS-C camcorders. The more you know about each function, the greater the pictures. The operational functions of both camcorders are given together because they are similar. Read the camcorder instruction manual through several times. Locate the controls on the camcorder to see how it operates.

Electronic Viewfinder. What you see in the viewfinder display is what is recorded on the cassette. Of course, the electronic viewfinder is in black and white, while the recording is in color. The electronic viewfinder can be used as a monitor during playback, of the recorded video. The EVF is easily removed in the RCA CPR300 camcorder (Fig. 3-2).

Microphone. The microphone is usually located to the front of the camcorder for good sound pickup. The mic can be mounted on the EVF assembly or camera section. The external mic-jack may be visible after the microphone has been removed in some models. Most microphones work in a monaural audio system.

External Microphone Jack. In most VHS camcorders, when the microphone is removed, the external mic jack is located underneath, or the same mic jack is used. Use the external microphone to pick up audio close to the subject. Some of these microphones have 600 ohms impedance.

Focus Ring. The *focus ring* is located at the front part of the lens assembly. Rotating the focus ring manually will change the focus of the lens. The focus ring should not be rotated manually when the camcorder is in the *Auto-Focus* mode.

The Lens. The lens is located at the front of the camera section. Most VHS camcorders contain a F 1.2, F 1.4, or F 1.6 lens assembly. Some units have a lens hood, and all lens assemblies should be capped when not recording.

Auto Focus Window. The VHS camcorder is automatically focused with the infrared light system. The infrared light is reflected off the object to be recorded, back to the auto focus window. Keep your hands away from the front area of the auto focus window. Some VHS models have two balanced windows.

Zoom Ring. You rotate the *zoom ring* for a close-up or wide-angle picture in some VHS camcorders. The size of the picture can be magnified with the zoom ring or lever.

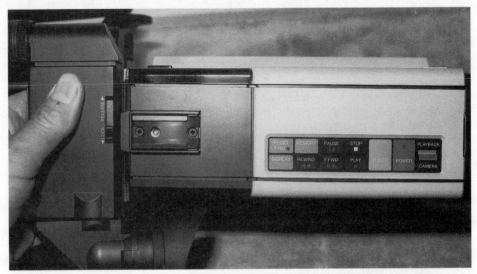

Fig. 3-2. The electronic viewfinder is easily removed and adjusted in the CPR300 model.

Macro Button. Usually, the *macro button* is located on the zoom ring assembly. The macro button is used to set the zoom lever for close-up work. Push in the macro button and rotate the zoom ring for close-up pictures. Slowly rotate the zoom ring for sharp focus.

Battery Eject Lever. The *battery eject lever* is located at the rear of the camcorder. Its batteries are mounted on the backside of the camcorder. Slide the button down to release the battery or ac adapter when operating from the power line.

Eyepiece Focus Control. A separate focus control is located at the bottom side of the EVF assembly to adjust the EVF focus. This allows you to remove your glasses while operating the camcorder. This separate focus control does not affect the picture being recorded.

Accessory Shoe. The *accessory shoe* is located at the top of some VHS camcorders. It allows you to slip the handle, optional microphone, or video accessories into this fitting. Do not mount a bright light in this shoe fitting or excess heat could damage the plastic case of the camcorder.

EVF Lock/Release Lever. In some VHS camcorders, a lever at the top of the electronic viewfinder (EVF) releases the EVF assembly for easy movement. The release lever will permit the EVF assembly to adjust to either the right or left position of the camcorder. Hold the release button to remove the EVF assembly. Move the lever to lock position to lock it in place.

Shutter Speed Button. The *shutter speed button* lets you select different shutter speeds in some models. This shutter speed is displayed in the EVF. A blinking shutter speed LED indicates you need more light. You may be able to select shutter speeds of $\frac{1}{120}$, $\frac{1}{250}$, $\frac{1}{1000}$ and $\frac{1}{2000}$ using the shutter button. Higher shutter speeds require more light.

Shutter/Normal Switch. For fast moving action, set the *shutter/normal switch* to control the shutter speed. Set the switch to normal for normal use. This switch may not be found in some VHS camcorders. Make sure the shutter/normal switch is in normal position for best results (Fig. 3-3).

Lens Cap Holder. Place the lens cap in the plastic holder underneath the camera section when recording. This holder prevents the cap from swinging around. Always keep the lens cap over the lens assembly when you're not taking pictures, to prevent damage to the image pickup element.

Auto/Manual Focus Switch. Set the switch to manual when operating the focus ring, and to automatic for automatic focus operation. In some models, the automatic focus operates from the time the switch is depressed, until the switch is released, for momentary auto focus scenes.

Color Balance Control. The *color balance control* can be operated in manual position. Adjust the control to get the most natural picture. A color television or monitor is used to view the camcorder picture while adjusting the color balance control. Usually, the best color is in the center position.

Battery Compartment. Some camcorders have a time-date display found in the viewfinder. Remove the battery cover to install its batteries. After the time has been set the camcorder will give the correct time and day until the batteries become weak, about one year.

Fig. 3-3. The shutter speed, shutter normal, auto color, display, and review buttons are found on the side of this VHS camcorder.

Auto Iris Control. For the best pictures, the *auto iris control* is set in the center position. Most camcorders adjust manually when needed. Turn the auto iris control counter-clockwise for bright subjects, and clockwise to open the lens when the subject appears dark with a bright background.

Review Button. Push the quick *review button* to play back the last few seconds of a recording. In some models, you're required to place the camcorder in Record/Pause mode, and then press the review button.

Display Button. The date/time will be displayed and recorded when it is indicated in the viewfinder. No date and time will be displayed and recorded when the switch is in the center position. This display button is used when setting up the time/date display.

Auto-Man Color Switch. Throw the switch to auto position for automatic color. If you like to readjust the color, slide the switch to manual, and adjust the color balance control.

External dc Voltage Jack. In the RCA CPR300 camcorder a 12-volt external jack is located at the rear of the camera (Fig. 3-4). The cigarette-lighter power source can be plugged into the external dc jack.

Power Connector. When the battery pack or ac adapter fits on the rear side of the camcorder, a power connector and connector cover hold the unit to the camcorder. The connector cover should be in the upward position at all times.

Audio-Video Output Jack. The audio-video cable or RF adapter is plugged into this jack for recorded cassette playback on a television set or monitor. This same jack is used to connect the unit to a VCR. The audio-video cable connects the camcorder to the direct input on the video monitor or VCR machine. The RF adapter connects the camcorder to television antenna terminals (Fig. 3-5).

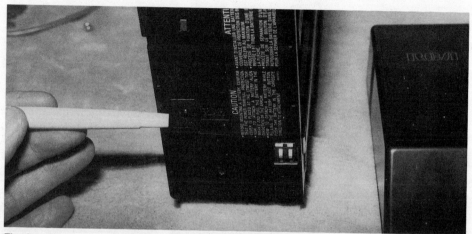

Fig. 3-4. The pen points to the location of the external power supply jack. The battery must be removed to get at the external power jack of this camcorder.

Earphone Jack. Some VHS camcorders have an earphone jack for monitoring the audio during playback or recording.

Record-Remote Jack. In some VHS models, a separate remote jack is available to start and stop the camcorder, away from the unit. The camcorder record-pause features are performed with the operator away from the camcorder.

Tracking Control. Rotate this control for the best picture when visual interference is noted in the playback. Black and white streaks appear on the television set or monitor. Slowly rotate the tracking control in either direction until streaks or interference lines disappear. Figure 3-5 shows the tracking control location.

Record/Start/Stop Button. The record, start, and stop button is a thumb-operated button on some VHS models (Fig. 3-6). Set the camcorder to camera mode and push the record start-stop button to record. Notice the record-indicator light should come on. Press the button again and the camcorder goes into pause mode. In other VHS models, press the play button at the same time for recording television programs.

Power Zoom Buttons. The pen points to the power zoom wide (W) and the telephoto (T) switches that control the power zoom motor (Fig. 3-7). The power zoom switches will move the lens assembly for close-ups (T), or wide angle direction (W). The zoom buttons are easily controlled with your fingers inside the hand strap. In some VHS models, a zoom lever manually zooms the picture in or out. A macro button may be provided for close-up photography.

Hand Strap. The *hand strap* or grip assembly is designed for easy and comfortable operation of the camcorder. Most grip straps are adjustable.

Viewfinder Connection. The audio-video input cable to the viewfinder plugs into the body of the camcorder for easy removal (Fig. 3-8). In some models you can use this same jack to allow camcorder recordings from the VCR and television monitors. The Character Generator may use the same jack.

Fig. 3-5. The AV Out, Rec Remote and tracking controls are found at the low rear side of this VHS camcorder. The RF adapter can be attached to the AV out connection when connecting to a television set.

AV OUT ——

Fig. 3-6. Your thumb is used to operate the Record Start-Stop button on the RCA CPR300 camcorder.

Fig. 3-7. The pen points to the telephoto (T) and Wide (W) push buttons of the power zoom assembly. Pressing the T button brings the subject close up.

EVF Lock Button. Most camcorders with a removable EVF assembly have a lock-button to hold the viewfinder in the best location. Release the lock-button when removing or storing the camcorder in a carrying case.

Fade Button. When the *Fade* button is pressed in the VHS camcorder, the picture in the viewfinder will fade out. Release this button, and the picture will automatically fade in.

White Balance Switch. Some VHS camcorders have an auto- or fixed-white balance switch assembly. In Auto position the optimum color balance is maintained in the outdoor or indoor range of lighting conditions.

Display Button. Some VHS camcorders have a counter-time display button that is indicated in the electronic viewfinder (Fig. 3-9). The counter and battery indicator will show when the button is pushed. Press the button again to display the battery indicator and the time remaining of the cassette. Press it again to return to the normal display.

Rewind Button. Press the rewind button to rewind the tape after playback or recording. Release the rewind button for normal playback from search-mode in some VHS models. This is called a Rewind/Scan button in some camcorders.

Fig. 3-8. You can make recordings from the VCR or television by plugging into the EVF socket, after the EVF-assembly cable is removed.

FFWD Button. To rapidly advance the tape, press the fast forward button. Press and hold the button while the camcorder is in the play mode, to scan the program in the

Fig. 3-9. Many of the operation function buttons are located on top of the camcorder for easy operation.

forward direction. Release this button to return the camera to normal operation. This is called the Fast Forward-Scan button in some VHS models.

Play Button. Press the play button to play back the recorded material or tapes. The camera switch should be in playback operation before pressing the playback button in some models.

Power Button. The power button turns the camcorder off and on.

Playback Camera Selector Switch. This switch is pressed in playback position for viewing of the cassette with the play button pushed. The same switch must be placed in Camera position for recording mode.

Power-Dew Indicator. In the RCA CPR300 camcorder the power light glows when the camcorder is turned on. When the same light is blinking, it indicates excessive moisture in the camcorder. Leave the power on, when the light stops blinking the camcorder is ready to take pictures.

Tape Eject Button. Press the eject button to remove or insert the cassette. Most VHS camcorders must be attached to a power source to load or remove the cassette. The eject button may be a manually operated cassette door in early model camcorders.

Stop Button. The stop button stops all playback, rewind, and fast-forward operations. This button may not have any effect during recording-mode in some camcorders.

Pause Button. During playback, press this button to display a still picture in the viewfinder. In some cameras, during recording a thumb trigger-control activates the Pause function. This Pause/Still Button will cause a pause in play or VCR recording modes in other VHS camcorders.

Memory Counter Button. You can index any place on the tape so the camcorder will stop at that point during fast forward or rewind modes. In some models the letter "M" may appear next to the counter or time display in the viewfinder. Some camcorders will stop, rewind, or fast forward when the counter reaches 0000.

Reset - T-160 Button. When pressing this button on the RCA CPR300 camcorder, the counter resets to 0000 in the viewfinder, T-160 equals 2 hours and 40 minutes for extended play (EP) of the cassette. This light will glow when the camcorder is in the T-160 tape mode.

Tally Light. The tally light (Red) flashes to indicate that recording is in progress on some VHS camcorders.

Back Light Button. To improve scenes with a darker subject than the surroundings, push this button to increase the amount of light.

Standby Button. Minimal battery power is used with the camera in standby mode. Push this button for standby mode, a light will indicate the camcorder is in standby position.

Audio Dub Button. Press the Audio Dub button and Play button to allow sound from another source to be recorded, replacing the original sound on the cassette.

IMAGE SENSORS

The pickup image of the VHS and Beta camcorders started with a pickup tube. The *Newvicon* and *SATICON* pickup tubes were used in the early camcorders. The General Electric 9-9606 model used a Newvicon tube, and in RCA's CLR200 a SATICON pickup tube was used (Fig. 3-10). Most camcorders today have a CCD or MOS solid-state image sensor. Both pickup tubes have heaters, this means a higher drain on the battery. The Saticon tube is made somewhat like the cathode ray tube, except a photosensitive striped filter is found in the end of the pickup tube (Fig. 3-11). Great care must be exercised when handling any pickup tube. Avoid touching or bumping the front surface of the Saticon tube. Dust or fingerprints on the front image surface creates spots and distortion in the video. Handle all pickup tubes with extreme care. The MOS and CCD image sensor used in the VHS-C camcorders is found in Chapter 7.

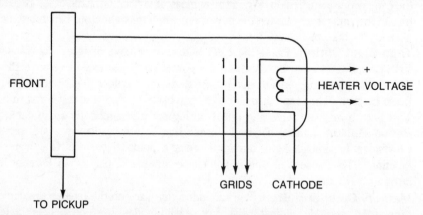

Fig. 3-10. The Saticon pickup tube was used as the image sensor in the early RCA CLR200 model. Notice heater voltage must be supplied to the Saticon tube for operation.

VIDEO HEAD DIFFERENCE

The VHS and VHS-C camcorders use the same tape format, since the compact VHS-C camcorder is a lot smaller than the VHS models in size and weight, a different video

head mechanism was designed. The smaller-diameter cylinder has four pickup heads, while the conventional VHS model has two heads (Fig. 3-12). The standard VHS cylinder has a tape wrap of 180° that rotates at 1800 rpm.

Fig. 3-11. A photosensitive striped filter is found in the front end of the Saticon image sensor. Be careful in removing and replacing any pickup image tube.

STRIPED FILTER

FRONT FACE OF SATICON TUBE

62 mm

DIAMETER

A HEAD

B HEAD

TAPE MOVEMENT

Fig. 3-12. The standard VHS head is quite large compared to the VHS-C camcorder. Only two video heads are found in the VHS head.

The reduced head drum of the VHS-C camcorder has four heads located on a 41 mm diameter cylinder rotating at 2700 rpm, 45 revolutions per second. The tape wrap of the VHS-C video head is wrapped at a 270° angle (Fig. 3-13). Head switching is needed with the 4 heads in the VHS-C camcorder. Recording is possible on this size head in the SP and EP modes. Approximately 60 minutes can be recorded in the extended play (EP), and 20 minutes in the standard play (SP), mode.

The major difference between the camcorder VHS-C system and the conventional VHS system is the four heads. This method provides a more compact camcorder with the same compatibility with previous VHS recorders. Since there are four different heads, complicated head switching circuits are necessary in recording and playback operations.

	Conventional VHS	VHS Movie
Cylinder diameter (mm)	62φ	41.33φ
Tape wrap-around angle (°)	180	270
Cylinder rotation (rpm)	1,800	2,700
Number of heads	2	4

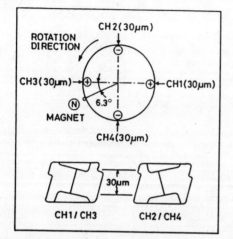

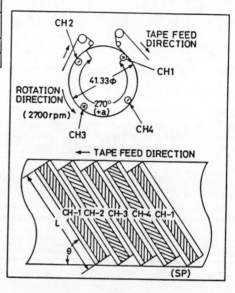

Fig. 3-13. The VHS-C video head is 41.33 mm in diameter, compared to the VHS head of 62 mm. Four different video heads are found in the VHS-C compact camcorder.

VHS-C VIDEO INPUT/OUTPUT CIRCUITS

The input circuit of the video section contains the luma and chroma signals from the camera, these pass through the main board and enter the luma/chroma board. In Fig. 3-14 the luma and chroma signals from the process board are fed to the main board. The luminance signal enters the luma process IC201. Also, the chroma signal is fed to the video amplifier generating the EE video signal. The video output circuit consists of the EE and the playback signal.

VHS-C VIDEO HEAD SWITCHING

The head switching IC (IC203) switches the video heads over between the record and play modes, according to the various control signals (Fig. 3-15). The monitor cut signal controls the recording amplifier to inhibit recording during pause and loading. Head switch SW1 to SW4 signals are supplied from the servo circuit to select the CH1 to CH4 video heads, one after another during recording and playback.

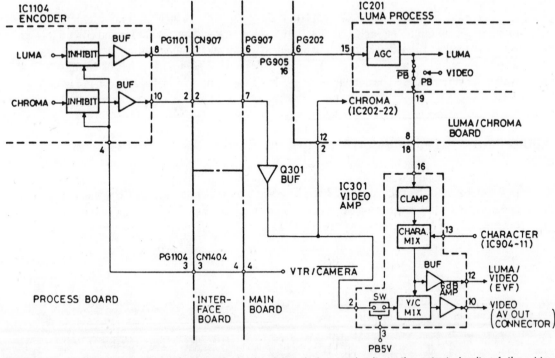

Fig. 3-14. The video input signals are fed from the luminance and chroma circuits to the output circuits of the video amp IC.

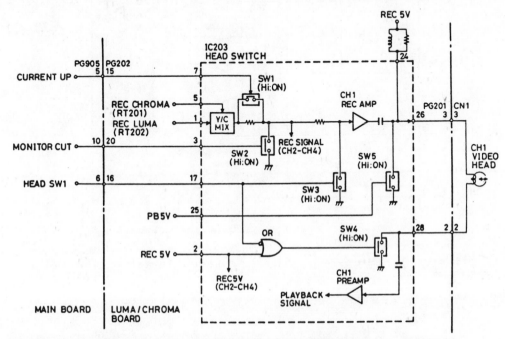

Fig. 3-15. The complete video head switching is performed by IC203 after the pre-amp circuits.

The REC 5V signal (at pin 2) supplied from the system is high (H) during record mode to set up the recording circuits with the video heads. The SW 30 Hz and SW 15 Hz signals select the video head output to obtain a continuous signal during play mode. The PB5V signal (at pin 25) is high (H) during play mode to set up the playback circuits within the video heads. The complete VHS-C head switching schematic is shown in Fig. 3-16.

AUDIO INPUT/OUTPUT CIRCUITS

The audio input circuit lets the audio signal enter the microphone or external audio jack and feeds to the audio amp (IC401). The audio output circuit supplies EE audio or audio signal to the earphone jack or AV OUT connector (Fig. 3-17). Connect the AV output cable or RF converter to the AV OUT connector to monitor the audio signal.

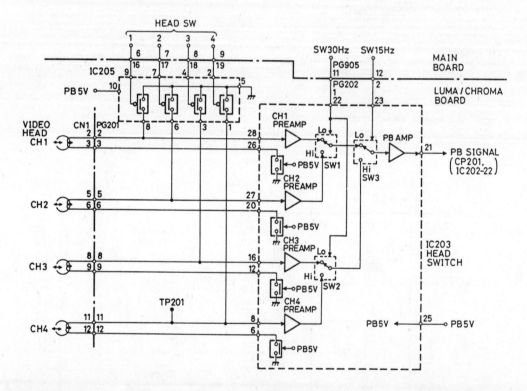

Fig. 3-16. There are four different video heads. The head switching IC changes the video heads in play and record modes.

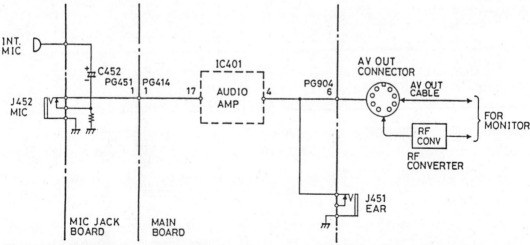

Fig. 3-17. The audio amplifier (IC401) amplifies the audio signal that is picked up by the microphone. The audio can be heard while recording, using the earphone, or tied to the AV out connector for monitoring.

VHS-C AUDIO HEAD SWITCHING

The playback (PB) signal from the system control IC is fed to pin 5 of head switching IC402 (Fig. 3-18). This signal is to switch the record/play heads between record and playback modes.

VHS-C Audio Amp IC

The audio amp (IC401) includes recording and playback circuits (Fig. 3-19). The IC401 audio recording circuit consists of the ALC circuit, which keeps the input level and output level constant, a recording amplifier, and recording equalizer circuit (Fig. 3-20). A playback audio equalizer circuit is also found in IC401 (Fig. 3-21). The playback equalizer circuit boosts the high frequency response, and flattens the low frequency response in EP and SP modes.

VHS-C Audio Bias Oscillator

Like the audio tape head in the conventional cassette player, a bias oscillator is used to provide a higher quality audio reproduction. Here a Hartley oscillator provides a 70 kHz bias current to the audio record/play head, audio erase head, and full erase head (Fig. 3-22).

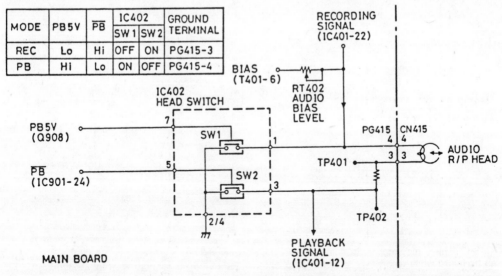

MODE	PB5V	\overline{PB}	IC402		GROUND TERMINAL
			SW1	SW2	
REC	Lo	Hi	OFF	ON	PG415-3
PB	Hi	Lo	ON	OFF	PG415-4

Fig. 3-18. The playback (PB) signal is fed from the system control to the head switching IC402.

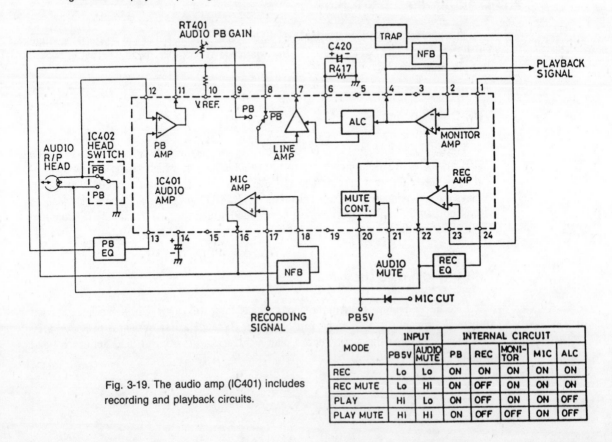

Fig. 3-19. The audio amp (IC401) includes recording and playback circuits.

MODE	INPUT		INTERNAL CIRCUIT				
	PB5V	AUDIO MUTE	PB	REC	MONI-TOR	MIC	ALC
REC	Lo	Lo	ON	ON	ON	ON	ON
REC MUTE	Lo	Hi	ON	OFF	ON	ON	ON
PLAY	Hi	Lo	ON	OFF	ON	ON	OFF
PLAY MUTE	Hi	Hi	ON	OFF	OFF	ON	OFF

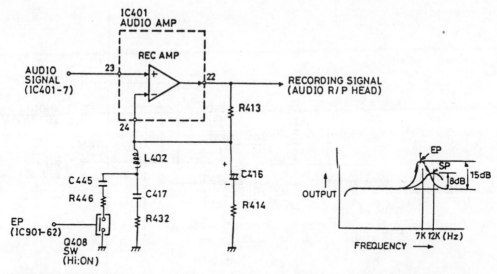

Fig. 3-20. The recording equalizer circuit is also found in the audio amp (IC401 in this VHS-C camcorder audio circuit).

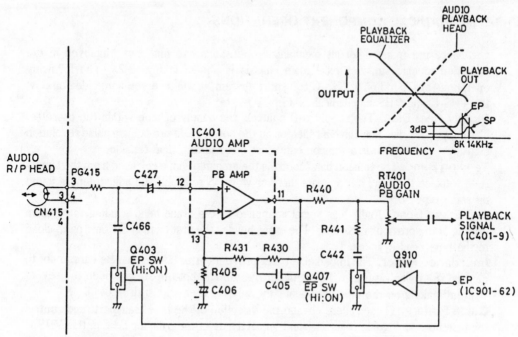

Fig. 3-21. The playback equalizer circuits are also found in the large IC sound amp (IC401).

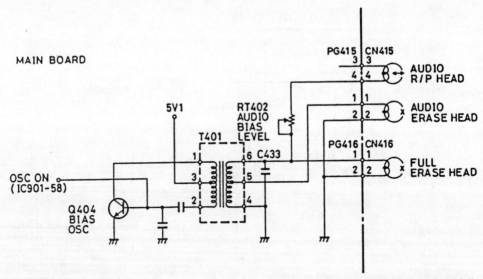

Fig. 3-22. The audio bias oscillator circuit provides bias current for the audio, audio erase, and full erase head.

VHS-C MECHANICAL COMPONENT OPERATIONS

There are many different mechanical operations and functions employed in the operation mechanism. A typical main chassis is shown in Fig. 3-23. The following operations are found on a VHS-C transport system, it will give you some idea on how the VHS-C and VHS mechanical systems operate.

Supply Reel Disc. The supply reel controls the supply of tape within the cassette. The supply reel disc may have a reflector on the bottom side providing a pulse revolution signal. At the bottom is a tension band that controls the tape tension.

Tension Band. The tension band controls the amount of tape released from the supply reel. Replace the band if it appears dirty or worn. A tension band adjustment is found on some tape decks.

Full Erase Head. Audio bias signal is applied to the erase head winding to perform erasing of the previous recording. The erase head is the first head in the tape path, close to the tape head cylinder.

Impedance Roller. The impedance roller prevents jitter conditions. Be careful not to damage the roller's surface. Felt rings at the top and bottom are provided to prevent oil from leaking on the tape. Lubricate the bearing area with a drop of oil.

Guide Rollers. These rollers change the direction of the tape transport, and control the tape height. A guide roller is found on each side of the cylinder head in this VHS-C model. The guide rollers should be adjusted so the bottom edge of the tape runs along a reference line.

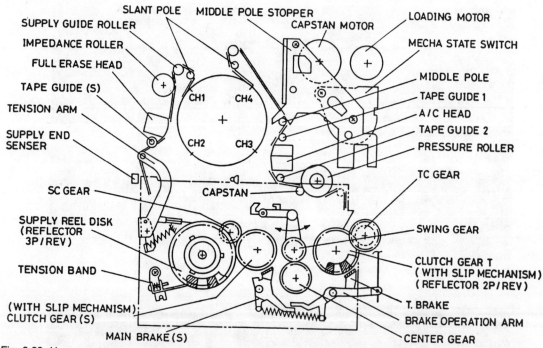

Fig. 3-23. Here are the many operating components found in the VHS-C tape transport system. (Courtesy of Radio Shack)

Slant Poles. Two slant poles are found in this tape transport, one on each side of the cylinder head. Do not try to straighten up these guide assemblies, as they are made this way. They are slanted so the tape winds at an angle around the cylinder.

Cylinder. The two video heads located on the cylinders are in contact with the tape at all times (Fig. 3-24). These heads switch during recording and playback.

Middle Pole and Stopper. The tape runs around another pole after leaving the cylinder and the slant pole, before it reaches the A/C head. Before the tape is loaded, the middle pole is located inside the takeup reel, it becomes erect as tape loading proceeds, and on completion of loading, the middle pole is positioned by the middle pole stopper, over the capstan motor and is locked by the arm on the A/C head plate. Most middle poles are adjustable.

A/C Head. The *audio control* (A/C) *head* contains the audio erase, audio head, and control head (Fig. 3-25). The audio erase head erases the audio signal in the audio dub mode. The audio head records and plays the audio signal, while the control head is used to record and play the servo control signal (CTL).

Mechanism State Switch. The mechanism state switch turns the loading motor off and on according to the current mode. The switching contacts control the eject, FF/Rew, Stop, Loading Midpoint, REC Lock, REC, Play, REC Pause, FF Search and REW Search.

Capstan/Flywheel. The capstan rotates the tape between the capstan and pressure roller. The capstan provides a capstan FG signal. The flywheel is supported by two bearings (Fig. 3-26).

Fig. 3-24. The two video heads are located on the cylinder of a VHS camcorder. This cylinder spins at 1800 rpm.

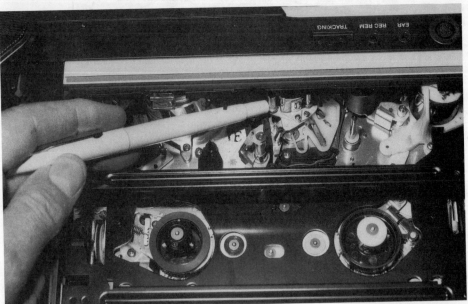

Fig. 3-25. The audio control (A/C) head consists of the audio erase, audio, and control head.

Center Gear. The center gear is rotated by a belt from the capstan flywheel assembly in the VHS-C transport. The swing gear is engaged by the center gear which swings to the right or left according to the center gear's direction of rotation to drive the takeup or supply clutch gear.

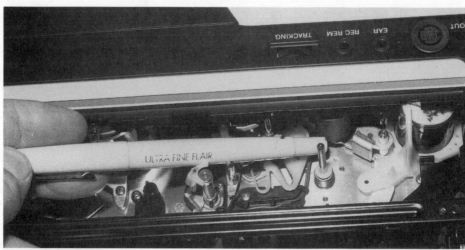

Fig. 3-26. The capstan/flywheel shaft rotates the tape by engaging the rubber pressure roller **against** it when operating.

Clutch Gear Assembly. This assembly has a slip mechanism which transmits torque from the capstan motor to the takeup reel hub, permitting slipping, this in turn takes up the slack tape. The clutch assembly operates in fast forward mode. The clutch gear stops rotating when rewinding is complete.

TC Gear. This gear transmits the capstan motor torque from the clutch gear to the takeup reel hub (Fig. 3-27).

Clutch Gear S. This gear has a slip mechanism which transmits the capstan motor torque to the supply reel disk, permitting slipping, to take up the tape, like the clutch gear assembly.

Main Brake. The main brake is driven by a cam gear linked to the brake at the top of the control arm, it applies braking to the clutch gears.

THE VHS-C LOADING MECHANISM OPERATION

The loading motor provides power to load and unload the cassette and tape. The tape is taken from the supply reel disc and wound around the cylinder during the loading process. The control cam gear is rotated by a worm gear on the loading motor (Fig. 3-28). The rotation of the control cam gear is transmitted to the adjacent cam gear, the ring gear, and the lower supply loading ring (which is one of the loading rings located around the cylinder) shown in Fig. 3-29.

Brake Drive Mechanism. The TE lever is linked with the upper cam groove in the control cam gear. The TE operation arm is linked with the TE lever end by the TE operation rod (Fig. 3-30). The TE operation arm contacts one end of the T-brake. When the control cam gear rotates counter-clockwise, the TE lever pin is driven by the cam groove of the control cam gear moving it counter-clockwise. The TE operation rod is

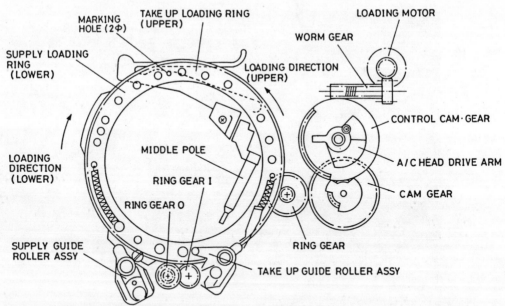

Fig. 3-27. The TC gear drives the take-up hub reel assembly from the capstan motor assembly. Notice there is a drive belt between the center clutch gear and capstan pulley. (Courtesy of Radio Shack)

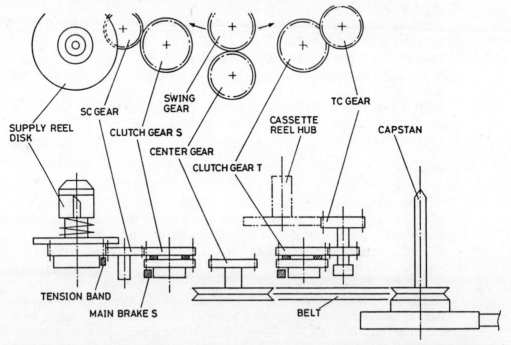

Fig. 3-28. The loading motor loads the cassette using a worm gear to drive the control cam gear, cam, and ring gear to operate the loading ring. (Courtesy of Radio Shack)

pulled upward, turning the TE operation arm counter-clockwise so the T-brake engages to weaken or stop (brake) the rotation of the takeup reel disc. The eject lever unlocks and lifts the cassette holder when the TE rotation arm has turned counter-clockwise completely.

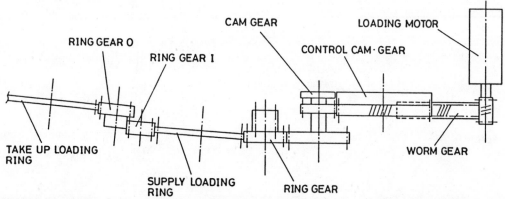

Fig. 3-29. The side view of the loading mechanism shows how each component is rotated by the loading motor.
(Courtesy of Radio Shack)

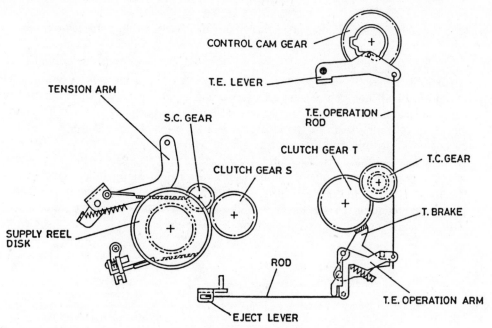

Fig. 3-30. The TE lever controls the T brake assembly by a long rod. The cassette eject lever is tied to the other end of the TE operation arm with another small rod assembly. (Courtesy of Radio Shack)

Tension Arm Operation. The lower cam groove of the control cam gear is linked with the pin at the end of the pressure roller operation lever. Teeth engage at the other end of the assembly (Fig. 3-31). The tension arm operation lever drives the tension arm by applying force to a pin attached to the tension arm.

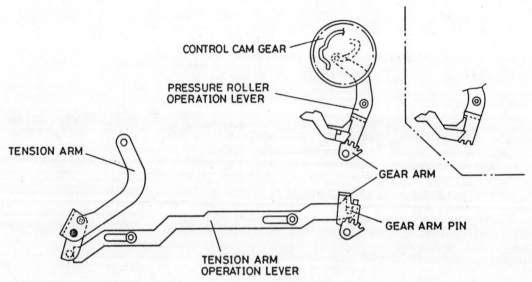

Fig. 3-31. The control cam gear operates the tension arm lever by engaging small teeth on the gear arm assembly.
(Courtesy of Radio Shack)

Pressure Roller Drive Mechanism. The lower groove of the control cam gear is linked with the pin of the pressure roller operation lever (Fig. 3-32), when the control cam gear rotates counter-clockwise, the pressure roller operation lever also turns counter-clockwise, engaging teeth on the gear arm rotating it counter-clockwise, moving the capstan shaft and bringing the roller in contact with the shaft.

Main Brake Mechanism. The outer groove in the upper surface of the control cam gear is aligned with the pin on the brake cam lever. The brake operation rod connects the brake cam lever to the brake operation arm (Fig. 3-33). When the control cam gear rotates, the rod turns the operation arm clockwise, the main brake (S) comes into contact with the clutch gear S, providing the braking operation.

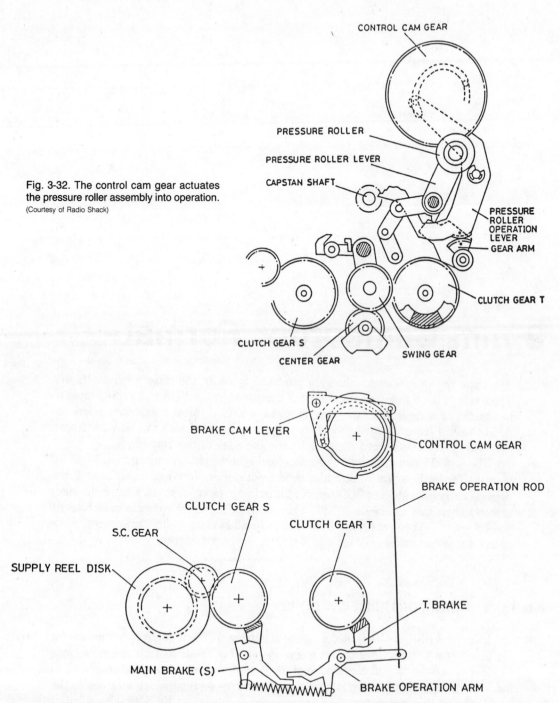

Fig. 3-32. The control cam gear actuates the pressure roller assembly into operation. (Courtesy of Radio Shack)

Fig. 3-33. The main and T brake assemblies are controlled by a rod tied between the control brake cam lever and the control cam gear groove. (Courtesy of Radio Shack)

4

8 mm Camcorder Format

The majority of 8 mm camcorders are produced by or for the camera manufacturers. The width of the 8 mm tape is quite small compared to the VHS and VHS-C tape, although the cassette is about the same size as the VHS-C. Most 8 mm camcorders use AFM (Audio Frequency Modulation), the sound is recorded with the video, whereas, the VHS camcorders record the sound along the edge of the tape.

The typical 8 mm camcorder is compact and light-weight, averaging from 2.8 to 3.2 pounds. The early 8 mm camcorders used a Saticon or Newvicon tube, most 8 mm cameras today have MOS or CCD semiconductor image pickup devices. 8 mm camcorders are only short play or standard (SP), while some of the latest cameras have both SP and LP speeds. The flying erase head (FE) is found in many 8 mm camcorders. Some of the 8 mm camcorders record only, with no playback features.

8 MM OPERATING CONTROL FUNCTIONS

Like the VHS-C or VHS model, there are many different controls to operate for the best 8 mm picture. The mounting and operation of these controls are quite close together, since the overall dimensions of the 8 mm camcorder are small compared to the VHS models. Some cameras have a separate grip section, which attaches to the main body of the camcorder. The grip section consists of the optical viewfinder,

microphone, Battery Eject, and Record/Stop buttons. All the basic controls are pictured in Fig. 4-1.

Accessory Shoe. The accessory shoe is used for the carrying handle, external microphone, and other accessories. Do not attach outside lighting equipment to the shoe area, the camcorder body can be damaged by heat.

Microphone. The built-in microphone is mounted on the front side of the camera area. Most of these microphones are unidirectional types. Some 8 mm camcorders have a mic jack to place the external microphone closer to the subject. Choose a low-impedance type microphone with a M3 miniplug.

Zoom Lever. The zoom lever is usually a rotating ring lever at the rear of the lens assembly. Find the subject through the viewfinder, and choose the desired picture using the zoom lever or power zoom buttons. Release the zoom lever from macro mode when using the power zoom buttons. Macro focusing is for extreme close-up shots. The power zoom buttons are located near the handgrip for easy operation. Press W (wide) to increase the angle of view, press T (telephoto) for close-up pictures.

Focus Ring. The focus ring is located to the front of the camera lens assembly. Set the focus selector to manual, and rotate the focus ring.

Lens Hood. The lens hood is the outside area of the lens assembly. A lens filter is used to protect the regular lens from dust, scratches, and possible damage. If the new lens is not protected, purchase a lens filter to protect it. To remove the lens cap, place the palm of your hand over the lens head, while pressing lightly, turn it counter-clockwise.

Lens Cap. The plastic lens cap is placed over the lens assembly to protect the image sensor from bright sunlight or damage. Keep the lens cap on all the time, unless you are recording. Some 8 mm cameras have a lens cover that slides over the lens area of the camcorder. To turn off the power, slide the lens cover over the lens area.

Lens Cap Hook. The lens cover is connected to a cord on the camcorder so it won't be lost. Some camcorders have a plastic post the cap fastens to, while others have a hook to hang the lens cap on while recording.

Auto White Balance Sensor. The white balance sensor is located under the lens area so try not to cover up this area during recording. White balance refers to the adjustment in the camcorder to color temperature of the light that illuminates the subject or image to be recorded. Proper adjustment of white balance provides accurate recording of the colors in the picture.

AF Button. When the auto focus (AF) button is set the camcorder will focus automatically during recording. Pressing the AF button during manual operation engages the auto focus function. In some 8 mm camcorders, releasing the AF button locks the focus at that particular lens setting.

Focus Selector. In some cameras the camcorder automatically focuses during recording, when the focus selector is set to auto focus. Use the focus lock function when the subject is not positioned in the center of the viewfinder. The center portion of the viewfinder is focused in the auto focus mode of some camcorders. Select the manual mode and aim the camera at the subject so the image is in the center of the screen, now press the

Indicator panel

MOVIE 8 VX-801-U

Counter memory indicator
Tape counter indicator
Moisture condensation warning indicator
Mode indicators
Battery warning indicator

All indicators cannot be displayed simultaneously.

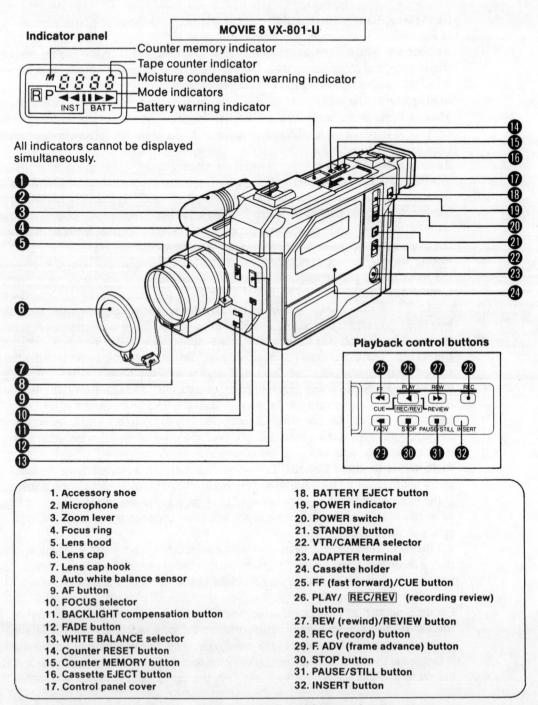

Playback control buttons

1. Accessory shoe
2. Microphone
3. Zoom lever
4. Focus ring
5. Lens hood
6. Lens cap
7. Lens cap hook
8. Auto white balance sensor
9. AF button
10. FOCUS selector
11. BACKLIGHT compensation button
12. FADE button
13. WHITE BALANCE selector
14. Counter RESET button
15. Counter MEMORY button
16. Cassette EJECT button
17. Control panel cover

18. BATTERY EJECT button
19. POWER indicator
20. POWER switch
21. STANDBY button
22. VTR/CAMERA selector
23. ADAPTER terminal
24. Cassette holder
25. FF (fast forward)/CUE button
26. PLAY/ REC/REV (recording review) button
27. REW (rewind)/REVIEW button
28. REC (record) button
29. F. ADV (frame advance) button
30. STOP button
31. PAUSE/STILL button
32. INSERT button

Fig. 4-1. Knowing where and how the controls operate will result in better pictures. (Courtesy Olympus VX-801-U Camcorders)

AF button. Release the AF button after focusing, and return to the original subject. The subject should remain in focus, even though it is not in the center of the viewfinder.
Back Light Compensation Button. This button is located on the front area of the camera. Some 8 mm camcorders are equipped with an automatic exposure system, it adjusts the lens aperture according to the amount of illumination of the subject. This system provides appropriate exposure during most recording situations, strong backlighting of the image will cause the lens aperture to be closed, and the subject to become black. Press and hold the back light compensation button during recording if the subject appears black.

Fade Button. Some of the more expensive camcorders have a fade button that can be used to fade in gradually from a totally dark image to an illuminated one. It can also be used to fade out the image in recording functions. In some 8 mm camcorders you have to hold the fade button before pushing the Start/Stop button. Press the Start/Stop button to begin recording. Release the fade button, fade-in will begin. Reverse the procedure when you wish to fade out a scene. Notice the viewfinder becomes dark. Press the Start/Stop button to enter the pause mode.

White Balance Selector. The white balance must be adjusted so that the white subject can be recorded white, no matter what the color of the light source. Some 8 mm camcorders have a white balance adjustment for artificial light or sunlight. The white balance will be automatically adjusted when the white balance selector is set to Full Auto. This is the normal operating position for the white balance selector. The white balance adjustment will be performed continuously, and automatically, in auto white balance operation.

Counter Reset Button. The tape counter indicator is displayed on the indicator panel, usually on top. The counter changes numbers as the tape advances, and is used to locate certain scenes at a later date. Just press the counter reset button and the tape counter returns to zero (000).

Counter Memory Button. In searching for a specific tape section, when fast forwarding or rewinding with the counter memory button pressed, the tape will automatically stop around the counter reading of (000). This is convenient for locating the same scene for repeated viewing, it is found in the expensive 8 mm camcorders.

To set the counter memory, press the counter reset button at the position you wish to return to during playback operation. Press the counter memory button, this memory (M) is displayed with the counter numbers. Pressing the memory button once again releases the counter memory mode.

Cassette Eject Button. The eject button is pressed to open the cassette door for loading and unloading the cassette. Press the button to eject the cassette after recording. This eject button will not operate during recording.

Battery Eject Button. To remove the chargeable battery pack, push the battery eject button. This release button is alongside the battery mounting location. In some 8 mm camcorders the battery slides into a compartment of the grip assembly.

Power Indicator. When the power is switched on, the power indicator should light. This power indicator is on one side of the camcorder or in the display panel. Make sure

the power indicator light is out, by turning off the power switch, when not recording or in playback modes.

Power Switch. The power switch is turned on to apply voltage to the camcorder. The power indicator light will come on indicating this. If the light does not come on, check the battery or ac pack connections.

Standby Button. Enter the camcorder in standby mode when record pause mode is to continue for an extended period of time. You can conserve battery power, and the camcorder is ready to proceed for the next recording. The picture will disappear from the viewfinder in the standby mode. In some camcorders, while recording, you must enter the pause mode before pressing the standby button. No playback or recording will take place with the camcorder in standby mode. The indicator panel will blink, in some models. To restart the recording process, press the start button after pressing the standby button. This feature is not found in some lower priced models.

VTR/Camera Selector. This switch will not be found on camcorders that only record, and have no playback features. The VTR/Camera is pushed to *camera* to record and to the *VTR* position for playback operations. Some camcorders record in LP mode, but will not play back in the 8 mm machine. After placing the camcorder in playback mode, press the play button to begin the playback process.

Adapter Terminal. The adapter terminal is found in 8 mm camcorders that will play directly into an AV connector, using a battery jack to the ac adapter, and directly to the television monitor. Both the sound and video out cables attach to the adapter. The adapter plugs into the adapter terminal on the camcorder. The adapter terminal plug can be used for recording from other video equipment.

Cassette Holder. The cassette holder contains the cassette when recording, loading, and unloading. Slide the eject switch in the direction of the arrow, and the cassette door will open. In some models the cassette compartment folds out, and in others it slides out for loading. The battery pack or ac adapter must be connected before the cassette holder opens. In other models you must press the cassette eject button, and then press the cassette unlock latch to release the cassette.

Close the cassette holder by pressing a push mark on the holder. In other models a close button is pressed to open and close the cassette holder. Be careful not to push against the cassette door on these models. Verify which method opens and closes your cassette door.

Fast-Forward (FF)/Cue Button. Press the fast-forward button to run the tape forward at high speed. *Only* press the FF button in the stop mode. The fast-forward symbol may be seen in the display panel. In some models, when the tape reaches its end during playback or fast forward, the tape automatically rewinds to its beginning, and the stop mode is entered. This feature may not be found on lower priced camcorders.

Play/Record Review (Rec/Rev) Button. In playback mode, set the VTR/CAMERA selector to VTR. Make sure the power is on and the cassette is loaded. You can see the playback mode in the electronic viewfinder on the camcorders that have it. Not so on the optical viewfinder. The electronic viewfinder playback feature is nice for a quick review of what was just recorded. If not satisfied, shoot it over on the spot.

You may be able to monitor the sound with the earphone plugged into the EAR-JACK during playback on some models. The letter P with an arrow indicates in the display

panel which direction the tape is moving. Just press the play button and monitor the pictures. Press the stop button to stop the playback mode. You must press the play button again to resume playback.

Rewind/Review Button (Rew/Rev). The rewind button should only be pressed in stop mode. Press the REW button to rewind the tape after recording, or to search for a certain piece of recording. Press the play or review button to check the recording. This button may not be found on models that only record, and have no playback features.

REC (Record) Button. Recording begins, after properly loading the cassette, turning the power switch on and pushing the record button, press the start/stop button. In some models the recording letter and tape movement arrow can be seen in the viewfinder. To stop the recording, press the REC Start/Stop button in some models, while pressing the start/stop button in others. To resume recording press the REC Start/Stop button again. It is best not to remove the cassette from the camcorder for consecutive recordings on the same cassette.

F. ADV (Frame Advance) Button. This button is found on the most expensive camcorders. Press the F. ADV button to check frame by frame spot checks of the recording. It can be used with insert recording to take out or put in other shots or titles.

Stop Button. The stop button is a single button on some cameras or is included in the REC/Start/Stop button function. All functions should start from a stop mode. On some models the REC/Start/Stop button has more than one feature. Pressing this same button down further puts the camcorder in standby mode.

Pause/Still Button. This button is referred to as the standby button in some models. The tape stops when the pause/still button is pressed during recording, press the button again and recording begins. In some models when the pause mode lasts more than 5 minutes, the stop mode will automatically shut off the camcorder. The pause/still button is also used to insert recordings in some models.

Insert Button. The insert button is used to insert new images into a previously recorded tape, the picture and sound are both recorded. Locate the end or place where you wish to insert a title or picture, and press the still button. Press the Reset button to reset the tape counter to 0000. Locate the starting point of the inserted recording by pressing the Review button and entering the still mode. Press the counter Memory button. Now press the INSERT and RECORD buttons simultaneously. The camcorder will enter the INSERT RECORD/PAUSE mode.

Set the VTR/Camera selector to CAMERA and press the Start/Stop button, insert recording begins. Insert recording ends and the Record/Pause mode is entered automatically, when the tape counter reads 0000. To stop the insert recording before the tape counter reads 0000, press the Start/Stop button. The Record/Pause mode is now engaged.

VIEWFINDER INDICATOR LIGHTS

Some of the 8 mm indicator lights are found inside and outside the viewfinder. Most of them are seen in the display panel.

Indoor Lamp. This is a yellow lamp that lights up when the white balance switch is exposed to night lights or an extremely sharp burst of light. Check for a sunlight indicator for recording indoors.

White Balance Warning Indicator. The white balance light has an orange lamp indicator. This lamp lights up when the white balance selector is not in FULL AUTO position in some camcorders.

Tape Run/Battery Lamp. This red lamp blinks when the inserted battery is exhausted. It also lights up when the recorder is set in the standby mode. In other camcorders the red lamp lights while recording, and blinks when the battery pack is getting low, it does not blink while recording.

Standby Indicator. This lamp is orange, it blinks *before* the recorder is set in the standby mode, and lights up when the recorder is set in the standby mode. In some units this light will alternately blink when the Tape/Batt lamp indicates moisture inside the camcorder.

Low Lamp Indicator. The yellow lamp lights up when there is insufficient light to take pictures.

EXTERIOR CAMCORDER LAMPS

Some camcorders have their warning indicator lights on the outside of the unit (Fig. 4-2).

Tape Run/Batt. This red light blinks when the battery is exhausted, and lights up during recording. Before a recording can be made this red indicator alternately blinks with the Standby light.

Standby Lamp. The orange indicator blinks before the camcorder is set in the standby mode, and lights up when the camcorder is set in the standby mode. When the video heads have been contaminated during recording, this indicator and the TAPE RUN/BATT indicators alternately blink.

Dew Lamp. The yellow dew lamp indicator lights up when condensation is inside the unit. Remove the cassette and let the unit stand with the cassette door open for about one hour.

TAPE RUN/BATT LAMP

STANDBY LAMP

DEW

CAUTION

Fig. 4-2. Warning lamps located on the outside of the 8 mm camcorder.

Caution Lamp. This caution lamp is red, and lights up when the video heads have been contaminated. Check the heads for clogged oxide-dust and dirt.

Exposure Indicator Bar. In a few camcorders the exposure indicator bar indicates if the picture is going to be underexposed, overexposed, or has correct lighting (Fig. 4-3). The camcorder will take a normal picture, when the bar is in the middle of the exposure display. This bar moves up or down according to the light level.

8 MM CAMCORDER MAIN CHARACTERISTICS

The typical 8 mm camcorder has a play-record or record only feature. The tape is wound 180° around the drum. Audio Frequency Modulation (AFM) is used, with no

CORRECT EXPOSURE UNDEREXPOSED MAY RESULT OVEREXPOSURE MAY RESULT

Fig. 4-3. Some camcorders show if the picture is over- or underexposed.

stationary audio tape head. It uses one section of the video track for Automatic Track Finding (ATF) as the tracking system. The Flying Erase head rotates with the video heads for erasing. The camcorder operates from real low voltage, 5 to 6 volts dc. One CPU controls the system control. The mechanical transport is driven by the drum, capstan, control, and loading motor. Several data controls regulate the video and servo block system. The latest 8 mm camcorder picture image sensor is a MOS or CCD device.

CCD IMAGE CHIP

Most of the 8 mm camcorders today use a CCD or MOS image sensor chip. You will find a MOS image sensor in some Kyocera and Pentax models. The CCD chip has high-resolution and color reproduction, low smear, quick start, and of course, less weight.

The CCD semiconductor device consists of orderly arranged capacitor cells, converting light into electrical energy, accumulating electric charges, and transferring these charges to the camera circuits (Fig. 4-4). To make good color pictures the CCD device must have a great number of picture elements. The CCD unit in the Cannon VM-E2 model has 210,000 pixel elements, while the VM-E2N has 250,000. The CCD and MOS image sensors are discussed in Chapter 7.

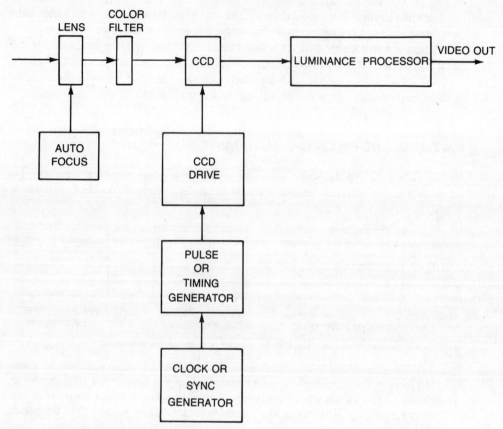

Fig. 4-4. A block diagram showing how the different circuits are tied to the CCD image sensor.

MAIN MECHANICAL COMPONENTS

Here are the eight main mechanical components that you will find in the 8 mm camcorder, and how they operate (Fig. 4-5).

Capstan Motor. The capstan motor drives the supply and takeup reels through a conversion gear, relay pulley, and pendulum gear assembly in some camcorders (Fig. 4-6). The capstan motor shaft usually controlled by the system or servo control IC, rotates the tape.

Pinch Roller. Like the pinch or pressure roller in the audio cassette, this roller rides against the tape and capstan drive shaft to feed or pull tape from the supply reel (Fig. 4-7). The pinch arm lever moves to press the pinch roller against the capstan by moving the pinch lever and pinch arm.

TGI Arm and Band. The TGI arm assembly with the band assembly, controls the braking around the base of the supply reels in some models. The band and brake assembly is fully on in stop position (Fig. 4-8). The TGI arm assembly releases the band when the tape is ready to move.

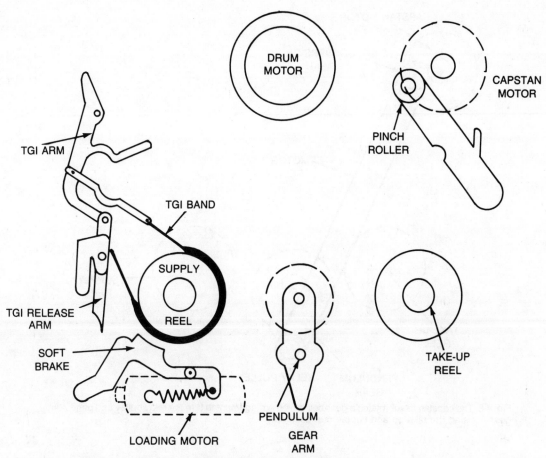

Fig. 4-5. Here are the main working parts found in the 8 mm camcorder.

TGI Release Arm. The TGI release arm is located at the end of the slider arm, and moves in either direction according to the slider arm assembly. The TGI release arm moves to release the TGI band for breaking.

Soft Braking. Braking of the supply reel is controlled by pressure from a braking lever against the area of the supply reel in some models (Fig. 4-9). The soft brake moves at the same time the TGI band is released.

LM Motor. The loading motor is gear driven to rotate the loading gear assembly. The speed of the loading motor is reduced considerably by using several loading gears and pulleys before rotating the loading slider assembly (Fig. 4-10). The loading motor operates in either direction for loading and unloading procedures.

Drum Motor. The drum motor rotates the drum assembly or cylinder and is mounted

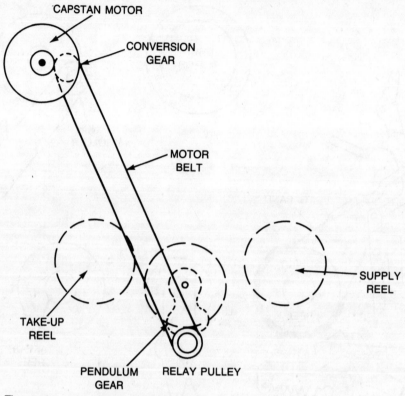

Fig. 4-6. The capstan motor rotates a gear-belt driven arrangement to turn the relay pulley and pendulum gear, rotating the take-up and supply reel assembly.

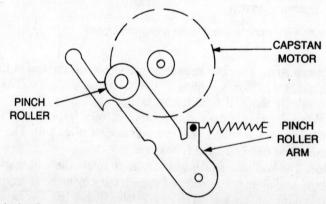

Fig. 4-7. The pinch roller places pressure on the tape and capstan shaft to rotate the tape through the head path.

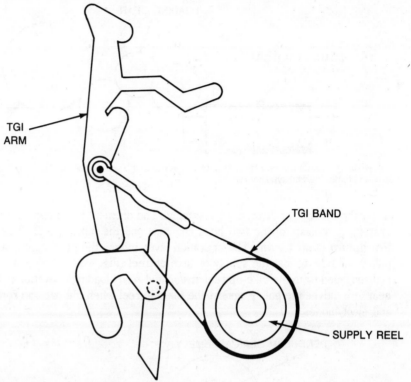

TGI
ARM

TGI BAND

SUPPLY REEL

Fig. 4-8. The TGI arm and band assembly provides braking action of the supply reel assembly. The TGI arm releases the band during tape movement.

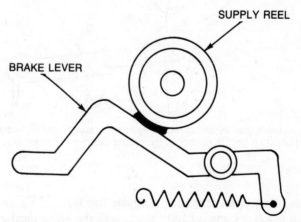

SUPPLY REEL

BRAKE LEVER

Fig. 4-9. Soft braking action is provided in some units with a small brake lever assembly.

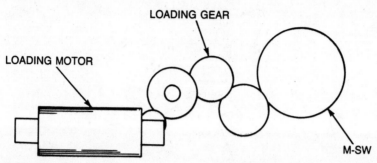

Fig. 4-10. The loading motor rotates a lot of gear assemblies to load and unload the cassette. This is a reversible loading type motor.

under the cylinder or drum head assembly. The drum motor is controlled by the servo system, it consists of the two head channels and the full erase (FE) head.

Pendulum Gear Lever. The operation lever moves the pendulum gear lever so the pulley will ride against the supply or take-up reel (Fig. 4-11). The pendulum gear arm is disengaged from the take-up reel in *stop* and *ready* loading operations. The pendulum gear arm moves the pulley against the take-up reel when the capstan rotates in record and eject modes.

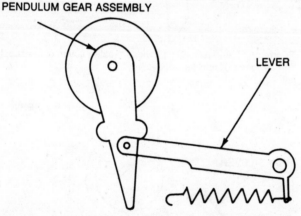

Fig. 4-11. The pendulum gear assembly rotates against the supply and take-up reel for different tape functions. The pendulum gear is controlled by the pendulum lever assembly.

Rotary Heads

The 8 mm rotary drum or cylinder contains two video heads and one erase head. The two video heads are spaced 180° apart, with the erase head in the middle (Fig. 4-12). The rotary erase head rotates counter-clockwise. Two tracks of the tape are erased at the same time. Erasing is performed along the track by the rotary erase head and

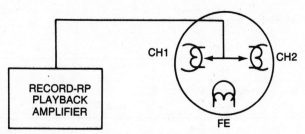

Fig. 4-12. The signal from the video record and playback amplifier is applied to CH1 and CH2 of the rotating cylinder head.

not by a stationary erase head, like those found in the VHS-C and VHS models. The flying erase head operates from the system control, flying erase (FE) amp, and erase head found in the drum or cylinder (Fig. 4-13).

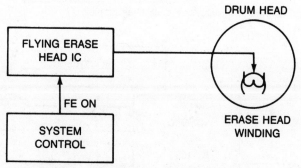

Fig. 4-13. A block diagram of the flying erase (FE) head circuits.

Playback/Record Head Amplifier

The record and playback amplifier supplies signal to the two channels in the rotary tape heads. Recording RF and playback RF are fed from the video amplifier circuits to the head amplifier module circuits (Fig. 4-14). The head amplifier IC consists of the CH-1 REC AMP, CH-2 REC AMP, CH-1 head amplifier, CH-2 head amplifier, RF second amplifier, and buffer amplifier circuits.

Video Amplifier

The video amplifier furnishes the playback RF, and recording RF signal to the head amplifier IC or module. The chroma and luminance signal (C and Y) is fed into the video amplifier (Fig. 4-15). The audio amplifier supplies the audio signal to the video amplifier in both playback and record modes, in camcorders with playback features.

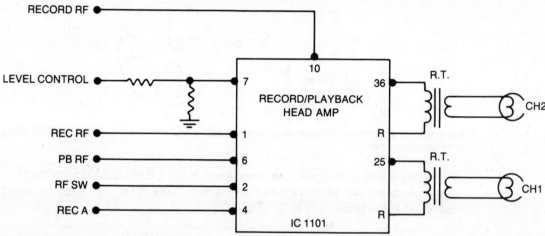

Fig. 4-14. A typical block diagram of a record/playback head amplifier.

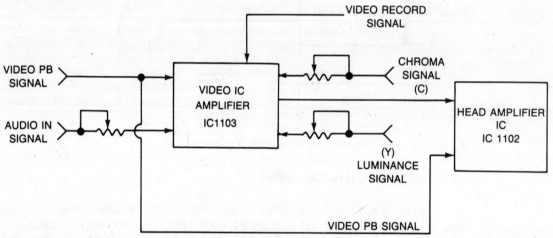

Fig. 4-I5. The video luminance, chroma, record and playback, and audio-in signals are fed into the video IC amplifier circuits.

Audio Circuits

The audio circuits consist of the microphone jack, external microphone jack, pre-amplifier IC, camera-line switching, mute control, AFM, FM de-modulation and low-pass filter circuits. The audio circuits are located in the same head amplifier IC1101 (Fig. 4-16). The pre-amplifier IC amplifies the signal from the built-in microphone, and feeds audio signals to the audio module IC. The low-pass filter (LPF) circuit cuts off unwanted frequencies above 20 kHz. The audio output signal from the audio amplifier ties into the video amplifier IC.

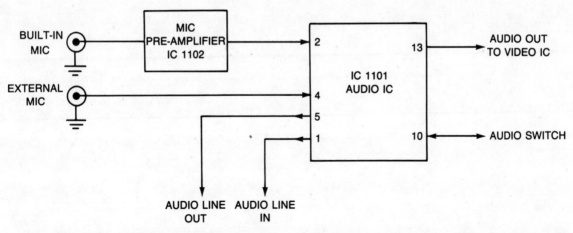

Fig. 4-16. In some 8 mm camcorders the audio IC amplifier includes the microphone pre-amp, audio line in and out, audio switch, and audio out to the video amplifier circuits.

5

Clean-up, Lubrication, and Battery Care

Cleaning of the tape heads, transport mechanism, proper lubrication, and battery care should provide the correct maintenance to keep the camcorder in tip-top shape. The upper cylinder of the camcorder tape head is smaller than the VCR tape head. The VHS VCR cylinder has two tape head channels, the camcorder cylinder is smaller with four different heads located 90 degrees apart (Fig. 5-1). Proper battery charging and maintenance will keep that camcorder ready at all times.

8 mm CLEAN-UP

The 8 mm rotary drum assembly can be cleaned like any VHS or VHS-C camcorder. Press a chamois cloth, soaked in cleaning fluid, lightly against the rotary drum assembly. Slowly rotate the upper drum assembly counter-clockwise by hand. Do not use the power supply or battery to rotate the drum head. Do not rotate the drum assembly in the clockwise direction. Do not move the chamois cloth up and down vertically or you will damage the tape heads. Do not use excessive pressure on the head assembly.

Clean all parts that are in contact with the tape or in the tape path. Press the eject button to open the cassette compartment assembly (Fig. 5-2). Clean up all pinch rollers and the capstan shaft, then clean the drive system. Clean the belts, surface of reel tables, and excess oxide at the bottom of the reel assemblies (Fig. 5-3). Use a chamois cloth

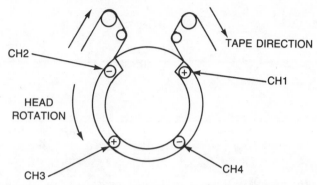

Fig. 5-1. The upper cylinder or drum of a camcorder is smaller in size than a VCR's, so four heads are used instead of two, like the VCR.

Fig. 5-2. Cleaning the tape heads and guide assemblies is done through the cassette door, instead of removing the top cover.

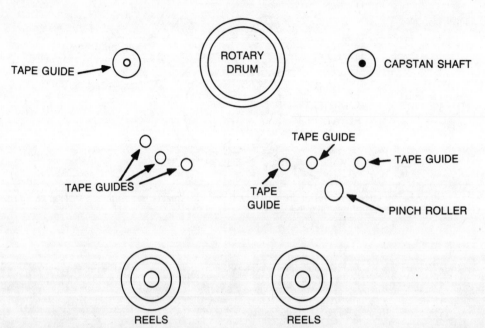

Fig. 5-3. Clean the heads, the guide roller, and reel assemblies, of the 8 mm camcorder. Check the pinch roller for excessive oxide dust.

soaked in cleaning fluid for tape path components. In all camcorders the dust settles towards the bottom and lands on tape heads and many critical moving parts.

VHS VIDEO HEAD CLEANING

The camcorder heads can be cleaned like any VCR machine. Picture playback from the recording becomes blurred, or poor image problems develop. The dirty tape head results in a noisy, blurred, and grainy picture. The sound is noisy and distorted, with excess oxide on the audio-control (A/C) head. After excessive use, the tape heads should be cleaned for the best picture obtainable. Always use high quality tape to prevent tape oxide build-up.

Some manufacturers suggest using a video head cleaning cassette every 100 hours or so, before attempting to get inside and clean the heads. Other experts say the cleaning cartridge in time will damage the heads. Some say the cleaning cassette leaves behind contaminants that damage the heads. The best cleaning cassette or cartridge is one using a wet system.

The unique, non-abrasive wet cassette system cleans the entire tape path. It cleans up the erase head, tape guides, video head, audio head, capstan, and pinch roller. The wet system removes harmful oxides and residues from the entire tape path. With the non-abrasive wet cleaning system, separate cleaning of the video heads and drive

components is accomplished with no danger of cross-contamination. Liquid from a bottle is applied to the non-abrasive tape inside the cleaning cartridge.

The video head can be cleaned with a can of cleaning fluid. A small plastic tube lets you spray the head area from the cassette holder area. When using this method, be careful not to spray the fluid all over the inside of the VTR area. Cleaning with the video head cleaning spray can is only a temporary affair.

The best method is to use a sponge swab or chamois with cleaning fluid. Do not use ordinary audio cleaning sticks. A lint free cloth dampened in isopropyl alcohol is good. Some technicians suggest using gauze material with freon.

Coat the cleaning stick with cleaning fluid, and touch the stick to the head cylinder. Rotate the cylinder to the right and left while holding the cleaning stick vertically (Fig. 5-4). The chamois part of the stick touches the video head, do not move the stick vertically. The head will be damaged. The tape head is rotated horizontally while holding the coated stick stationary. Make sure the head is dry before attempting to play a cassette. If cleaning fluid remains on the video head, the tape will get wet and be damaged when it comes in contact with the cylinder head surface.

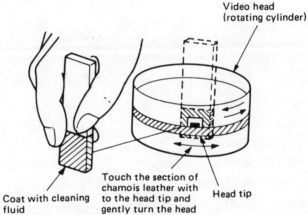

Fig. 5-4. Move the cleaning stick horizonally and not vertically, to prevent damage to the head tip assembly. Keep your fingers off the tape head surface.

In most VHS camcorders you can clean the various heads, guides, and rollers from the opening of the cassette area. The top cover must be removed when cleaning up the regular VHS VCR machine. Keep your fingers off the tape head surface. Oil and dirt from your fingers will contaminate the tape head. Clean up all tape heads, guide pins, capstan, and rollers in the same manner. Visually inspect the tape drive areas for brown-oxide dust and dirt. In addition to a poor picture and sound, improper clean-up of pressure rollers, and the capstan results in tape eating or pulling out tape from the cassette.

Most manufacturers have their own tape head cleaning kit and solvent. If possible, purchase the kit suggested by the manufacturer.

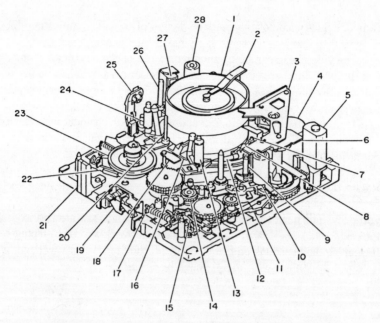

TAPE TRANSPORT MECHANISM – TOP VIEW

1. Upper Cylinder
2. Static Discharge Brush
3. Middle Pole Stopper
4. Capstan Motor
5. Loading Motor
6. Mechanism State Switch
7. Take-up Guide Pole (1)
8. Audio/Control (A/C) Head
9. Take-up Guide Pole (2)
10. Pressure Roller
11. Pressure Roller Arm
12. Middle Pole
13. Take-up Guide Roller
14. Reel Drive Idler
15. Brake Relay Arm
16. End LED
17. Supply Main Brake
18. Dew Sensor
19. Cassette Holder Switch
20. Tension Pole
21. Safety Tab Switch
22. Tension Band
23. Supply Reel Disk
24. Supply Guide Roller
25. End Sensor
26. Supply Guide Pole
27. Full Erase (FE) Head
28. Impedance Roller

Fig. 5-5. Periodic cleaning should be done to the various parts of the camcorder. Locate the different components, using the top and bottom views of the tape transport mechanism.

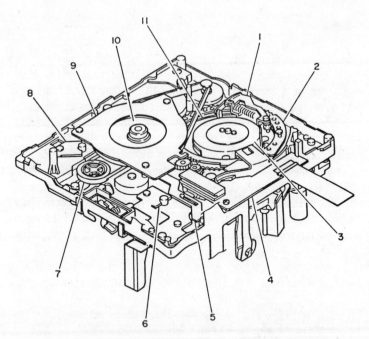

TAPE TRANSPORT MECHANISM – BOTTOM VIEW

1. Middle Pole Lever
2. Supply Loading Ring
3. Lower Cylinder
4. Cyl. Motor Drive Circuit
 Board
5. Tension Control Plate
6. Supply Reel Sensor
7. Center Pulley
8. Take-up Reel Sensor
9. Flywheel FG Circuit Board
10. Capstan Flywheel
11. Take-up Loading Ring

PERIODIC CLEAN-UP

To ensure continuous performance from the VCR mechanism, periodic clean-up is needed (Fig. 5-5). Use a cleaning stick that doesn't have fiber hairs. Many of the manufacturers supply clean-up kits for the camcorder. A cleaning solvent or alcohol works best. Be careful not to spill the cleaning fluid on the plastic gears or panels. Clean up and lubricate the following parts periodically, as shown in Table 5-1.

Pressure Roller. The pressure roller holds the tape securely, like any pressure roller in an audio cassette player. Tape oxide builds up on the surface of the pressure roller, and can cause speed problems. Sometimes, if excessive tape pulls out, it winds around the pressure roller, and gets down close to the pressure roller support arm.

Capstan Shaft. The pressure roller presses the tape against the capstan shaft for tape rotation. The capstan shaft should be shiny and clean, if not, clean off the capstan shaft with cleaning fluid and lint free wipes. Clean off excess oxide dust at the bottom of the bearing shaft.

Idler Wheels. There are several idler wheels in the VCR or camcorder. Clean off the moving surface with cleaning fluid. A shiny surface may indicate the idler wheel is slipping.

Table 5-1. Here is a chart showing the various parts that should be cleaned and lubricated periodically.

Part or Component	1000 Hrs	2000 Hrs	3000 Hrs	4000 Hrs	5000 Hrs
All Heads	C	C	C	C	C
All Pulleys	C	C	C	C	C
All Guide Posts	C	C	C	C	C
Supply Reels	C	C	C	C	C
All Gears	C-O	C-O	C-O	C-O	C-O
All Belts	C	C	C	C	C
Loading Rings Loading gears		G		G	
All shaft Areas	O	O	O	O	O
Roller Assemblies	O	O	O	O	O
	C-Clean		O-Oil		G-Grease

Tape Guide Posts. The tape guide posts guide the tape around the tape path with ease. Often, the guide posts are plastic spindles with a metal pin bearing support. Where the tape runs against another surface, oxide dust rubs off, and collects on the guide spindles. Clean the take-up and supply roller guide posts.

Supply Reel. Clean up the round surface of the supply reel where it comes in contact with the tape (Fig. 5-6). Check for oxide dust around the supply reel area on the mechanism chassis.

Pulley Belt. The pulley belt is found between the capstan flywheel and the capstan motor. Excess oxide dust or oil on the belt produces slow and erratic speed problems. Check the motor pulley for a shiny surface, indicating slippage. Clean off the flywheel drive surface and motor pulley area with cleaning fluid. A loose motor drive belt will cause improper speed problems.

Center Pulley. Clean off the center pulley surface with a lint free wipe dipped in cleaning fluid. This pulley is located under the main mechanism chassis.

Impedance Roller. Often, the impedance roller is the largest roller assembly, and is mounted next to the full erase head (Fig. 5-7). Clean off the roller surface with cleaning fluid. Be careful not to dislodge any parts while cleaning the different components.

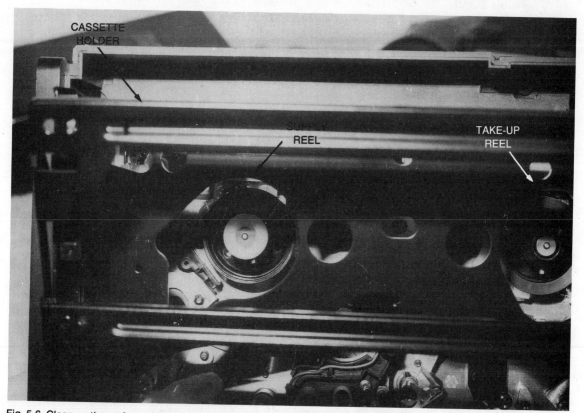

Fig. 5-6. Clean up the surface of the supply reel and down around the flange area for excessive oxide dust.

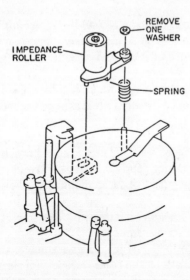

Fig. 5-7. Clean off the tape surface area of the impedance roller located near the cylinder or drum assemblies.

Tension Band. The tension arm applies pressure to the tape movement and is connected to the tension band assembly. The tension band wraps around the bottom area of the supply reel turntable. Clean off the band area where dirt and dust collect. **Supply and Take-Up Gears.** Check the gear teeth area for gummed-up grease and dirt (Fig. 5-8). These two gears should be removed and cleaned with cleaning fluid. A small "E", "C", or washer at the top holds the gears to the metal bearing spindle shafts.

Clean-Up Conclusion

Every 60 to 100 hours clean up the tape heads and tape path components with a wet-type cleaning cassette. Leave the camcorder set to dry. Every 1,000 hours manually clean up the tape heads, and all parts in the tape path. Select the manufacturer's cleaning kit, or a chamois cloth soaked in isopropyl alcohol. Use the best alcohol available. Clean all rubber drive areas with chamois and cleaning fluid, such as freon. If you feel the 1,000 hour clean-up is too much work, take it to the manufacturer's service depot or to a local camcorder technician.

LUBRICATION

Most tape VCR mechanisms are properly lubricated when they leave the factory. Lubrication should not be needed for at least the first year, under normal operating conditions. Periodically lubrication is needed thereafter. If you hear a whining or squeaking noise, try to locate where the noise is coming from. The squealing is a sure sign of a bearing in need of oil or lubrication. Use whatever brand the manufacturer recommends.

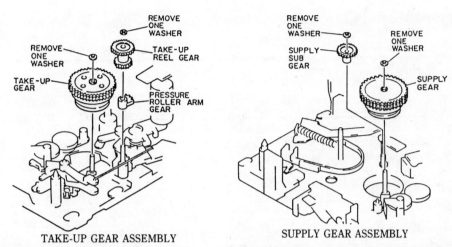

TAKE-UP GEAR ASSEMBLY SUPPLY GEAR ASSEMBLY

Fig. 5-8. Clean out possible gummed up grease and dirt from the take-up and supply gear assemblies. Remove them for a proper clean-up.

Try to remove the old grease first, if possible. Be careful when applying oil or grease to components. Do not use a spray can. Excessive oil can fly on friction driving parts and cause slow speed problems. Too much oil or grease, in time, will drop down on other moving components. Keep oil off of belts and moving pulleys. It's always best to under-oil than over-oil. Wipe off the excess oil or grease with a lint free stick dipped in isopropyl alcohol.

Each manufacturer recommends a certain type of oil or grease for their camcorder. If in doubt, always use a light oil and grease on parts where it is used. If the camcorder is used extensively the first year, you can save a few repair bills by taking it to the manufacturer's repair depot, and have it cleaned and oiled once a year.

OIL AFTER 1,000 HOURS

Check the following camcorder parts for lubrication after 1,000 hours of operation (Fig. 5-9).

Supply and Take-Up Reel Shafts. The supply or take-up reel may produce a squealing noise after heavy use, and need lubrication. Sometimes this noise is confused with a noisy cassette. Try another cassette to make sure the noise is coming from one of the reel tables. Clean and lubricate both reels.

The supply or take-up reel table should be removed for proper cleaning and lubrication. You many have to remove the cassette holder to get at the reel assemblies. Check for a small washer at the top of the reel assembly. Be careful not to lose any of these small parts. Sometimes, there are stack washers underneath the reel assembly. Take care to replace them. Clean off the shaft, reel, and bearing with cleaning fluid. Place a light coat of oil on the spindle shaft, and replace all parts in reverse order. Spin the reel, and make sure no excess oil is found around the spindle area.

Fig. 5-9. A close-up view of the various components that may require lubrication after 1,000 hours of use.

Supply Gear Shaft. Locate the supply gear assembly, it drives the supply reel assembly. This gear is easy to check for lubrication with the supply reel off. Remove the supply gear and the small washer at the top. Clean up and apply light oil to the shaft area. If the gears are making noise apply a dab of light grease to the sub and supply gears.

Cam Gear Shaft. A lot of parts must be removed to get at the cam gear assembly. This cam gear lubrication should be left to the camcorder technician.

Idler Shaft. The reel drive idler wheel is located close to the reel turntables. A drop of oil on the shaft area is all that is needed to satisfy a dry idler bearing. Wipe up all oil with solvent or alcohol on a cleaning stick.

Take-Up Reel Gear Shaft. Most reels and small gears are held into position with a small washer or "C" type washer. The take-up reel, and reel gear are located quite close together. Be careful not to displace the small shaft washers. Clean off the shaft and lightly oil it. Replace all removed components in reverse order.

Tension Arm Lubrication. The tension arm shaft is lubricated with the supply reel removed. The tension arm is connected to the tension band assembly. A drop of oil on the tension arm shaft is all that is needed.

A/C Head Base Shaft Lubrication. Place a drop of light oil on the audio control head shaft after removal. Inspect the shaft for dry areas.

GREASE AFTER 2,000 HOURS

Check the location of the various parts that need lubrication before attempting to apply grease or oil. Parts that the manufacturer doesn't list should not be greased or

oiled, unless noise is detected. Apply only a light film of grease on the following components.

Gutter of Both Cam Gears. Locate the cam gears on the VCR assembly. Usually, a pivot arm moves inside the gutter and grooved area. Sometimes, this grease and dirt hardens, and slows down the pivot action. Remove the old grease and apply a light coat of grease to the gutter area.

Loading Gear. The loading gear rotates the loading ring assembly. Apply light grease to the loading gear and shaft areas, especially the bottom side area of the gear assembly after cleaning off the old grease and oil.

Loading Ring Shaft. The supply loading and take-up loading rings are located near the bottom of the chassis. Apply grease to the loading ring shafts. These loading rings are difficult to get at and should be greased by the camcorder technician.

Guide Rollers and Gutters. The guide rollers are held into position with a hex screw at the base area (Fig. 5-10). Remove the cassette holder to get at the guide rollers. Clean off old grease and dirt. Apply a coat of light grease at the bottom of the guide roller assembly.

Ring Idler Gear Shaft. The ring idler gear rotates against the loading ring assemblies. Clean up the gear shaft and lubricate it with light grease.

Between Pressure Roller and Shaft. When some parts are removed for lubrication, adjustment procedures must be made after they are replaced. Remove the ''C'' or ''E'' ring to pull out the pressure roller. Apply light grease after clean-up. Middle pole position adjustment should be made after installation.

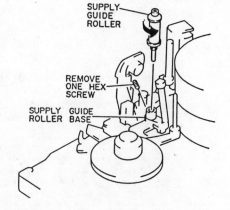

Fig. 5-10. Clean off the old grease and oxide on the supply guide roller. Apply a light grease at the bottom of the guide roller assembly.

LUBRICATION CONCLUSION

Try to use the same oil and grease recommended by the camcorder manufacturer. After one year of heavy usage, cleaning and lubrication should be done yearly. Keep screwdrivers and other tools away from the tape transport to prevent damaging parts. Take the camcorder to the camcorder service depot or local camcorder technician if you cannot do the job.

If possible, keep the camcorder out of dusty areas. When traveling long distance over dirt or gravel roads, keep the camcorder sealed in a plastic bag. Preventive maintenance keeps electronic equipment functional over many years. Do not over oil or grease. One or two drops will do.

BATTERY MAINTENANCE

The camcorder can be powered by three different sources. The ac adapter-charger is used when ac power is conveniently available, some of these units will operate in foreign countries. By using a rechargeable battery or a separate battery pack (Fig. 5-11), the camcorder can be operated from the cigarette lighter socket of the automobile with a special adapter cord.

Most camcorders today use nickel-cadmium batteries. Like any battery, they will lose their charge after a few hours use, and must be charged at once. Although the nickel-cadmium battery loses its charge much faster than the lead acid types, it can be recharged within one or two hours. It's best to keep the battery charged up before it goes completely dead. Charge up the battery if it is not used for several months.

The external battery pack will last much longer than the small battery which clips on the back of the camcorder. Of course, these batteries may take longer to charge up. The battery pack plugs into a separate external battery jack on the camcorder.

Battery Temperature. Extreme temperatures affect the small batteries. Cold will cut down on the battery operation time, and will not last as long when you are out taking snow scenes or shooting while skiing. Take along a couple extra batteries and store them in an inside pocket close to your body to keep the batteries warm. The cold battery may appear dead and takes longer to charge up.

Extremely hot temperatures are not good for the self contained batteries or camcorders. Keep them out of the sun or enclosed areas during the summer. Place the camcorder, case and all in a large foam cooler during summer vacation trips. Batteries

Fig. 5-11. An RCA CPR300 battery and ac adaptor.

should be charged at a temperature from 50° to 95° F, stored at 14° to 85° F, and operated at 14° to 104° F.

Battery Level Indicators. The condition of the battery may be viewed by watching the battery level indicator, inside the electronic viewfinder. In the RCA CPR300, whenever the tape-counter or time-remaining display is presented in the viewfinder, it will appear with a 3-dash readout. When the battery is fully charged, the display reads E- - - F. After several minutes, only two dashes appear. When the battery is nearly finished, only one dash remains. When the last dash starts blinking, the battery should be recharged.

In other camcorders a weak battery is indicated with a flashing LED. In the Minolta C 3300 model, when the battery pack gets too low, a battery symbol blinks on the LCD panel, and the battery blinks in the viewfinder. If the battery gets weaker, the camcorder switches off automatically.

Different Battery Packs. Each manufacturer may have a different battery pack and it may not be interchangeable with another manufacturer. Batteries that are made for different manufacturers by one firm may interchange with another manufacturer. Some manufacturers have up to three different battery packs for one camera. Each battery has a different recording or playback time, 30, 45, 60 and 120 minutes. The recording time is determined by use of the zoom motor, and the duration of standby operation. Always have one or two extra charged-up battery packs on hand. You may be able to obtain batteries from other sources than the camcorder manufacturer.

Attaching the Battery. Most batteries clip on the backside of the camcorder. Position the battery so the rails match up with the grooves of the camcorder. Slide the battery in, until it clicks in place. In other cameras line up the tabs on the battery with the notches on the backside of the camcorder. Slide the battery in the direction of the arrow (downward). Press the camcorder power button and notice if the indicator light is on. The external battery pack is plugged into the internal jack of the camcorder with a cable. Remove the battery by holding down the eject lever and sliding the battery up.

Charging the Battery. Recharging the standard camcorder battery takes from 2 to 4 hours, depending on the size of the battery. Small batteries with less recording or playing time take from 60 to 90 minutes. After many hours of use, and repeated charges, the battery becomes weak, and will not last very long. The battery should be discarded if only a few minutes of operation time is provided. The small slip-on batteries have a very short life.

The battery pack supplied with the new camcorder must be charged before using the camera (Fig. 5-12). While the camcorder battery is being charged, read over the new operation manual several times. The camera will not take good pictures unless you know how to operate every button. When fully charged, the battery should last according to the manufacturer's specifications.

The battery should not be undercharged or overcharged. A charge indicator light is on during charging time. Some ac adapter/charger units have an on indicator light, and a separate charge LED. The battery should be removed from the charger when the charge light goes out. If the battery is charged from another source, time the charging process with a clock or wristwatch according to the manufacturer's charging time limit.

Attaching Battery to Adapter. Line up the battery like you are replacing it in the camcorder. Align the reference notches of the battery to those on the ac adapter. Push

Fig. 5-12. The finger points at a red LED, which indicates the battery is charging. The charging LED will go out after the battery is charged.

the battery flush with the adapter or until it is fully on. Plug the ac adapter/charger into the nearest 120V ac outlet. Place the camera/charge switch in charge position. The charge indicator light will come on, and later goes out when the battery is fully charged.

Power Stops During Camcorder Operation. In some camcorders the unit will shut off automatically when the battery is too weak. Sometimes, the battery has enough power left to eject the cassette. If not, let the camcorder set a few minutes turned off, then try it again. When the battery reaches the flashing stage, it is time to stop and change batteries.

If the camcorder does not eject the cassette when you press the eject button, do not attempt to force open the cassette door. You may damage the door. Simply power the camcorder with another battery or the ac adapter charger to eject the cassette.

DO's AND DON'Ts

- Do not short circuit the battery terminals with a screwdriver or let metal objects lay across the terminals.
- Do be careful not to bend or catch the battery terminals, throwing them out of line.
- Do not burn the worn out batteries, throw them in the garbage to be hauled away.
- Do not drop the batteries.
- Do not recharge until the battery is discharged.
- Do not be alarmed if the battery and charger are warm during the charging process.

- Do not try to modify or disassemble the old battery.
- Do not be alarmed if the ac charger-adapter provides interference in the radio during the charging process.
- Do keep the batteries out of direct sunlight.
- Do keep the camcorder and batteries out of extremely hot or humid places.
- Do not leave the battery in the ac charger after being fully charged. Remove and disconnect the plug.
- Do not turn the ac-adapter/charger upside down while attached to the camcorder. The battery may fall off if attached to the camcorder, and damage the battery or operator.
- Do be careful when charging the battery or operating the camcorder from the car battery. Make sure the car battery is negatively grounded. The center conductor of the cigarette lighter should be positive.

6

The Videocassette

The tape within the videocassette you purchase is a much tougher, better grade, and of a higher quality construction than those of a few years back. The videocassette price varies from $5.00 to $20.00 for either 8 mm, VHS, VHS-C or Beta types. Of course, you can pick up the bargain cassette for under $5.00 at discount stores, but you get what you pay for. If it's not a known brand tape, forget the so-called bargain.

CHOOSE GOOD VIDEOCASSETTES

Choose a known brand cassette that gives you the best pictures and stick with it. Cheap cassettes cause dropouts, white flecks, or flashing noise on the screen. Most dropouts occur at the beginning or at the end of the tape. Uneven thickness of the tape threads poorly, binds or rides up and down on the spindles, causing jittery pictures. The poor grade of tape clogs up the tape heads and spindles, resulting in poor pictures or repeated head cleanup. Some cassettes lose part of their signal after several repeated plays. Try several well known brands, and pay the price for good tape.

8 mm-TYPE TAPE

Like audio tape, the 8 mm videocassette can contain metal particles. The 8 mm cassettes can be coated with either iron-oxide or chromium-dioxide particles. The metal

cassettes retain their magnetic properties, stand up longer, and have better storing results than the regular oxide coated tape. The metal tape has a higher magnetic density than ordinary videocassettes. These metal tapes cost more, within the $6.00 to $22.00 range, depending upon the length of playing time.

CASSETTE CARE

The videocassette will last for many years if it is handled with care, and is stored properly. Try to keep the cassette dry at all times. If the camcorder is brought directly from a cold or warm location, moisture condenses on the drum assembly inside the camera. The tape may cling to the head drum and damage the tape. It's best not to leave a videocassette inside the camcorder for any length of time (Fig. 6-1).

If moisture is present, the tape Run/Batt light (usually red) and standby lamp (usually orange) blink alternately, and the yellow dew lamp lights up in the camcorder. Simply remove the cassette, and let the camcorder holder open so air can circulate for at least one hour. Most camcorders will not operate with moisture inside the unit or videocassette. In other machines when there is condensation, all buttons (except the eject) will not function and the recording stops.

Do not use or lay the videocassette near strong magnetic fields, such as radio or television transmission antennas, near large motors or magnets, or whenever a strong magnetic field is present. Be careful not to lay the camcorder or cassettes on top of a large speaker column. These magnetic fields can cause striped "noise" patterns to appear, and distort the recordings. Sometimes a portion, or even the entire recording may be erased in strong magnetic fields.

Keep the cassettes out of strong sunlight, or where temperatures exceed 60° C (140° F). Avoid leaving the videocassettes in an automobile with the windows closed, or in the trunk area. Keep the cassettes away from radiators or heat sources. Be careful

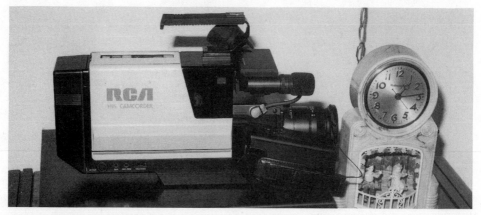

Fig. 6-1. Always remove the videocassette from the camcorder after use. Place it back into the original container and stack it vertically.

not to drop the cassette or expose it to violent vibrations or shocks. The cassette case may be cracked or damaged internally, jamming the tape mechanism.

CASSETTE STORAGE

Treat videocassette tapes with extreme care. Keep the videocassettes away from extremely dusty areas. These dust particles can scratch the tape area, resulting in drop-out or scratched pictures. Never leave the cassette inside the camcorder or out in the open. Place those valuable video pictures back into the protective boxes or plastic cases the videocassette arrived in (Fig. 6-2).

Do not touch any portion of the tape in the cassettes, it's possible dust and oil marks from your fingers will damage the video pictures. Keep the tape rewound at all times to prevent tape stretch and damage.

Store videocassettes vertically inside their cases, in a cool, dry place. Store the tapes at moderate temperatures somewhere between 50 and 80°. If you live where the temperatures are quite hot or extremely cold, store the tapes in a special insulated cabinet.

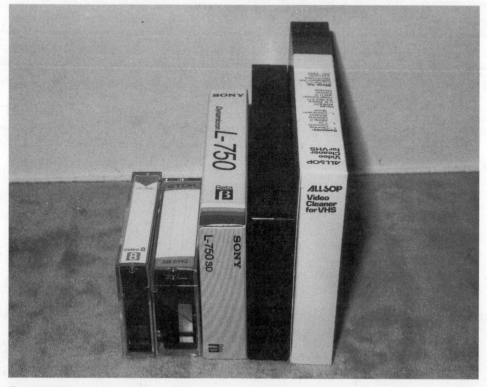

Fig. 6-2. Do not let the cassette lay around to prevent tape damage.

Here are ten do's and don'ts in tape storage and care:

- Do avoid storing cassettes in humid or dusty places.
- Do not store the cassettes near strong magnetic fields or near large stereo speakers.
- When smoking, do not drop cigarette ashes down inside the cassette or videocassette adapter.
- Do place the cassettes in regular cassette cases or boxes, and position them vertically.
- Do not store videocassettes on top of the television cabinet.
- Do not let cassettes set in a window or under direct sunlight, and keep them away from heat ducts.
- Do not drop the cassettes. Do not expose them to violent vibrations or shocks.
- Do not insert anything in the small holes at the rear of the cassette. These holes are usually to sense the kind of tape, thickness of tape, or if tab is out.
- Do not load and unload the cassette repeatedly without allowing the tape to run at all. This can slacken the tape and cause damage.
- Above all, do not let the videocassettes pile up on the floor, in chairs, under papers, or magazines. They can be walked or sat on. Replace them in their respective boxes and store them vertically after playing them.

THE DIFFERENT CASSETTES

There are four basic different videocassettes on the market, VHS, VHS-C, Beta and 8 mm. Each cassette operates in its own tape format. If you have, or plan on purchasing a VHS camcorder, choose the VHS videocassette. The Beta cassette fits in the Beta machine only. The VHS-C videocassette is smaller than the VHS, and loads in a VHS videocassette adapter, while the small 8 mm cassette fits only the 8 mm camcorder (Fig. 6-3). None of the above cassettes will directly interchange with each other.

VHS Cassette. The VHS cassette is the most used and most purchased cassette on the market. You can pick up these videocassettes in any store that sells television, music, or electronic products. The VHS cassette plays and records longer than any of the other cassettes. The VHS T-120 cassette is the most popular and purchased videocassette.

VHS cassettes are found in four different lengths in time of operation, T-30 (½ to 1-1½ hours), T-60 (1 to 3 hours), T-120 (2 to 6 hours), and the long one T-160 (2½ to 8 hours), 180 minutes. When you slow down the speed of the tape, picture quality suffers.

The VHS cassette is enclosed in a hard plastic container to provide smooth operation of the take-up and supply reels, keep tape in line, and protect the tape from dirt and dust. The front cover, which inserts into the camcorder is raised, so the tape can be placed around the tape head and spindles. Most VHS cassettes have an arrow pointing to which side is to be inserted into the recorder. Before the door can be raised, a plastic catch must be pushed to release the front door cover.

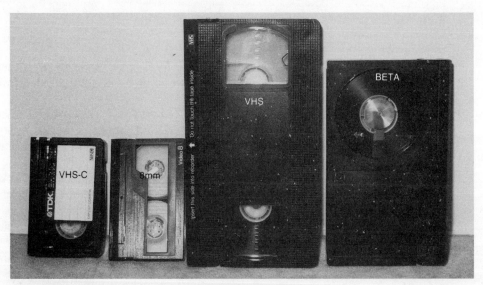

Fig. 6-3. The VHS-C cassette is about ¹/₃ smaller than the VHS-type. The 8 mm Beta videocassette is the smallest. It plays from 20 minutes to one hour of recording.

Fig. 6-4. The view of the components located inside the VHS videocassette. Notice the metal and plastic tape guide assemblies.

Looking inside the VHS cassette, two large take-up supply reels are shown which handle the tape supply. Two large metal spindles are at the front of the cassette to apply tape to the camcorder (Fig. 6-4). Each spindle has a flat spring underneath, to apply pressure to the spindle area. The tape is held in line at the rear of the spindles with spring-hinged plastic pieces. The tape feeds from one spindle to the other through several plastic guide assemblies. Do not touch or finger the tape or you will damage the recording.

Beta Videocassette. The Beta cassette will fit in only the Beta Camcorder and videocassette player. The Beta cassette is physically smaller than the VHS, and provides less playing time. The L-125 (15 to 45 minutes), L-250 (1 to 1½ hours), L-500 (2 to 3 hours, L-750 (3 to 4 hours) and L-830 (up to 5 hours) provide plenty of playback/recording time. The L-750 is the most popular cassette for the Beta machine. The L-830 videocassette is found only in the Super HG cassette.

VHS-C Compact Cassette. The VHS-C compact cassette is about ⅓ smaller than the VHS. The TC-20 videocassette records from 20 minutes to one hour in the VHS-C camcorder. The standard play (SP) has a tape speed of 1⁵⁄₁₆ ips, and in extended play (EP) ⁷⁄₁₆ ips. The SP mode operates when the camcorder is connected directly to the television set or monitor, while the LP and EP modes are found with the VHS-C cassette placed in the adapter unit. The adapter unit is the same size as the VHS cassette that can be inserted into the VHS videocassette recorder for playback operation.

The compact videocassette appears quite like the VHS cassette except the take-up function is driven by a gear (Fig. 6-5). The take-up reel gear assembly is rotated by a small idler gear in the VHS-C cassette adapter (Fig. 6-6). Several tape guides are provided to keep the tape in line during operation. When inserted, the supply reel disc of the VHF deck drives the supply reel of the VHS-C cassette.

8 mm Cassettes. The 8 mm videocassette is the smallest cassette, and is coated with pure metal particles (Fig. 6-7). The 8 mm cassette travels at a much lower speed than

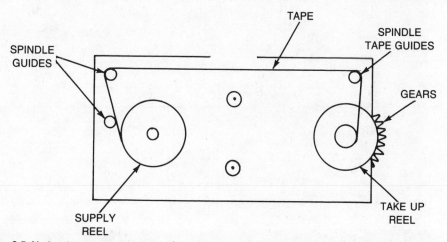

Fig. 6-5. Notice the take-up reel gear tooth assembly driven by the idler gear inside the VHS-C adapter unit.

other cassettes. These 8 mm cassettes cost more for the manufacturer to build, to manufacture a higher quality of tape, and the cost is passed on to the consumer.

There are five different sizes of 8 mm tape format, P6-15 (SP) 15 and LP mode 30 minutes, P6-30 (SP) 30 minutes and one hour in LP mode, P6-60 (SP) one and (EP) 2 hours, P6-90 (SP) 1 hour-30 minutes and 3 hours in LP, P-6-120 (SP) 2 and 4 hours in LP mode. The 2 hour 8 mm cassette is marked MP-120 (metal particles) or P6-120 MP. The tape width is 8 mm and thickness approximately 13 μm.

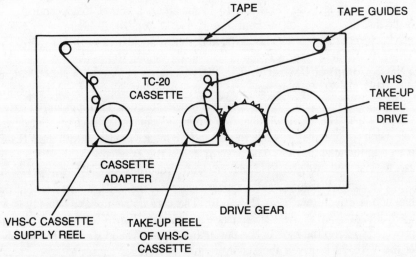

Fig. 6-6. Here a VHS-C compact videocassette is loaded inside the cassette adapter. The take-up reel drives the take-up reel inside the geared TC-20 videocassette.

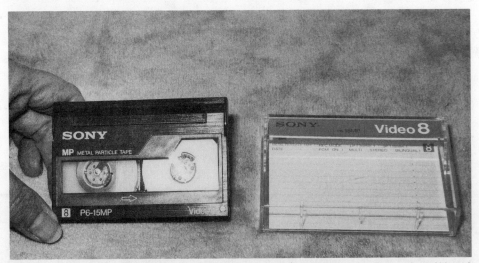

Fig. 6-7. The 8 mm compact videocassette is the smallest of all the present day camcorders. Although a 4 mm format has been mentioned, none are at present on the market.

The 8 mm videocassette is constructed somewhat like other videocassettes, with a take-up and supply reel in a see-through plastic top (Fig. 6-8). You can easily check the remaining tape at a glance through the clear plastic. Instead of metal or plastic spindles at the front to guide the tape, hard resistance plastic holes are found in the container. A convenient side tab is provided to prevent accidental erasures. The front cover of the cassette is lifted when it is inserted into the camcorder.

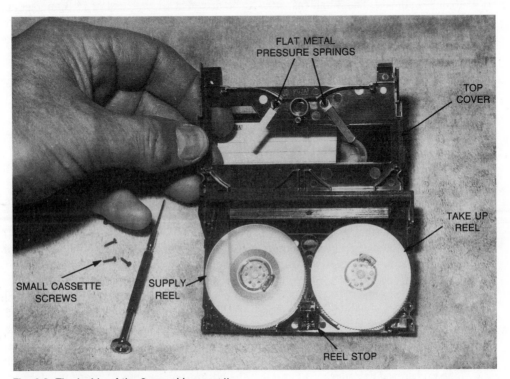

FLAT METAL PRESSURE SPRINGS

TOP COVER

TAKE UP REEL

REEL STOP

SUPPLY REEL

SMALL CASSETTE SCREWS

Fig. 6-8. The inside of the 8 mm videocassette.

GENERAL CASSETTE FUNCTIONS

The VHS videocassette for the camcorder is the same cassette used in recordings with the regular video camera or VCR player. The VHS cassette is loaded directly into the camcorder for recording and playback to a television or monitor. The same videocassette can be played back in your VCR machine.

The VHS-C compact cassette is about ⅓ smaller in size and may record or play back directly to the television receiver or monitor. This VHS-C videocassette may be inserted into an adapter that looks like a regular VHS videocassette, is locked in place and inserted into the VCR player for playback operations. The VHS-C compact camcorder is smaller in size and weighs less than 4½ pounds, compared to the heavy-weighted VHS camcorder. You will find some VHS-C camcorders only record and do not play back.

The Beta camcorder cassette is the same cassette that operates in the Beta VCR recorder, although the Beta videocassette is slightly smaller than the VHS cassette, with less recording time, most people feel the Beta format provides a clearer, more distinct picture. The Beta camcorder plays through the television receiver/monitor or on the Beta VCR machine.

The smallest videocassette camcorder of all is the 8 mm format, and weighs less than 3½ pounds. The 8 mm cassette can be driven at a low speed of 14.3 mm/sec. or 0.56 ips. The 8 mm camcorder plays back directly into the television receiver or monitor. The small 8 mm videocassette cannot be placed in the adapter or VCR player for playback operation.

VHS-C ADAPTER

Usually the VHS-C adapter comes with the VHS-C compact camcorder. You will find each manufacturer has their own VHS-C adapter unit.

JVC GR-C7U VHS-C Adapter. The VHS-C compact videocassettes recorded with the GR-C7U camcorder can play back with a standard VHS VCR by using the provided C-P3U cassette adapter. A compact VHS-C videocassette installed in the cassette adapter is fully compatible with a standard VHS machine for both recording and playback.

Before inserting the VHS-C compact cassette into the adapter, take up the slack in the cassette so the tape will not be damaged. Push the sliding latch in the direction of the arrow to open the door (Fig. 6-9). Insert the cassette with the hinged door toward the front of the adapter. Close the compartment door. The tape should be automatically loaded. The loading dial turns and stops with its indented dot aligned with the blue dot. The safety catch will retract. This indicates that the tape loading is completed.

After the VHS-C cassette is loaded, check the tape for slack. Do not open the door. If there is slack in the tape, remove it by turning the reel in the direction of take-up. You may find an arrow on the cassette adapter showing the tape rotation direction. During tape loading and unloading, do not touch the bottom reels in the adapter for safety and tape protection. Sometimes, in slow motion or special-effect playback, the picture will vibrate or noise bars appear on the screen with the VHS-C cassette inside the adapter.

Fig. 6-9. The JVC GR-C7U VHS-C compact videocassette can be played in the regular VCR with a C-P3U VHS adapter.

Adapter With Battery Failure. To remove the videocassette from a JVC C-P3U adapter, slide the latch in the direction of the arrow and the tape should unload automatically. When the indented dot on the loading dial stops, and is aligned with the red dot, the compartment door will open. Push up the cassette from the underside-hole with your finger. Be sure the cassette is unloaded completely before trying to remove it. Close the compartment door so dust and dirt will not collect in the adapter unit.

If the battery goes dead during tape loading and unloading, the loading mechanism may stop midway, resulting in a locked-in cassette. Slide the compartment latch toward the arrow. Remove the battery. Turn the loading dial with a coin clockwise or counterclockwise until it stops. Normally you never touch the loading dial with a coin, only in emergencies. The compartment door should open and release the VHS-C cassette.

ADAPTER DO'S AND DON'TS

- Do not force the videocassette into the adapter unit when it fails to load. Inspect the area for foreign objects.
- Do not attempt to load the videocassette into the adapter with the safety catch protruding upward, indicating loading of the tape is not completed. You can damage both the cassette and adapter.
- Do not load and unload the cassette adapter into a recorder repeatedly without allowing the tape to run. This will lock in the tape and cause tape damage.
- Do remember, the cassette adapter cannot be loaded upside down. Load it in the VCR like any VHS cassette.
- Do not touch the tape when inserting the compact VHS-C cassette into the cassette adapter.
- Do push in the safety catch so that the videocassette slides into the adapter case during loading.
- Do not use a sharp instrument such as a screwdriver or pencil point to remove the videocassette from the adapter.
- Do not stick any sharp object in the holes in the videocassette adapter.
- Do not leave the videocassette inside the adapter after use.
- Do remember, the cassette adapter is a precision-manufactured piece of equipment. Try to avoid violent shocks and vibrations. Do not drop, dismantle, or try to modify the adapter. The adapter may not operate the next time.

VHS-C REEL DRIVE PRINCIPLE

The VHS-C videocassette is loaded into an adapter the same size as a regular VHS cassette. The tape take-up function is driven by a small gear. The videocassette contains a supply reel, but the take-up reel is not present (Fig. 6-10).

When the cassette is inserted in the adapter, the adapter extracts the tape and positions it in the same configuration as a full-size VHS videocassette. This allows the

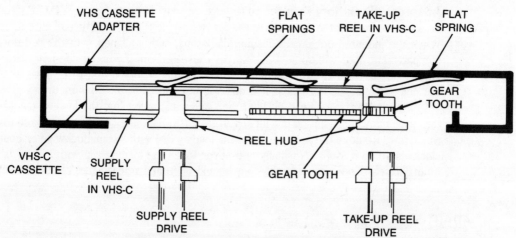

Fig. 6-10. The VHS-C cassette fits right inside the VHS cassette adapter. The supply reel hub is driven by the VCR supply drive, while the take-up reel hub rotates from gearing in the take-up reel of the VHS-C cassette.

tape to be inserted into a regular VHS format VCR. The supply reel disc of the VHS deck drives the supply reel of the VHS-C cassette when it is inserted into the adapter. However, the take-up reel disc of the VHS recorder drives the take-up operation of the VHS-C cassette with a pulley and gear inside the adapter. Notice the small tooth gear at the edge of the take-up reel in the VHS-C cassette.

The Different Speeds

The VHS and VHS-C videocassettes can be operated in the SP, LP, and EP modes, while the 8 mm cassette is only operated in the SP and LP modes. Usually, the standard play (SP) produces the best video picture, LP is the long play mode. EP or extended play permits recording of up to 60 minutes on a VHS-C cassette. Standard play (SP) permits recording for up to 20 minutes on a VHS-C cassette. The extended play (EP) of a VHS T-160 cassette permits up to 8 hours of playing or recording. Often, the SP/EP selector can be changed during the recording.

Recording Protection

Most videocassettes provide a hole or switch to protect a previous recording. Usually, the VHS and VHS-C videocassettes have a safety tab that can be broken out at the rear of the cassette when you want to save a particular recording. Use a small screwdriver for this purpose. When the tab is removed, the VCR or camcorder cannot record on the tape (Fig. 6-11). When the camcorder refuses to record, the tab is likely removed

Fig. 6-11. Check the indentation at the rear of the videocassette when the camcorder will not record. The tab must be left in, or cellophane tape placed over the opening.

from the cassette. Simply try another cassette with the tab in place. If you wish to record on a cassette whose tab has been removed, use adhesive or cellophane tape across the slotted area.

On the 8 mm videocassette, the previous recording is preserved by sliding a tab over, to cover the cassette opening at the rear of the cassette. The 8 mm videocassette has a sliding tab, while the VHS and VHS-C cassettes have a knockout tab. To re-record on the cassette, simply slide the tab in.

LOADING AND UNLOADING THE CASSETTE

Make sure power is applied to the camcorder before attempting to load the videocassette. Insert the battery or ac adapter and connect the power cord to the ac outlet. Press the power switch to turn the camcorder on. First, remove the tape slack in the cassette. Always insert the videocassette in the correct direction. Never insert it upside down. The transparent window of the cassette should be facing outward. In some camcorders the videocassette cannot be loaded when turned over.

Open the cassette holder by pressing the eject button. Insert the tape, and follow the arrow on some models. Correctly load the cassette, and press the upper righthand corner or center of the cassette holder to close it.

Unload the cassette by pressing the stop button, then pressing the eject button. Remove the cassette and close the cassette holder. Always shut off the power to the camcorder when not in use. The eject switch or button may slide to eject the cassette in some models.

Loading Notes. In some models when the battery is discharged, the tape is unloaded and the power is turned off. However, pressing the power switch while holding the eject button, may turn the power on and eject the cassette. Always, run the camcorder at least 15 seconds at the beginning of a cassette before recording, to avoid missing the

starting point during playback on a videocassette recorder. Return the videocassette to the plastic holder to protect the recording.

Test Cassettes

There are many test cassettes that the homeowner or electronic technician must use to keep the camcorder in tip-top shape. The different videocassettes are listed here:

- Alignment Cassette
- Cassette Torque Meter
- EP Mode Check Cassette
- Back Tension Cassette
- Video Sweep Signal Alignment Cassette
- Video Drop Out Cassette
- Spare Recording Cassette

The *alignment cassette* is used in both mechanical and electrical adjustments of the tape path (Table 6-1). Electrical adjustments may be required after replacing mechanical parts or video heads. The *torque cassette meter* is used to monitor the take-up tension, FWD and REV playback operations, supply and take-up reel adjustments, and mechanical alignment. The *EP mode cassette* checks the speed and alignment in the extended play or slower speed mode. The *back tension cassette* is primarily used to check back tension and take-up adjustments.

The *video sweep signal alignment cassette* is used when adjusting the playback equalizer amplifier for the NTSE system. The *video dropout cassette* is to check the recording for video-audio dropout correction circuit adjustments. The playback time on

Table 6-1. Here the different camcorder manufacturers are loaded with the different alignment cassettes.

Manufacturer	Alignment Cassette	Cassette Torque Meter	EP Mode	Video Sweep
Cannon	DY9-1070-000			DY9-1060-001
General Electric	29-0542-79			
JVC	MH-C1	PUJ50431-2	CH-C1L	
Minolta	7982-8012-01	7982-8010-01		
Mitsubishi	859C35909	859C36001		
Sony	J5-8-967-995-01	J9-6080-624A		
Sylvania	VFMS0001H6			
Zenith	868-206	868-262	868-247	

these cassettes is about 15 minutes. These videocassettes have a lifetime of only 30 passes.

The *record spare cassette* is used for recording and running checks. Use the spare cassette to check out the various tests before using the test cassette to prevent damage to the test cassettes when they're connected to alignment fixtures and cable connections. These test cassettes are very expensive, and you may want to leave all adjustments and alignment problems up to the electronic technician or camcorder repair depot. When storing these test cassettes, be careful of high temperatures, humidity, and avoid dust and electromagnetic forces.

REMOVING JAMMED CASSETTES

The camcorder may end up with a jammed cassette, and the compartment door won't release it. Most cassettes can be released by removing the two small screws holding the front cover. Be careful not to damage the alignment tabs when removing or realigning cassettes.

Some cassettes can be removed by inserting a small screwdriver into the area between the corner of the cassette, and the inside top righthand corner of the holder unit (Fig. 6-12). Push in and down on a part of the eject lever with the screwdriver. Do not

Fig. 6-12. A small screwdriver is used to release the eject button so the jammed tape can be removed. Be careful not to damage the tape or cassette with excessive force.

lift and hold the unit by the cassette holder rod. This will put an excessive load on the cassette locking parts. Pry and release the jammed cassette from the cassette holder.

To remove the most difficult jammed cassette, remove the cassette holder cover. The loading motor worm gear must be released at one end by removing a "C" or split washer. Rotate the gear counterclockwise so as not to mesh with the end gear. Turn the gear to the point just prior to the stop or eject mode. Grasp the cassette holder and rotate the gear to the eject mode. Turn the take-up gear of the cassette housing to return the tape within the cassette. Be careful not to damage the tape. Remove the jammed cassette. Replace the gear and washer components to the original position.

Always remember to try another cassette when the cassette will not rotate or appears jammed in the cassette holder. Try another cassette if the camcorder appears to have too many picture dropouts, to see if the cassette or camcorder is at fault. Try another spare cassette when making alignment or adjustments after replacing mechanical components. If the cassette will not record, try another cassette with the indent tab in position when the camcorder will not record. You may find, on the inexpensive cassettes, that the beginning and end of the tape is wrinkled, causing picture dropout.

7

The Camera System

The basic camcorder circuits can be broken down into the camera and VCR systems. The camera section consists of the lens assembly, image sensor, luminance and chroma processing, and electronic viewfinder. The VCR section consists of the system control, servo, audio, and all mechanical tape movement circuits. Of course, within each section there are many different circuit operations.

8 MM CAMERA CIRCUITS

The 8 mm camera lens assembly contains the focus lens, automatic focus (AF), iris control, and zoom lens assembly. The image sensor consists of a color filter, CCD pickup sensor, CCD driver or preamplifier, and generator circuits (Fig. 7-1). The brightness or luminous processing has iris control, AGC, a YH low pass filter and a YL low pass filter, vertical and horizontal aperture operation, and matrix or mixer and encoder circuits. The color or chrominance process consists of color detection, white balance, R-YL/B-YL switching, and mixer circuits.

VHS/VHS-C CAMERA CIRCUITS

The VHS and VHS-C camera section contains the lens assembly, automatic focus (AF), iris or AIC control, and the zoom motor assembly. The image sensor consists

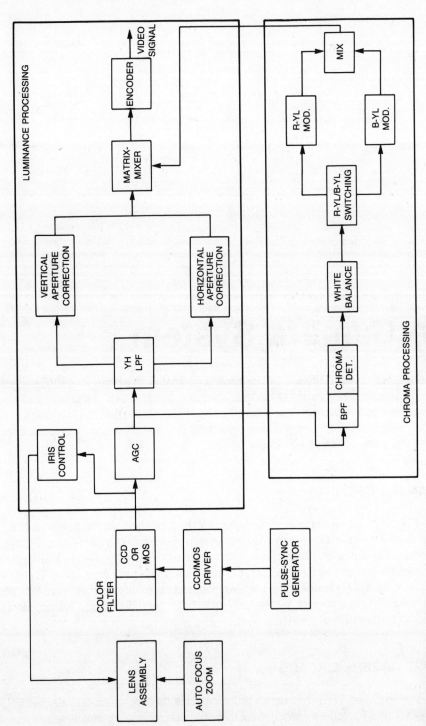

Fig. 7-1. A typical 8 mm camera block diagram.

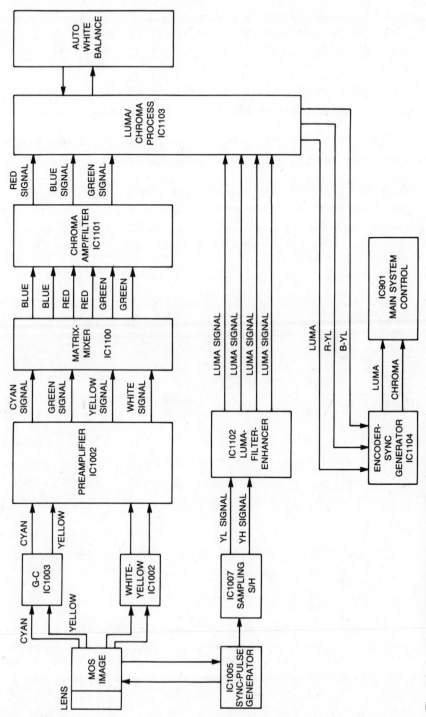

Fig. 7-2. A typical VHS-C MOS color camera block diagram.

of a tube, CCD or MOS pickup sensor, CCD or MOS drive pulse generator and preamplifier circuits. Other VHS camera circuits are sample and hold, sync generator, matrixing and filter circuits, signal processing, luminance signal processing, chroma signal processing, automatic white balance, encoder and power distribution systems (Fig. 7-2).

ELECTRONIC VIEWFINDER (VHF)

Most recent cameras have an electronic viewfinder, some of the smaller cameras have the optical type viewfinder for easy viewing. The electronic viewfinder looks and acts somewhat like the small B&W television chassis. The EVF circuits consist of a miniature picture tube with horizonal and vertical deflection circuits. The flyback transformer provides high voltage to the CRT (Fig. 7-3). Vertical and horizonal sync circuits are generated and fed to the EVF deflection and VCR system control circuits. A small amplifier and sync separation circuit round out the EVF circuits. The electronic viewfinder is found in all types of camcorders.

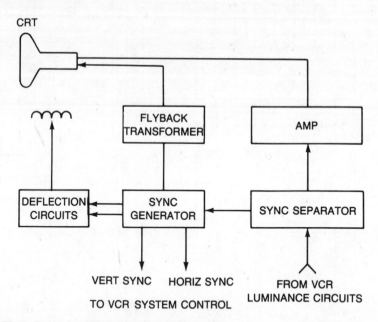

Fig. 7-3. Block diagram of the electronic viewfinder (EVF).

The electronic viewfinder (EVF) permits monitoring of the pictures taken by the camera and playback. You can see the picture that was taken through the EVF. Also, you can see the playback of those pictures through the electronic viewfinder.

The video signal is taken from the main board and fed into a video IC (IC 8011). Here the video signal is amplified to the driver (IC 8012) to the grid of the EVF CRT (Fig. 7-4). A sync separator circuit inside IC 8011 sends a sync signal to the vertical

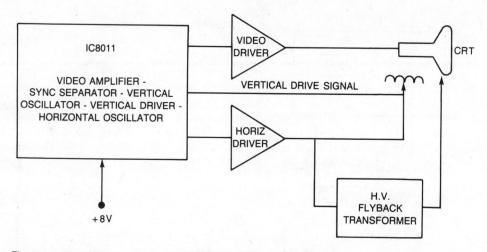

Fig. 7-4. A typical electronic viewfinder (EVF) sweep block diagram.

oscillator and vertical drive circuit. The horizonal sync signal is separated, and sent to the horizonal oscillator and driver circuits. High voltage is developed in the flyback transformer and is applied to the anode terminal of the IC. Both the vertical and horizonal drivers provide sweep to the deflection coils.

Vertical Deflection Circuits. After the video signal enters the low pass filter (LPF), which removes high-frequency components, it enters IC 18011. The vertical sync separator, separates the composite sync signal from the video signal (Fig. 7-5). This signal triggers the vertical oscillator section, and drives the vertical driver stage. The vertical driver provides a sawtooth waveform signal to the vertical deflection yoke.

Horizonal Deflection Circuit. The phase detector compares the separated horizonal sync signal and the horizonal drive pulse generated by the horizonal oscillator which feeds back the error voltage to the horizonal oscillator (Fig. 7-6). This signal passes through

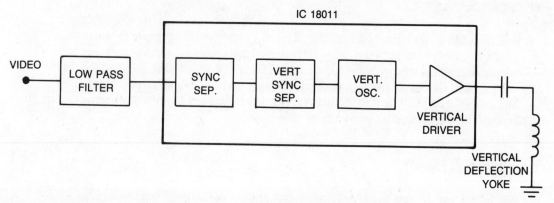

Fig. 7-5. A typical vertical deflection circuit in the EVF block diagram.

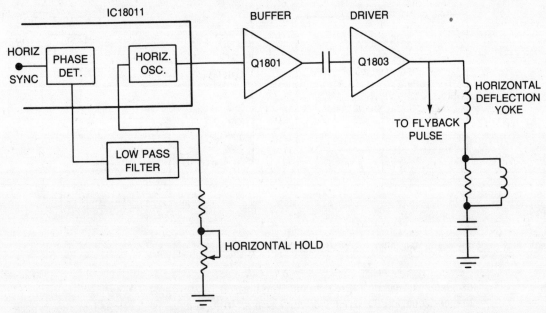

Fig. 7-6. Horizonal drive block diagram in the EVF circuits.

a low pass filter (LPF) so that the horizonal drive pulse is synchronized with the horizonal sync signal.

The horizonal oscillator signal is applied to a buffer and horizonal driver IC, which drives the horizonal deflection yoke and flyback transformer. High voltage is developed in the flyback transformer, and is rectified by the high voltage diodes found in the horizonal output transformer. The flyback transformer also provides heater, screen, and focus voltage for the EVF CRT.

HQ TECHNOLOGY

HQ (high quality) circuits are now found in many camcorders to improve the luminance range, contrast, white clip level, edge sharpness, detail enhancer, reduce smearing, and reduce highlight blooming. Some HQ camera circuits improve on color bleeding and color rendition. Generally, the high quality picture is improved in both standard play (SP) and extended play (EP) mode recording speeds. HQ technology has recently been added to improve the camcorder picture recording process.

CCD PICKUP ELEMENT

In the early video cameras, a small image tube called the Videcon, Saticon, or Newvicon was used. The electron pickup tube is constructed somewhat like a pentode

tube, with higher voltages applied to make it operate. The lens cap must be kept over the lens assembly at all times to prevent damage from the sun or bright subjects that can cause image burn. In most cases, the image tube must be replaced, resulting in costly camera repairs.

The charge-coupled device (CCD) and metal-oxide semiconductor (MOS) image sensors are used exclusively in all camcorders (Fig. 7-7). The CCD has a longer life compared to the heater type pickup tube. No image lag or burn is found in the CCD pickup. The CCD pickup is vibration and damage proof, compared to the weak glass tube and filament construction. The CCD pickup element needs no warm up period like the small pickup tube (Table 7-1).

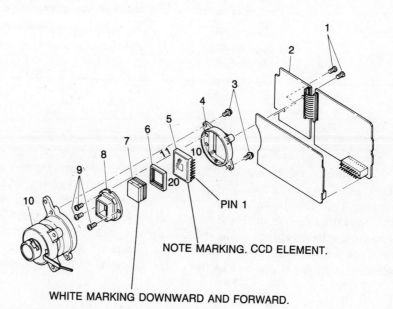

NOTE MARKING. CCD ELEMENT.

WHITE MARKING DOWNWARD AND FORWARD.

Fig. 7-7. Photo of a CCD or MOS image device.

The CCD image sensor is a semiconductor device consisting of orderly arrange arrays of cells (capacitors). When light shines on the element, an electric charge is developed that varies with the intensity of light. The CCD device can store the charge in a well or hole when certain voltages are applied. The depth of the well or hole varies with the voltage applied to the electrode. The charge collected in the adjacent cell or hole is moved to the cell the voltage is applied to. With many different cells the self-scanning process keeps repeating.

The surface of the chip is divided into thousands of light sensitive spots called pixels (picture elements). In the Zenith VM 6150 camcorder the CCD array utilizes 223,368 pixels (picture elements) with a resolution in excess of 270 lines. Most recent camcorder CCD picture elements average between 200,000 and 290,000 pixels.

Table 7-1. CCD and pickup tube comparison chart.

	CCD	PICKUP TUBE
Life and Reliability	Long Life	Heater or filament weakens
Image lag and burn features	No after image No burn with strong light	May have image lag and pickup image burn
Figure Distortion	Perform self scanning and exact figures	Difficult on both center and perimeter scanning
Vibration and Breakage	Strong semiconductor chip	Weak glass bulb and filament damage.
Picture Warmup	Fast...uses no heaters	Heater or filament must warm up before taking pictures.
Size and Weight	Light and small	Tube, deflection and components....heavy parts.
Power Usage	Low power with semiconductors	Heater current and higher voltages needed

MOS PICKUP ELEMENT

The MOS (metal-oxide semiconductor) image device is found in some Pentax, Radio-Shack, and RCA camcorders. When light falls on the picture element, an electron/hole pair is generated inside the N+ layer and P+ layer that form the photodiode (Fig. 7-8). As the electrons flow out the N+ layer and the P+ layer, the hole remains. With positive pulses and voltages applied to the metal electrodes, the electrons are moved through the silicon base providing vertical and horizonal picture scanning. Low infrared and well-balanced sensitivity is obtained by using photodiodes as picture elements.

VHS-C SIGNAL CAMERA PROCESS

The CCD sensor picks up the picture and transfers light into electrical energy, this in turn is amplified after passing through the picture element (Fig. 7-9). Four signals, cyan, white, green, and yellow are derived by the sampling frequency. The cyan, green, yellow, and white signals are amplified by IC 1003 and IC 1002. These four signals are fed into a pre-amplifier (IC 1006). These color signals are mixed at the matrix or mix IC (IC1101) which produces the colors, red, blue, and green.

MOS Image Pulse Generator. The MOS image drive pulse generator (IC 1005) drives the MOS image sensor and signal processing circuits (Fig. 7-10). The pulse generator consists of a high speed section, horizontal and vertical frequency, shutter control, and clock pulses. It furnishes the sensor drive pulse a correction signal, and processes signal burst level adjustments. Black pulse, auto white, and auto white balance circuits are tied into the pulse generator circuits.

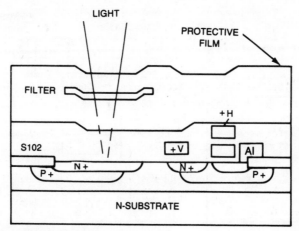

Fig. 7-8. MOS picture element sensor.

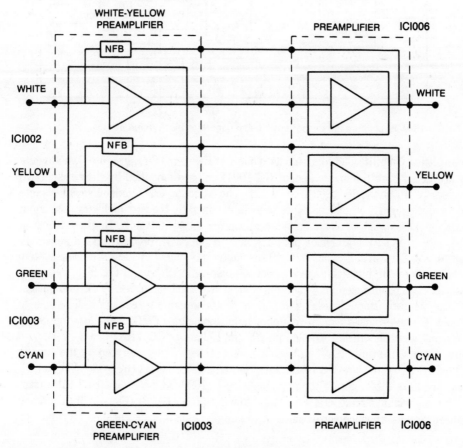

Fig. 7-9. VHS-C preamplifier signal processing block diagram.

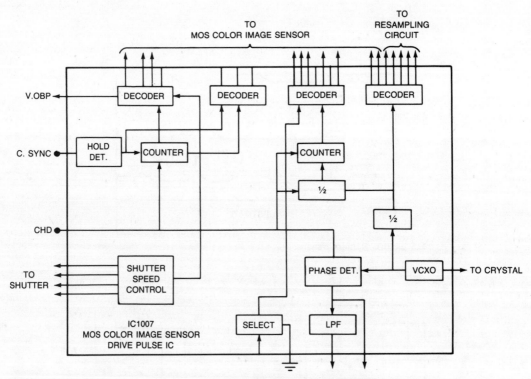

Fig. 7-10. VHS-MOS color image sensor drive pulse generator block diagram.

Preamplifier Circuit. The four signals, yellow (YE), cyan (CY), green (G), and white (W), are taken from the image sensor (IC 1001) and are amplified by their respective amplifiers IC 1003 and IC 1002 (Fig. 7-11). The MOS or CCD sensor signal is quite weak, and the signal-to-noise (S/N) ratio is determined by the preamplifiers. The input impedance of the preamplifier are quite low at approximately 500 ohms. Negative feedback to the gate of the FET amplifier provides bias to the MOS or CCD image sensor.

Resampling Circuits. Expanded (high) resolution is obtained by the resampling system which improves the high-frequency signal-to-noise ratio (S/N) and the high frequency response. Each picture element generates some noise, and is amplified by the preamplifier ICs. The sampling frequency is an important factor in camera resolution. The sample and hold IC also provides a high-frequency luminance signal (YH), and a low-frequency (YF) signal which is applied to the Luma/Filter/Enhancer (IC 1102) in Fig. 7-12.

Luma/Filter/Enhancer IC. The luma signals (YH and YL) generated by the sample and hold IC (IC 1007) are fed to the luma/filter/enhancer (IC 1102). The YH and YL signals are mixed to generate the luma signal. IC 1102 also includes a 10.7 MHz trap, blanking, and clamp circuit, and a 4.5 MHz low pass filter (LPF) (Fig. 7-13). The luma enhancer circuits enhance those parts of the edges where black changes to white, or

Fig. 7-11. Photo of preamplifier (next to finger) and camera components.

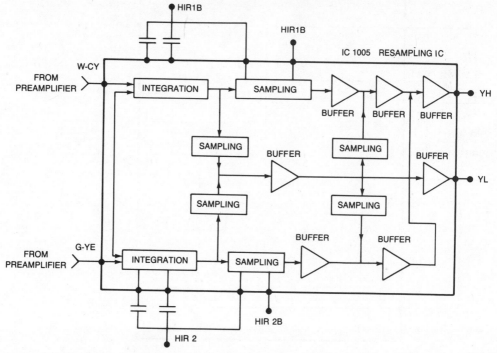

Fig. 7-12. Typical VHS sampling block diagram.

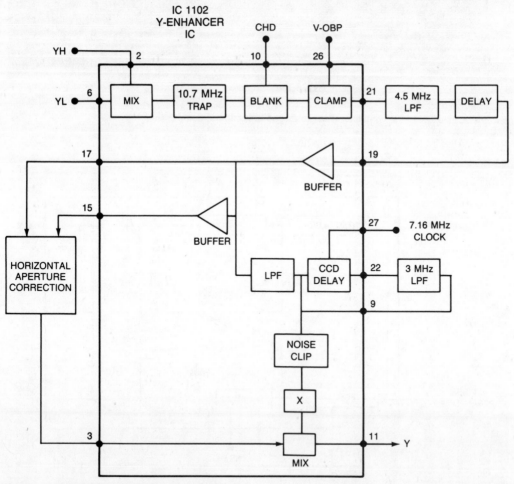

it reverses in the vertical direction. The luma signal removes the spurious high-frequency components with a low pass filter. The enhancer circuit also consists of a subtractor, which generates an edge-enhancing signal, and a base noise clip-circuit that removes high-frequency components from the signal. The luma signal from IC 1102 is fed to the luma/chroma process IC (IC1103).

Matrix or Mixer Amplifier Circuit. The complementary color signals coming out of the preamplifier (IC 1002) enter the matrix and chroma amplifier (IC 1101). The chroma or color signals are mixed, and result in the basic blue-blue, red-red, and green-green colors. A temperature compensator circuit handles fluctuations in the output of the preamplifiers by varying the dc-bias of the matrixing circuit, according to the temperature (Fig. 7-14). The basic colors are then tied into a chroma amplifier/filter IC.

Fig. 7-13. Luma/Filter/Enhancer block diagram.

Chroma Amplifier/Filter Circuits. IC 1101 is a three-channel chroma amplifier. The R channel passes through a low pass filter (LPF) which removes spurious high-frequency components of 700 kHz or more. The B and E channels are produced in the chroma amplifier/filter like the R signal, removing spurious high-frequency components with a low pass filter (LPF). The red (R) and blue (B) gain controls are found in these circuits. The three basic colors red, blue, and green are then fed to the luma/chroma processing IC.

Chroma Processing Circuits. The basic chroma signals (R, B and E) are fed from the chroma amplifier/filter (IC 1101) to the input terminals of IC 1103 (Fig. 7-15). The chroma or color process circuits are basically the same as the luma processing channel, including the feedback clamp, gamma, blanking, white clip, dark clip and AGC circuits.

The big difference in the two are chroma shading correction, white balance control, low-brightness compensation, YL matrix circuitry, and color difference signal matrixing. The chroma shading correction circuit corrects horizontal shading caused by the capacitance gradient of the horizontal signal lines of the MOS color image sensor. The correction signal from IC 1105 is applied to the chroma shading, to adjust the shading level. The output is added to the G signal to correct shading. The white balance control circuit is

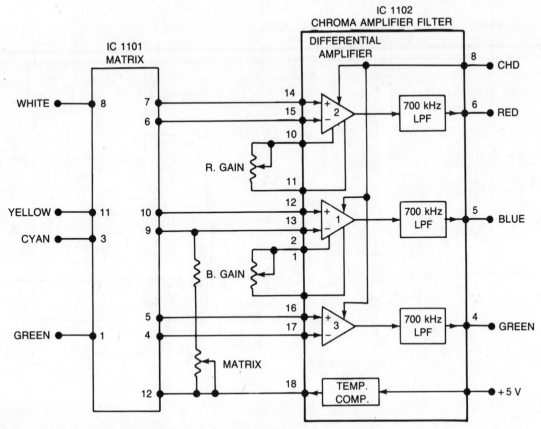

Fig. 7-14. VHS matrixing and chroma amplifier block diagram.

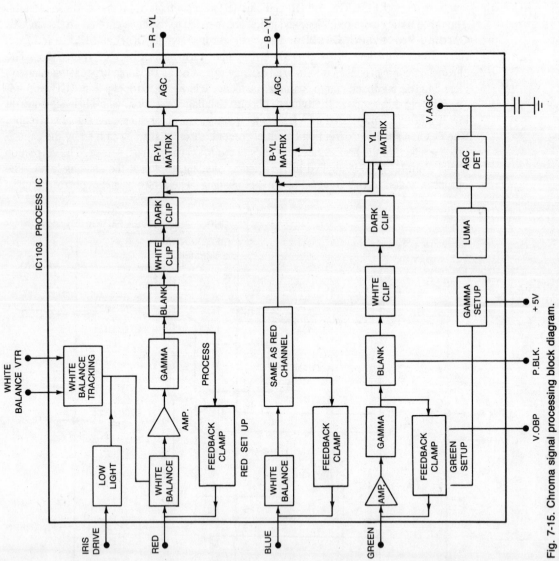

Fig. 7-15. Chroma signal processing block diagram.

variable according to the white balance control voltage. The low brightness compensation circuit operates when the object brightness is low, the iris opens and varies the light on the MOS color image sensor. The picture is greenish, if the low brightness compensation circuit does not monitor the iris drive voltage. The YL matrix signal is used to generate the color difference signals. The color difference signals (R-YL) (B-YL) are fed to the encoder IC.

Encoder Circuits. The encoder consists of the luma signal processing and chroma processing signal circuits. The luma, R-YL, and B-YL signals are fed to the input terminals of encoder IC 1104. The color compensator section improves the quality of red when the object has a low color temperature (Fig. 7-16). A 3.58 MHz trap switch circuit reduces high-frequency noise when the object brightness is low. It reduces high-frequency noise in the range of chroma signals involved in the luma signal, to prevent a mixture of high-frequency noise in the chroma signal.

The chroma signal processing circuit signals R-YL and B-YL from the luma/chroma processing (IC 1103) are fed to the encoder input terminals. A balanced modulator inside the encoder mixes the signals to generate chroma signals. A pulse mixer, gain control, inhibit, and 3.58 MHz bandpass filter circuits are also found in the encoder IC. The luma (brightness) and chroma (color) signals are fed to the main control IC (IC 901).

Automatic White Balance. The automatic white balance circuit controls the gain of the red (R) and blue (B) color signals, to maintain color temperature under various lighting conditions (Fig. 7-17). This circuit controls the two different colors (R and B) signals, and feeds them back to the gain control circuit, so that a white object is obtained as white, regardless of the light source. This ensures the white areas of the picture will not have a blue or red cast or tint.

The white balance control consists of a clamp, gate, chip, color temperature detector, and control voltage generator circuits. When the white balance switch is set to automatic (auto) position, red and blue photodiodes generate light currents corresponding to the level of the color spectrums. These currents continually correct the red and blue gains as the light temperature changes.

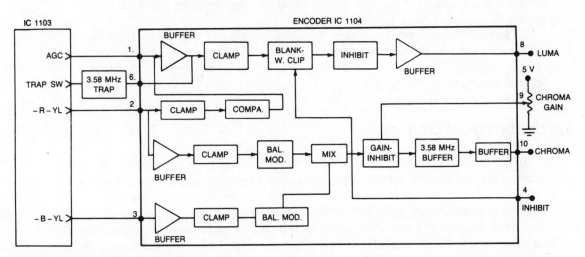

Fig. 7-16. VHS encoder block diagram.

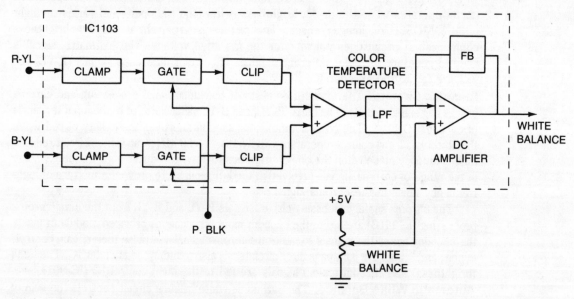

Fig. 7-17. Typical automatic white balance block diagram.

IRIS CONTROL CIRCUITS (AUTO)

The AIC or IRIS control circuits are also associated with the camera section. This circuit controls the lens iris according to the brightness of the object. The output level of the video signal is also controlled by the AIC circuit. The iris control circuit consists of the AIC current iris control and the iris motor (Fig. 7-18).

When the average lighting of the scene viewed by the camera decreases. the comparison voltage input also decreases. Likewise, the output of this AIC circuit decreases, and when the average lighting increases, the output of this same circuit increases.

The video output level is controlled by the combination of AIC and AGC circuits. In adjusting the AIC control, the crossover point for the automatic iris and automatic gain is controlled. The AIC control is adjusted during set-up procedures under certain lighting conditions.

AUTOMATIC FOCUS CONTROL

The AF circuits control the lens iris according to the brightness of the object. Some camcorders have infrared and piezoelectronic focusing methods. You may be able to use both manual and automatic focusing on some cameras. The AF control consists of the infrared detectors, process IC, LED drive, motor driver, and auto focus motor.

When the focus switch is turned to auto, the power switch is turned on, and dc voltage is applied to the automatic focus control circuits (Fig. 7-19). The signal from the

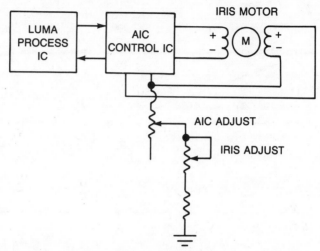

Fig. 7-18. VHS-AIC, IRIS control and motor block diagram.

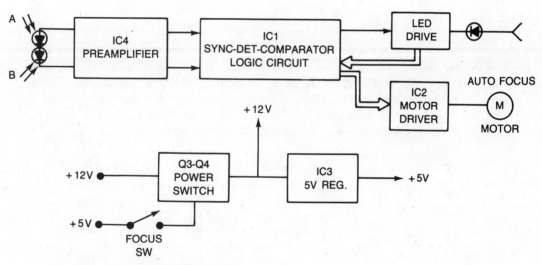

Fig. 7-19. Typical automatic focus (AF) block diagram.

two infrared detectors is amplified and fed to the IC processor. The two signals are detected and compared in the process IC. The control signals are generated by the logic section of IC1, and are applied to the motor drive IC, which operates the auto focus motor.

The AF control system operates on the principle of triangulation using the reference of infrared rays. Infrared rays emitted by the infrared LED pass through a projection lens and reach the object (Fig. 7-20). These infrared rays are reflected back from the object to a sensor via the receiving lens. The sensor is composed of two photodiodes, A and B. The focus lens is moved until the two photodiodes receive an equal amount of light, resulting in automatic focusing.

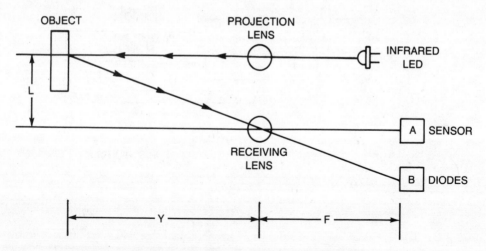

Fig. 7-20. Block diagram of auto focusing principles with infrared diodes.

ZOOM MOTOR DRIVE CIRCUITS

The zoom motor and drive circuits are located in the camera section. The zoom lens is a means of adjusting the picture, and framing the subject. This can be done in some camcorders with a telephoto position (zoom in) or wide angle (zoom out). The speed of the zooming motor is determined by the voltage applied to the speed control (Fig. 7-21). When the voltage is low applied to pin 10 of the driver IC the lens zooms in, with a higher voltage the lens operates in the wide direction.

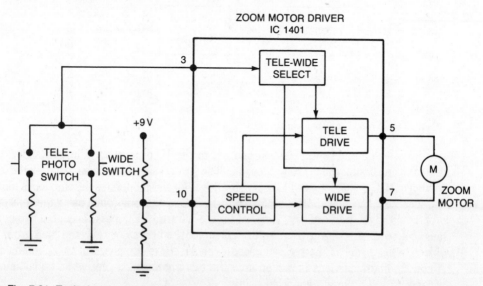

Fig. 7-21. Typical zoom motor block diagram.

The difference between the telephoto and wide angle setting determines the zoom ratio. Some camcorders have a short ratio, 3 to 1, while other cameras have a high ratio, 8 to 1. The average zoom ratio is 6X power or 6 to 1.

8 MM SIGNAL CAMERA PROCESS

Most of the 8 mm camera section employs the CCD element sensor. A zoom lens can be found in some models, with auto focus and iris control in many different 8 mm camcorders. Often, the luminance and chrominance processing circuits are quite similar to the VHS models.

The sync or clock generator with the timing processor combines the original oscillator signal, providing various timing pulses to the CCD driver and CCD image sensor (Fig. 7-22). The sample and hold (S/H) and clamp circuits provide signal separation to the data sampling circuit. The AGC circuits keep the signal level constant at all times. The color separation, S/H, and detector circuits sample and separate the color signals. A white balance circuit combines the white balance with the auto-white balance to eliminate white balance. The matrix circuit mixes the R-YL and B-YL colors, providing a color video signal to the VCR section.

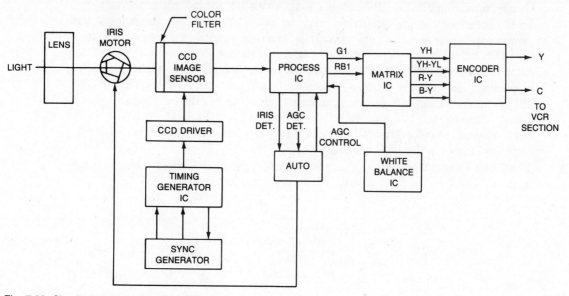

Fig. 7-22. Simple 8 mm camera block diagram.

8 MM PROCESS CIRCUITS

The process IC section contains signal-separation, AGC, AGC detection, color separation S/H, and white balance circuits (Fig. 7-23). The picture signal from the CCD

image sensor is fed to the process IC. The signal is separated with color separation through the AGC circuits. Iris and AGC detection are controlled before and after the AGC circuits. Clamping, black level, and white clip circuits may be included in the process circuits. The process IC working operations can be broken up in separate ICs or processors in other 8 mm cameras.

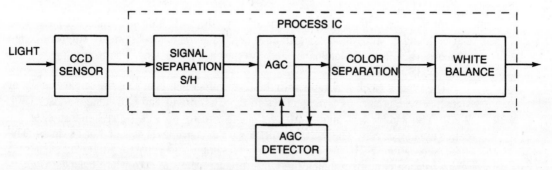

Fig. 7-23. 8 mm process IC circuit block diagram.

8 mm Matrix Circuits. The matrix IC input G and R/B signals are mixed in the matrix circuits, producing YH, YL-YH luminance signals with R-Y and B-Y chroma signals (Fig. 7-24). These signals are fed to the encoder IC. The luminance (brightness) and chrominance process circuits are individually mixed in other 8 mm process circuits.

8 mm Encoder Circuits. The encoder consists of luminance processing, clamp, aperture correction, YG and PED (pedestal), Y, sync mixing, chroma information, and color signal processing. The luminous process circuits in some 8 mm include AGC, YH LPF, YL LPF, vertical and horizontal correction, and mixing circuits, while the chrominance process circuits consist of BPF, chroma detection, white balance, R-YL/B-YL switching, R-YL and B-YL mod and color mixing. The encoder output Y and C signals are fed to the pre-emphasis circuits in the VCR section.

The 8 mm Timing Generator. The timing generator produces timing signals and pulses to the CCD driver, process, matrix, IHDL, and encoder circuits (Fig. 7-25).

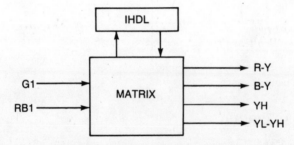

Fig. 7-24. 8 mm matrix block diagram.

8 mm AGC Circuits. The CCD output signal is maintained at a certain level by the AGC circuits. The main level control is performed by the iris narrowing the optical input when the level of the CCD sensor output signal is high. The signal level is maintained by amplifying the AGC when the level is low, with the iris wide open. The AGC amplifier gain can be controlled with a separate maximum AGC control. The AGC circuit can also control the AGC detection signal level (Fig. 7-26).

8 mm White Balance Circuits. The white balance can be preset at color temperature indoors and outdoors. Color temperature switching is obtained with transistors of ICs. Good white balance is controlled with proper level of B and R control (Fig. 7-27).

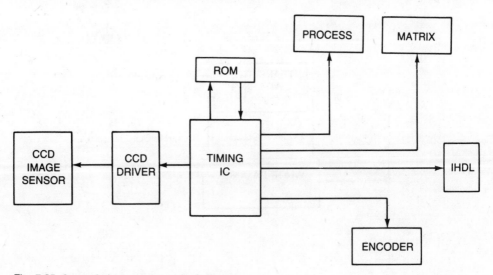

Fig. 7-25. 8 mm timing generator block diagram.

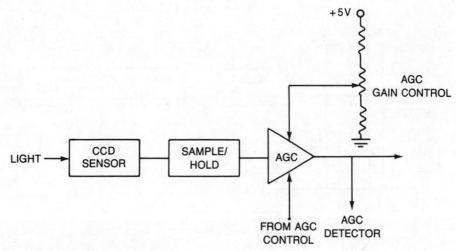

Fig. 7-26. 8 mm AGC block diagram.

8 mm Automatic Iris Circuits. The automatic iris mechanism consists of an iris motor or meter system with drive and brake coils. The optical signal from the CCD image sensor is processed by the process IC, and is converted to a voltage waveform. The signal is clipped, detected, and amplified by the iris IC (Fig. 7-28). A reference voltage is set by the iris set control (R1). When the iris control voltage is lower than the reference voltage, R1 indicates low illumination. The level output becomes high (H) when the LED inside EVF lights up.

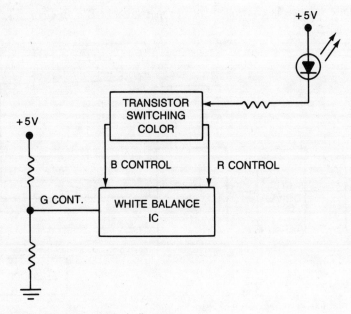

Fig. 7-27. 8 mm white balance block diagram.

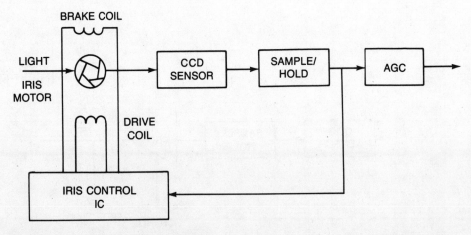

Fig. 7-28. 8 mm IRIS circuit block diagram.

8

The VCR System

The VCR system in the camcorder consists of the video and audio signal, servo and system control, power and mechanical operation circuits (Fig. 8-1). The video section contains the video heads, rotary transformer, head switching, preemphasis, RF, recording amplifier, playback amplifier, luminance and chroma recording process, and luminance playback and chroma playback circuits. The audio section consists of the microphone amplifier, AGC, noise reduction (NR), voltage controlled oscillator, and the audio input/output circuits.

The servo system includes the capstan servo, drum, drum servo, capstan motor, capstan phase control, motor driving circuits, cylinder motor drive, cylinder speed/phase control, and the loading motor circuits. The system control circuits control the oscillator, reset, power control, auto change detection, function switch, tape speed detection, servo-luma-chroma control, trouble detection mechanism, tape run, loading motor, mechanical, and on-screen display controls.

The power sources in the VCR section consist of battery and ac operation with a dc-dc adapter power supply. The mechanical operation contains all the VCR mechanical components, gear trains, locks, levers, driving reel tables, tape path, and mechanical operations. The VHS video, audio, and mechanical operations are described in Chapter 3.

THE VHS SYSTEM CONTROL

The system control microprocessor controls sensors, switches and motors that make it up (Fig. 8-2). It controls power operation, on-screen display, unloading, tape running,

Fig. 8-1. The VCR mechanical parts section.

and operating-mode displays. System control detects battery discharge problems, and protects circuit and mechanism tape speed during playback, it also sets tape speed.

THE POWER CIRCUITS

The power supply board generates power to all the different circuits (Table 8-1). Camcorders are operated from a battery pack or from the ac. adapter. After power is supplied from batteries or the adapter, the power circuits begin to operate. The power circuits distribute regulated voltage to many IC components.

Power On and Off. In Fig. 8-3, when the power switch is turned on, the base of the 12V switch (Q904) is grounded through ZD901 and D803, it turns Q904 on, and applies 12 volts to the 5.6V regulator (IC905). When 5V-2 is applied from D914 to pin 26 of the system (IC901), 5V-3 from D914 is also applied to the reset system. When pin 14 is low (LO) the system (IC901) determines that the power switch is on, and outputs a power signal from pin 54. Power is now applied to the regulators. When the power switch is turned on again, the system (IC901) determines that power has been switched off with a high (HI) power signal from pin 54.

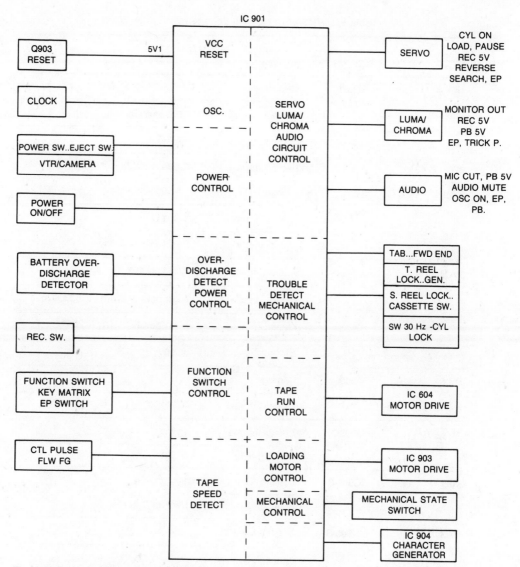

Fig. 8-2. Typical VHS system control circuits.

Eject Operation. When the eject switch (S810) is pushed in the power-off state, the system (IC901) operates because the 12V switch (Q904) is on, as it was during power on. The eject operation can be performed with the power switch on or off. Now the system (IC901) output is high (HI) from pin 54, because pin 15 (eject switch) input is low (LO) and eject is detected. When eject mode is complete, the power-off signal sets the power off (stop) mode. During power-on, eject operates in all modes except the record and the power-on state are held after eject is completed.

Table 8-1. VHS power circuit voltage distribution chart.

Supply Power	Generator	Distribution	Applied
12 volt	RL901	Camera	
		AV Out	RF Generator
		System control	IC9011
		Servo Circuit	IC604 & IC551
8 volt	SWR	Camera	
		Luma/Chroma	IC3011
		EVF Camera	Electronic Viewfinder
5V-1	SWR	Audio Circuit	IC401, IC402, Sensors
		Servo Circuits	Main power, IC601, IC603, IC605
		Luma/Chroma	Main power IC201, IC204
		System Control	IC9011
PB 5v	Q908C	Camera	
		Luma/Chroma	IC201, IC203
REC 5V	Q909C	Luma/Chroma	IC202
		Servo Circuit	IC601
5V-2	IC905-3	System Control	IC9011
		Function Switch	Backup Detector
5V-3	IC905-3	System Control	IC902
		Function Switch	Power LED, Backup Detector
B + CYL	SWR	Servo Circuits	IC551
B + Capstan	SWR	Servo Circuit	IC604

TYPICAL VHS INPUT CIRCUITS

The input circuits consist of the function switch input, battery over-discharge detection, trouble detection, and tape speed detection circuits.

Function Switch Input Circuit. The function switch input circuit detects the key input.

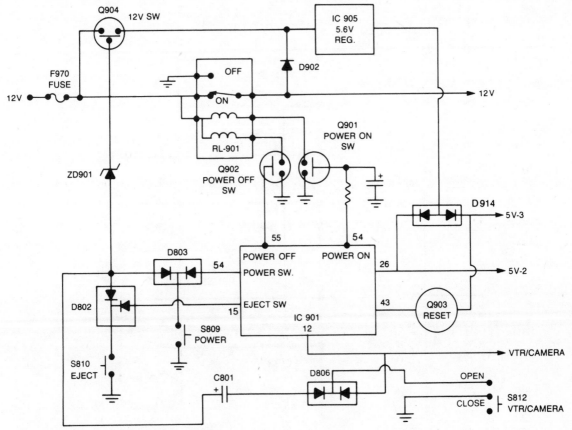

Fig. 8-3. Typical VHS power control circuit.

It consists of the key matrix, the input circuit in the camera section, the input circuit in the VTR section, and the system control processor (IC901) (Fig. 8-4).

When the start/stop switch (S901) is pressed, in the input circuit of the camera section, pin 8 (REC. SW) goes low (LO) and the start/stop mode is detected. The mode control output is inverted every time a signal is input, and the record and record pause modes are repeated. This input is detected only in camera mode when the lens door switch (S812) is set to open, by opening the lens door.

IC901 produces matrix signals from pins 2 and 3, applying them to the function switches. When a function switch is activated, the matrix signal is returned through the switch terminals back to IC901, then IC901 controls the various functions.

The tape speed switch (S811), turned on by the operator, determines the tape speed during recording of the input VTR section. The lens door switch (S812) and tape speed switch (S811) output is high (HI) respectively in the close and SP positions and applies them to pin 12 and pin 63 of the system control (IC901).

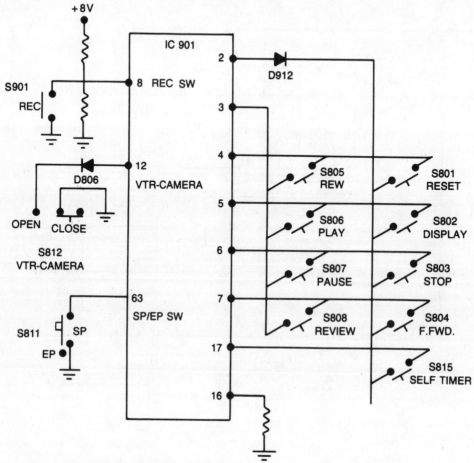

Fig. 8-4. Typical VHS function input circuit.

Battery Over-discharge Detection Circuit. The battery over-discharge detection (ODC) circuit monitors the battery terminal voltage, detects over-discharge, displays characters in the electronic viewfinder (EVF) screen to indicate discharge, and, if the voltage is less than normal, it turns off the power (Fig. 8-5). If the mode is VTR, power-off corresponds to stop. If the mode is camera, power-off corresponds to record/pause position.

The 12 volt power passes through fuse 970, latch relay switch (RL901) to zener diode (ZD903). The 7.5V zener diode regulates the voltage at 7.5 volts. This voltage is applied to over-discharge level control (RT901) to emitter of the comparator transistor (Q905), which compares the voltage with a reference voltage. The reference voltage is fed to the base switch of Q906. The reference voltage at the base of Q906 changes, depending on the detected voltage at pin 51 of IC901.

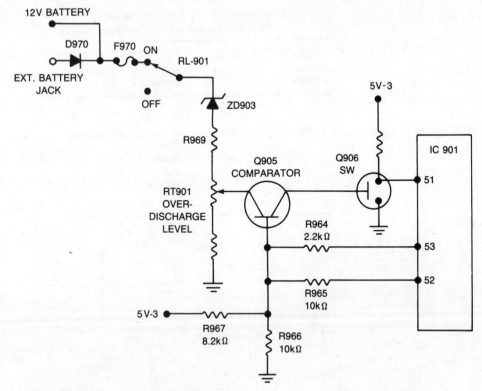

Fig. 8-5. VHS battery over-discharge block diagram.

When the battery is fully charged (12.3 volts) the reference voltage is 4.2 volts, and is displayed in the EVF indicating a charged up battery (Table 8-2). When the battery voltage drops to 11.6 volts, a battery warning signal from the microprocessor (IC901) indicates the battery output is low and it flashes in the EVF. The microprocessor stops the mode, and places the camcorder in a record/pause mode when the battery level drops below 10.9V with a voltage reference level of 2.75V.

TROUBLE DETECTION CIRCUITS

The system control (IC901) monitors the end sensor, dew sensor, take-up reel sensor, supply reel sensor, cassette switch, mechanism state switch, safety tab switch, and the cylinder lock signal. When the system (IC901) detects trouble it puts the system in the stop mode (Fig. 8-6). This prevents damage to the camcorder when a component breaks down.

End Sensor Circuit. When the tape reaches the end of its forward direction (forward search, fast-forward or play), the clear leader part of the tape lets light from the end sensor lamp fall on the surface of the supply end photosensor. The supply end photosensor

Table 8-2. How the detection circuit operates with normal and low voltages.

Battery Terminal Voltage	Reference Voltage at IC901	Display EVF Screen	Output Mode
12.3V	4.2V	E-F	No change
11.6V	3.45V	E-Blinks	No change
Less than 10.9V	2.75V	Power turns off	Power off

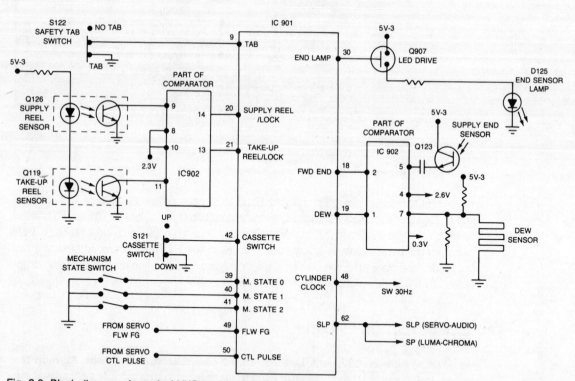

Fig. 8-6. Block diagram of a typical VHS trouble detection circuit.

applies 5 volts to pin 5 of the IC902 comparator. A high (HI) signal is placed on terminal 18 of IC901, stopping the mode.

Dew Sensor Circuit. When moisture is found in the camcorder, the dew sensor circuit springs into action. If the moisture increases, the resistance of the dew sensor increases, and the voltage applied to pin 7 of IC902 increases. When moisture is detected, the output signal at pin 1 is high (HI) and is applied to pin 19, placing the camcorder in the stop mode.

Take-Up Reel Sensor. Reel pulses are generated from a reel take-up sensor mounted underneath the take-up reel assembly. IC902 shapes these pulses and applies them to pin 21 of IC901. The system uses this to detect reel-lock. IC901 will place the camcorder in stop mode to prevent tape damage if the reel lock signals are not detected during camcorder operation.

Supply Reel Sensor. The supply reel sensor is attached to the bottom of the supply reel assembly. The supply reel signal from pin 14 of IC902 controls the supply reel pulse, and produces tape-counter display, and tape-end warning characters in the EVF screen.

Mechanism State Switch Assembly. IC901 inputs mechanism mode data from the mechanism state switch to decide whether selected mode and mechanism mode are the same. If they do not become the same in 10 seconds, IC901 places the camcorder in the stop mode. During loading, detection enters stop mode after unloading. During unloading, detection enters power-off mode.

Safety Tab Switch Operation. The safety tab sensor circuit detects tabs to prevent accidental erasure of the cassette. The operation will not enter the record mode even if the lens door switch (S812) is opened. The camcorder enters the stop mode. Check the setting of the tab switch if the camcorder will not record.

Cylinder Lock Signal Sensor. The cylinder lock signal detects the pulse width of the SW 30Hz signal obtained by the servo circuit for detecting a drop in cylinder motor speed. If the pulse width is less than the rated value, IC901 detects the cylinder lock signal. When detection is made the VTR mode enters stop operation.

TAPE SPEED DETECTION

The capstan flywheel is equipped with a Hall effect IC which produces a flywheel signal. IC901 inputs the flywheel signal pulse at pin 49 and a CTL pulse at pin 50 to detect tape speed. The speed is detected by counting the number of flywheel signal pulses within three periods of the CTL pulse. The tape speed is EP, if the flywheel signal pulses occur within three periods or the CTL pulse is equal or less than seven. If the number is equal to or larger than 8, the speed is SP.

TYPICAL VHS OUTPUT CIRCUITS

The output circuits contain the functions of the on screen display, LED indicator drive, loading motor drive, capstan motor drive, and the mode control signals.

On-Screen Display Circuits. The characters are displayed in the EVF screen of the on-screen display. When the display switch is pressed, the battery voltage, tape speed, operation mode, and tape counter are displayed in the EVF screen. IC901 generates a low (LO) signal when the display switch is pressed, and is found on pin 25 and at pin 3 of the character generator (IC904) (Fig. 8-7). The system control (IC901) applies data to the character generator to display the battery lead and the tape counter.

The character generator (IC904) generates a signal at pin 11 which is synchronized with the horizontal and vertical signals applied to pins 14 and 15. The character signal is applied to pin 13 of video amplifier IC301, and is mixed with the luminance or video signal from pin 16, coming from the luma/chroma board.

LED Indicator Drive Circuits. The power LED (D801) lights when the driver transistor (Q801) is driven by phase 1 signal output from pin 3 of the system IC901 (Fig. 8-8). When condensation occurs the indicator begins to blink. A self timer LED (D807) is driven by the LED driver (Q912) when a low (LO) signal is at pin 31 of the system IC901. The self timer LED blinks 10 seconds for standby mode, and then lights up after 10 seconds of recording mode.

Loading Motor Drive Circuit. The output signals from the system IC901 at pins 22 and 23 control the loading drive IC903, which drives the loading motor. The loading motor ejects and loads the cassette, and loads and unloads the tape. Approximately 9 volts is applied to the motor in either loading or unloading operations.

Capstan Motor Drive Circuit. The system control IC901 controls the direction of rotation of the capstan motor with a forward signal at pin 36, and a capstan-reverse signal at pin 37. These signals are tied to pins 5 and 6 of the capstan driver (IC604), see Fig. 8-9.

The speed of the capstan motor in playback mode (forward/reverse) is controlled by the servo output, pin 54 of IC601. In other modes (record, fast-forward, rewind, etc.) the speed is controlled by the system IC901 at pins 32 through 34. The output signal from pin 35 of system IC901 determines if the capstan motor is controlled by the system control (IC901) or the servo circuits. The capstan reference voltage varies from 2 V to 4.6 V.

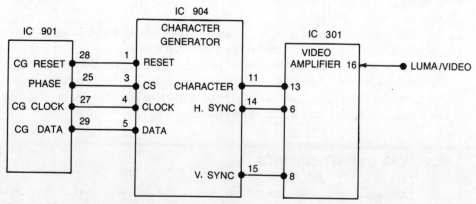

Fig. 8-7. VHS block diagram of the on screen display.

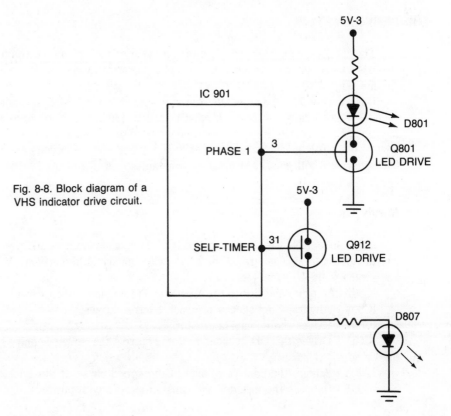

Fig. 8-8. Block diagram of a VHS indicator drive circuit.

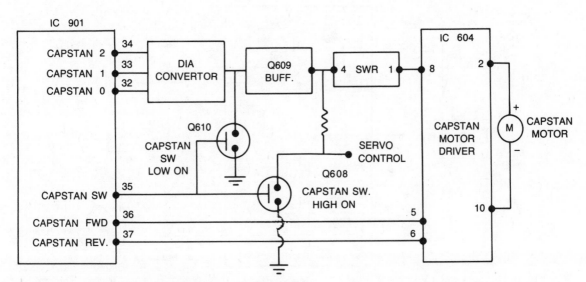

Fig. 8-9. Block diagram of a VHS capstan motor drive circuit.

THE SERVO SYSTEM

The VHS servo system consists of the cylinder motor, capstan motors, cylinder speed and phase control, capstan speed and phase control, flywheel FG, and video process circuits (Fig. 8-10).

During recording, the tape must run at a fixed speed of 3.34 cm/second. The upper cylinder in recording and playback must rotate at 2700 rpm. The phase and speed of the capstan and cylinder motors must be controlled together. The phase control circuits control the small speed fluctuation, while the speed control circuits control the large fluctuations so both motors maintain a constant speed.

Servo ICs

IC601 - Controls the speed and phase of the cylinder motor, and the phase of the capstan motor. It also generates the head switching signal, the artificial V. sync pulse, and switches the capstan speed.

IC602 - Amplifies and shapes the capstan FG pulse, and detects capstan speed error.

IC603 - Amplifies and shapes playback control signals.

IC604 - Drives the dc capstan motor.

IC551 - Drives the DD cylinder motor, controls the power supply, and amplifies the cylinder FG pulse.

IC605 - Buffers the control voltage of the speed/phase of the cylinder motor.

IC951 - Supplies the cylinder and capstan motors with power.

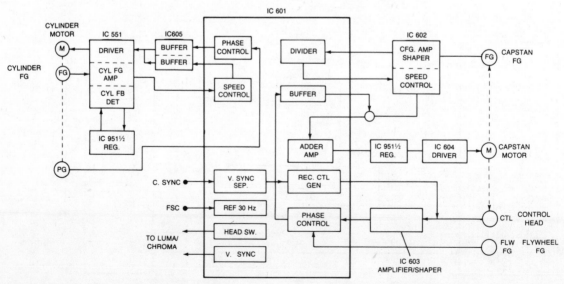

Fig. 8-10. Block diagram of a VHS servo circuit.

Servo System Signals

1/2V Sync Signal. The reference signal for phase control of the cylinder during record and assemble modes. The 1/2V sync signal is obtained by dividing V sync extracted from the video signal.

REF 30 Hz. The reference signal for cylinder phase control during play, and capstan phase control during recording and play modes. This is accomplished by dividing the 3.58 MHz color sub-carrier extracted from the chroma signal processing circuit to 30 Hz.

Tach (PG) Pulse. This signal is used for cylinder phase control. A disc with a magnet is attached to the bottom of the cylinder motor shaft. As the cylinder motor rotates at 2700 rpm, the magnet passes a Hall-effect IC during each revolution. The Hall device produces a 45 Hz pulse. The 45 Hz pulse is fed to the servo circuit producing a 15 Hz, 30 Hz, and 60 Hz PG' pulse.

Cylinder FG Pulse. The signal used to detect the speed of the DD cylinder motor and control the speed of the cylinder motor during record and playback modes. The FG pulse is 720 Hz. The FG pulse is generated from a printed pattern magnetic sensor installed on the motor body which detects the passing of a rotary magnet having 32 poles fitted to the rotor of the DD cylinder motor.

Capstan FG Pulse. The signal used to detect the speed of the dc capstan motor, this pulse is generated by a magnetic sensor installed to the motor body, it detects the passing of a rotary-magnet having 28 poles fitted to the rotor of the capstan motor. The CFG pulse and the REF 30 Hz signal phases are compared during recording operations to control the phase of the capstan motor. This same CFG pulse controls the capstan motor speed during record and playback operations.

Flywheel FG Pulse. The signal used for the capstan phase control during the record mode. This FG signal is generated by a printed pattern magnetic sensor installed on the chassis which detects the passing of a rotary-magnet having 204 poles fitted to the capstan flywheel. When the correct video head speed is obtained, the frequency pulse signal is 360 Hz, in the SP, and 120 Hz in the EP mode. Divide the frequency by 30 Hz to obtain the flywheel FG pulse.

Control (CTL) Pulse. The signal used for capstan phase control during play mode, the cylinder phase control reference signal (½V Sync) is shaped into a square wave and recorded on the control track of the tape during recording. The control (CTL) pulse is this signal, reproduced during playback. When the video head speed is maintained, the frequency signal is 30 Hz.

THE 8 MM VCR

The different 8 mm VCR circuits consist of the system control, operation circuit, capstan motor, cylinder motor, servo, video, and audio circuits (Fig. 8-11). The video, audio, and head circuits are found in the 8 mm format of Chapter 4.

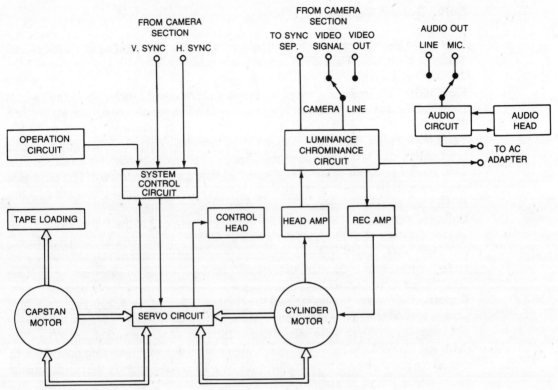

Fig. 8-11. Typical block diagram of a VCR section of an 8 mm camcorder.

THE 8 MM SYSTEM CONTROL

The 8 mm system control consists of the warning detection, loading motor, sync generator, D-D convertor, switching modes, key, LED functions, video digital servo, capstan, and drum driver circuits (Fig. 8-12). Like the VHS camcorder, the system control process is controlled by a large microcomputer or processor IC.

The output control signals from the system control processor are the loading motor, indication (LED) control, and the video control circuits. The input control signals are for switching input, warning detection, and various video signals, the servo, capstan drive and motor, and drum drive and motor are also controlled by the control system processor.

WARNING DETECTION

There are many different warning devices found in the camcorder to prevent damage to the unit or to keep the tape from jamming, these warning devices prevent and shut down operation, before more damage can be done. There are several different indicators, such as weak battery, dew, tape end, reel rotation, clogged head, drum rotation, loading motor safety, drum phase lock, and LED indication.

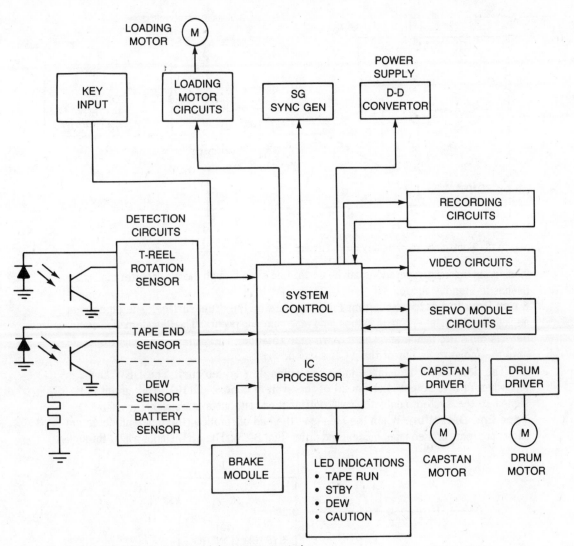

Fig. 8-12. Typical 8 mm block diagram of the system control.

Weak Battery Indicator. A low (L) battery indicator dictates the battery is low and should be recharged. The battery indicator comes on when the voltage falls below the unregulated voltage source, whether 6, 8, or 12 volts. Since there are many motors to operate in the camcorder, the batteries may not last for more than 30 minutes to an hour of use (Fig. 8-13).

The loading motor may not operate when the power signal is low (L). When operating in Tape Run operation, the unit may stop within 30 seconds after the battery low (L) indicator comes on in some models. During recording, the battery indicator may flash repeatedly, indicating only a few seconds are left to record before shutdown. Sometimes

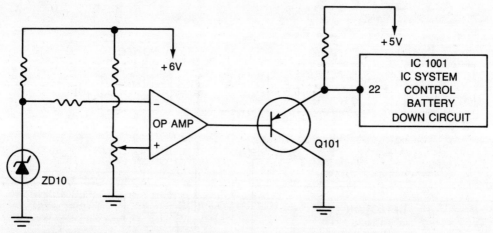

Fig. 8-13. Block diagram of battery down circuits.

loading and unloading operations can be performed even though the weak battery indicator flashes in standby mode.

8 mm Dew Indicator. Sometimes dew appears on the drum surface. The tape might stick to the drum tape, rotation stops, and tape jamming occurs. The dew detection circuit detects moisture inside and shuts down tape rotation. The camcorder cannot operate until the moisture is out of the VCR section.

The dew sensor resistance increases when dew is detected. The DEW signal is low when dew is detected at pin 26 of the system control IC1101. The circuit is designed so the system control IC will not function without a start signal (Fig. 8-14).

Tape End Detection. When the tape is at the end of rotation, the tape end detection circuit prevents broken tape, guides, and drum (Fig. 8-15). The LED shines a light through

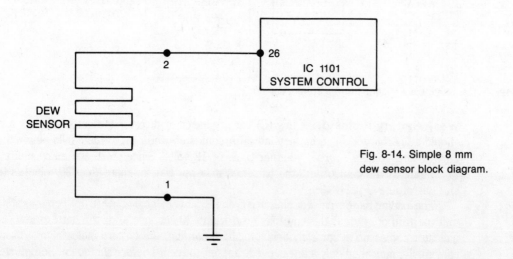

Fig. 8-14. Simple 8 mm dew sensor block diagram.

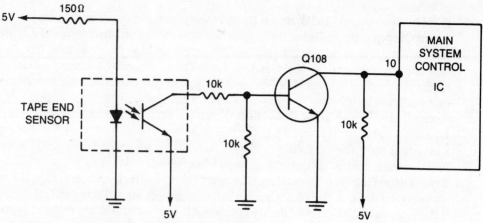

Fig. 8-15. 8 mm block diagram of the tape end sensor.

the transparent end of the tape striking a phototransister. The tape end signal is fed to the system control IC, shutting down tape rotation immediately.

8 mm Reel Rotation Detect. Clogging or jamming of the tape results when the take-up reel intermittently stops of does not rotate. To protect the tape, the reel detection circuit shuts down rotation if the take-up reel fails to rotate. If the take-up reel detection circuit becomes faulty, the tape will run out, jamming the tape operation, the cassette may get stuck and not be able to be removed during eject mode.

The detection circuit consists of an LED and phototransistor mounted on the bottom of the take-up reel (Fig. 8-16). A pulse shape reflected signal from the phototransistor

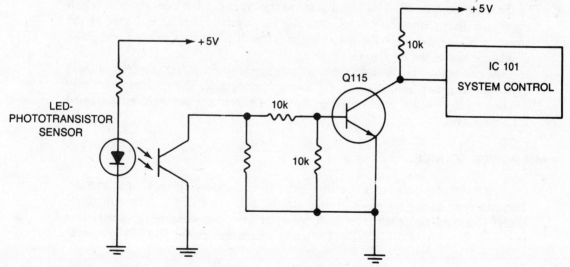

Fig. 8-16. Typical block diagram of an 8 mm take-up reel rotation detector.

is fed to an op amp (IC1001), and in turn to the system control IC to stop tape motion.

8 mm Clogged Head Detection. Sometimes, in record or standby mode, a clogged head will prevent record or play action. If magnetized dust from the tape fills up the tape gap, recording or playing cannot be done. Often, this occurs when the head runs on the tape surface in a humid or dewy condition. The clog detection indicator will come on to inform the operator that the tape head is clogged up.

8 mm Drum Phase Lock Detection. When the tape tension becomes high, or the tape sticks to the drum assembly, phase lock detection begins. The recording is stopped if abnormal recording or standby action is noted. The detection circuit sends a signal to the system control IC preventing record operations.

8 mm Drum Rotation Detection. The drum rotation detection occurs when the tape sticks to the drum at the beginning of the ejection operation. Tape jamming happens if the tape sticks to the drum during normal eject operation. A drum rotation signal is sent to the system control IC shutting down tape rotation.

8 mm Loading Motor Safety Detection. If the load on the mechanism becomes too great, or if the loading motor is broken, the loading motor should be turned off to prevent a broken drive circuit and excess current flow. A safety timing detection circuit prevents the above damage. The loading motor detection is done in unloading, loading, ready transition, and hold up or hold down modes.

8 MM SERVO CIRCUITS

The servo system consists of a drum-capstan sensor amplifier, drum-capstan servo, drum motor drive, and the capstan drive circuits (Fig. 8-17).

A sine wave signal from the drum coils (FG) is generated, amplified, and shaped by the drum amplifier IC. This signal is fed to the drum-capstan main servo IC which provides a signal to the drum motor drive IC. The capstan PG pulse is shaped by the amplifier (IC201) and fed to the drum/capstan servo IC. The capstan error and phase signals are tied to the capstan motor drive IC.

The drum motor is a 3-phase type, without any brushes. Direct current voltage is applied to the motor terminals from the motor drive circuits. The capstan motor may also be a 3-phase bi-directional brushless motor. Motor circuits and problems are found in Chapter 11.

8 MM POWER SOURCES

The 8 mm power source is operated with a Ni-Cad battery, dc pack, or ac adapter. The battery or ac adapter power source are 6V, 8.5V, or 10.5V dc. An unregulated battery source can be applied to the dc-dc converter and servo, while the regulated power source supplies +5 volts (Fig. 8-17). The power source is controlled by a CPU power IC.

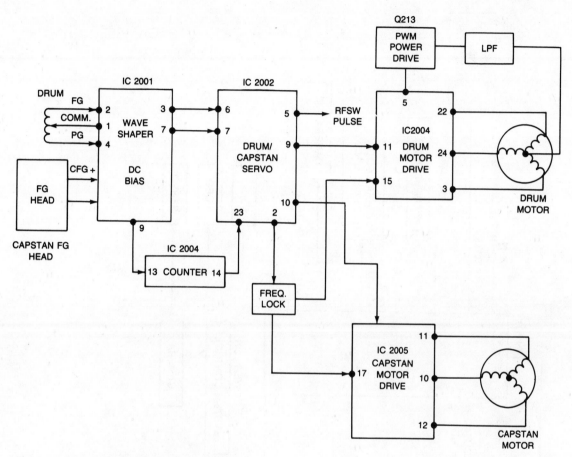

Fig. 8-17. Block diagram of an 8 mm servo circuit.

The dc-dc converter provides many dc voltages with an unregulated input voltage. The regulated 5V provides voltage to the audio, video, drum servo, and electronic viewfinder (EVF). The 16 to 20 volts goes to the CCD and camera circuits. Separate 5, 8, 9, and 12-volt sources also go to the camera section. The dc-dc converter circuits are found in Chapter 14.

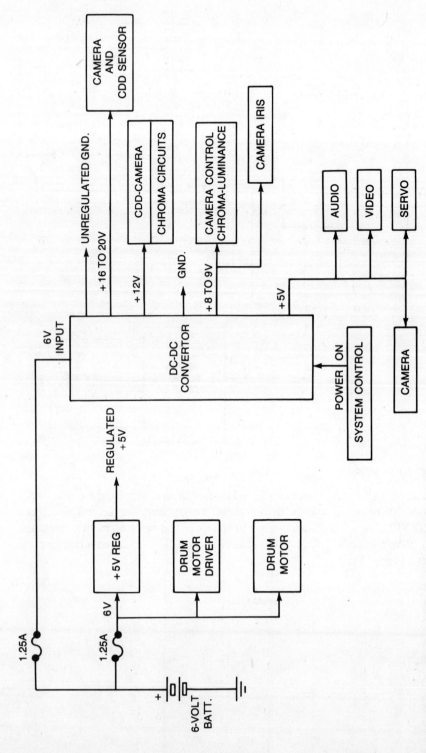

Fig. 8-18. Typical 8 mm block diagram of the power source.

9

Cover Panel and Component Removal

Before attempting to remove components from the camcorder, determine what must be disassembled before the defective part can be removed. Lay out the various parts, and if possible, have a service manual handy (Fig. 9-1). Many of the parts are easily taken off by removing a couple of screws, except in cases where several components must be removed before getting at the required part. Camcorders are crammed full of parts, and extreme care must be exercised in repairing the unit. Make sure the part is defective before removing it. A VHS disassembly flow chart, with the order of component removal is shown in Table 9-1.

Devise a system for laying out the different screws, nuts, bolts, and parts as they are removed. Evaluate the situation, then determine what parts must be removed. Often, you must remove more parts than estimated. Be careful not to lose or misplace the small screws. The different size screws are used in several locations. Most of the outside cabinet screws are round- or flat-head type, and of different lengths. Some are small phillips-head, and regular flat-blade screws. Use enough pressure on the screws so as not to let the screwdriver slip, scarring the head of the screw or bolt.

ELECTRONIC VIEWFINDER REMOVAL

In some VHS camcorders the electronic viewfinder is removed simply by releasing the lock-lever, and sliding it outward (Fig. 9-2). Remove the cable connecting the EVF

Fig. 9-1. Lay out the various screws on a chart or drawing when removing parts and components.

to the main camcorder. With smaller VHS-C cameras, several lids and covers have to be removed because the electronic viewfinder is fastened to the main cabinet. Remove the left case and cassette lid. Take off the front cover. Remove three screws holding the VCR section, and disconnect the EVF cable connector from the main body.

The grip cabinet or part of the case may contain the 8 mm electronic viewfinder. Remove the connector tying the EVF to the camera circuits. Release a slide-lock switch at the rear, and under the eyepiece, so the cabinet will come off. In other 8 mm camcorders several screws are removed to separate the EVF from the main camcorder case.

OPTICAL VIEWFINDER REMOVAL

Optical viewfinders were used in the early VHS, and in some small, inexpensive camcorders. The viewfinder may be attached to the top plastic cabinet (Fig. 9-3). Take

Table 9-1. Here is a disassembly flowchart.

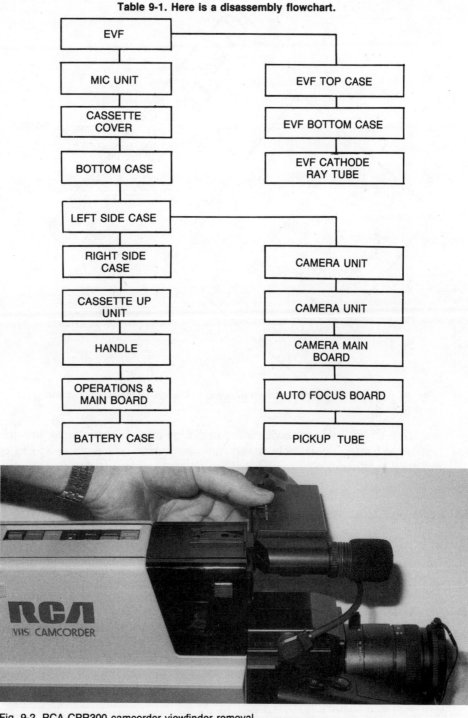

```
          EVF ─────────────────────────────┐
           │                               │
       MIC UNIT                      EVF TOP CASE
           │                               │
      CASSETTE                     EVF BOTTOM CASE
       COVER                               │
           │                          EVF CATHODE
     BOTTOM CASE                       RAY TUBE
           │
    LEFT SIDE CASE ───────────────────────┐
           │                              │
     RIGHT SIDE                      CAMERA UNIT
       CASE                               │
           │                         CAMERA UNIT
    CASSETTE UP                           │
       UNIT                         CAMERA MAIN
           │                          BOARD
       HANDLE                             │
           │                      AUTO FOCUS BOARD
   OPERATIONS &                           │
    MAIN BOARD                       PICKUP TUBE
           │
    BATTERY CASE
```

Fig. 9-2. RCA CPR300 camcorder viewfinder removal.

Fig. 9-3. The optical viewfinder is often mounted to the main top case with screws.

out the 6 screws holding the viewfinder to the top case. Do not attempt to repair the optical viewfinder, reassembly is very time consuming, and requires special optical adjusting equipment.

MICROPHONE UNIT REMOVAL

The early VHS cameras had the microphone unit held in position with a couple of screws. Slide the unit outward, away from the camera, and disconnect the microphone cord (Fig. 9-4). In other early camcorders, the microphone slides into a slot, and is locked into place.

Today, the microphone is easily removed because it is fastened to the same EVF section. Simply release the lock assembly, and slide the whole assembly away from the camcorder. Disconnect the cable connector on the body of the camera section (Fig. 9-5). Most 8 mm microphones slide off with the electronic viewfinder or are removed by taking out a couple of screws.

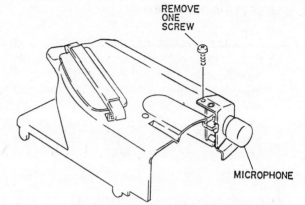

Fig. 9-4. Remove one screw to free the microphone on a VHS-C camcorder.
(Courtesy of Radio Shack)

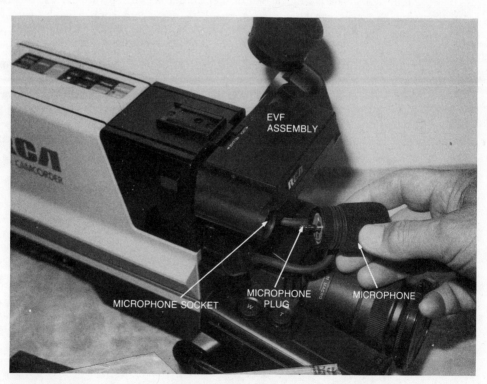

Fig. 9-5. Remove the microphone and pull out the cable connector to release the microphone assembly.

CASSETTE COVER REMOVAL

The cassette cover must be removed from some camcorders before you can clean up the tape heads and guide assemblies. In the RCA CPR300 model, two rubber strips must be pulled out to get at the small screws that hold the cover to the cassette loading assembly. On the 8 mm camcorder, the cassette cover is taken off by removing two small screws at the top of the cover. In other 8 mm camcorders the entire front piece must be removed. The smaller camera cassette covers are removed by taking the left plastic case off. The cover can be seen, and the two metal screws removed at each side of the cassette lid (Fig. 9-6).

LEFT AND RIGHT CASE REMOVAL

Often, the outside plastic case of the camcorder is two separate pieces. Before either case or panels can be removed, the EVF and microphone must be removed. Sometimes, the EVF unit mounted on top holds part of the case together. Remember there may be two different types of screws, of different lengths. Lay out a rough diagram of the camcorder body, and place the screws that come from the top and bottom on the drawing for easy replacement.

More screws must be removed from the left case of the smaller VHS-C camcorder after removing the EVF unit (Fig. 9-7). Disconnect any connections tied to the left side of the camcorder. The 8 mm camcorder may have a front and rear cabinet. Check all areas for outside screws holding the cases to the camcorder base unit. Remove both left and right cases in the same manner, if needed.

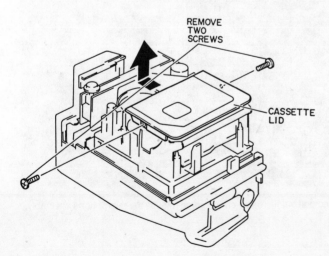

REMOVE
TWO
SCREWS

CASSETTE
LID

Fig. 9-6. Remove the two small screws to remove the cassette cover from the cassette transport assembly. (Courtesy of Radio Shack)

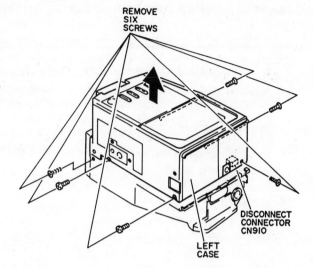

Fig. 9-7. Remove six screws to release the left case in a VHS-C camcorder. (Courtesy of Radio Shack)

FRONT COVER REMOVAL

After removing the left case in the VHS-C camcorder the front panel is removed. Check the bottom, top, and side areas for small screws holding the front cover to the metal framework (Fig. 9-8). Check for all cables or connectors that hold the front cover to the base unit. In the 8 mm camera the front cabinet or cover is held in place with two or three small metal screws. Be careful with the sliding door and locking plate during removal or replacement.

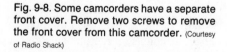
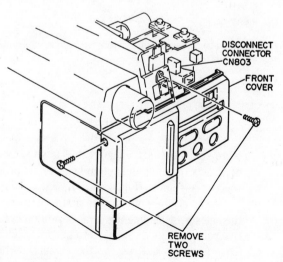

Fig. 9-8. Some camcorders have a separate front cover. Remove two screws to remove the front cover from this camcorder. (Courtesy of Radio Shack)

CASSETTE HOLDER AND VCR ASSEMBLY REMOVAL

After removing the side case panel, the cassette UP or holder can be removed. Six or more screws hold the loading assembly in the early VHS models. Remove any other components, like supply and take-up transistors from the assembly. The cassette holder should be in the down position during replacement.

Removing the four screws, one in each corner, lets the cassette arm assembly pull out of the 8 mm camcorder. Likewise, removing three or more screws lets the whole VCR section come loose in the VHS-C camcorder (Fig. 9-9). The left case, cassette lid, and front cover must be removed to get at the VCR section. Unplug any connectors or cords from the VCR section.

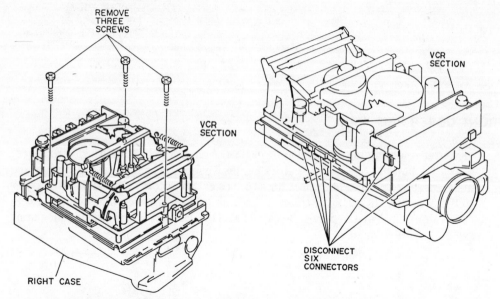

Fig. 9-9. Several screws and all the wire cable connectors must be removed, when removing the VCR section from the camcorder. (Courtesy of Radio Shack)

CAMERA SECTION REMOVAL

The camera section in the VHS camcorder is held to the main chassis by three or more screws on each side of the camera. Disconnect all connectors. Remove a couple of screws from the deflection board. The process board now can be removed from the process assembly (Fig. 9-10).

After all the components and panels are removed with the VCR section, remove the one screw holding the camera section in the VHS-C camcorder (Fig. 9-11). Remove two screws holding the camera section. Release the wires from the wire harness. Release one tab, and remove the camera section in the direction of the arrow.

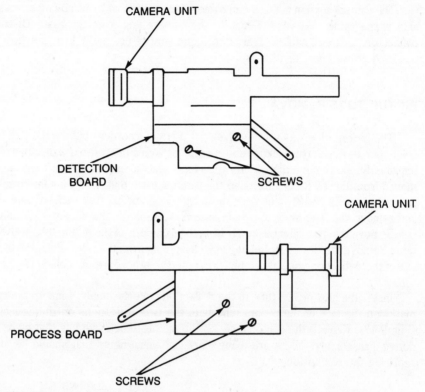

CAMERA UNIT

DETECTION
BOARD

SCREWS

CAMERA UNIT

PROCESS BOARD

SCREWS

Fig. 9-10. Remove four screws to free the camera unit in a VHS camcorder.

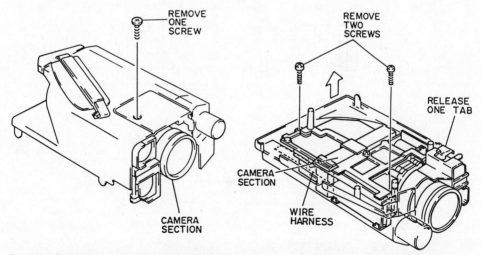

REMOVE
ONE
SCREW

REMOVE
TWO
SCREWS

RELEASE
ONE TAB

CAMERA
SECTION

CAMERA
SECTION

WIRE
HARNESS

Fig. 9-11. Removing screws from both sides of the camera section may be necessary before the camera can be removed from the main assembly.

The camera section in the 8 mm camcorder is removed by removing screws on each side of the camcorder case. Separate the camera unit from the case. Disconnect all connectors and wire cables. The black 7 mm screws are easily lost, so place them on the hand-drawn chart or in a cup.

VHS PICKUP TUBE REMOVAL

The pickup tube was used in the early VHS camcorders before the CCD or MOS solid-state devices. This pickup tube is easily broken if the camera is dropped or handled improperly. To remove the camera tube for replacement, the camera unit must be removed from the VCR unit. Remove the three screws that hold the camera tube to the camera unit (Fig. 9-12). Unsolder the target lead and the tube shield case. Unsolder and remove the lead or pickup tube assembly. Remove the socket assembly.

Remove the front filter assembly from the front area of the pickup tube with its locking tabs. Remove the tilt-screw holding yoke assembly from the tube. Push the pickup tube out of the deflection yoke assembly. Reverse the procedure to replace the new pickup tube.

Insert the new pickup tube in the deflection yoke assembly. Line up the two arrow marks on the face of the pickup tube with the two projections on the deflection yoke (Fig. 9-13). Replace the components on the picture tube assembly that were removed during disassembly. There are many electrical adjustments that should be made after replacing the pickup tube.

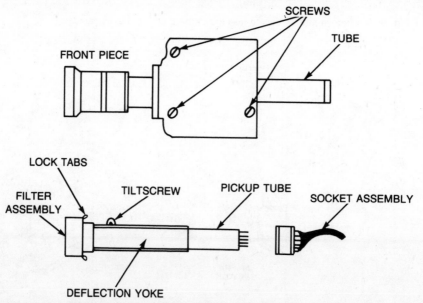

Fig. 9-12. Remove the pickup tube assembly from the camcorder, then remove the pickup tube from the front filter assembly and deflection yoke.

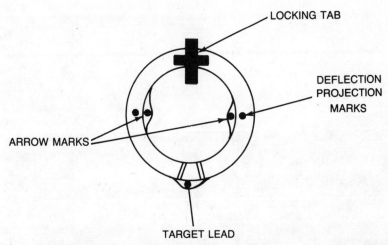

Fig. 9-13. Line up the arrows on the front of the pickup tube and deflection assembly before installation.

SOLID-STATE SENSOR BOARD REMOVAL

Often the solid-state MOS or CCD sensor is in a shielded assembly. The MOS device is located directly behind the lens assembly in the RCA CPR300 VHS camcorder (Fig. 9-14). The sensor assembly cannot be removed until the camera section is removed.

The solid-state sensor board in the VHS-C camcorder is removed after the camera section separates from the main camcorder body. Disconnect all connectors. Remove two or more screws that hold the camera circuit board holder. Remove the camera board from the process circuit and interface circuit boards. Remove one screw that holds the metal sensor shield (Fig. 9-15). Remove the two screws that hold the sensor circuit board to the front end of the camera section. The CCD unit in the 8 mm camcorder is in front of the metal shielded area of the main chassis.

AUDIO/CONTROL HEAD REMOVAL

Although the A/C head is located down inside the guide assemblies, it is fairly easy to remove. Make sure the head is defective by performing continuity and bias checks. First disconnect the cables to the head. Most of these unplug. The cassette holder and cover must be removed to get at the VCR assembly. Remove two or three screws that hold the head in the VHS-C chassis. Remove the A/C head from the A/C head base (Fig. 9-16).

Locate the position of the A/C head in the VHS cassette chassis. Remove the screws holding the head to the base area. There are two different adjustment screws found on the A/C head that should not be removed, they come off with the A/C head assembly. Disconnect the cable wires to the audio control head. The A/C head electrical adjustments should be made after replacement.

Fig. 9-14. The MOS device is located right behind the lens assembly on the RCA CPR300 camcorder.

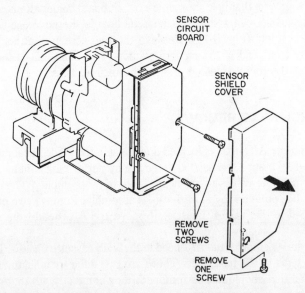

Fig. 9-15. Remove the screw that anchors the sensor shield, and the two mounting screws to get at the sensor circuit board.

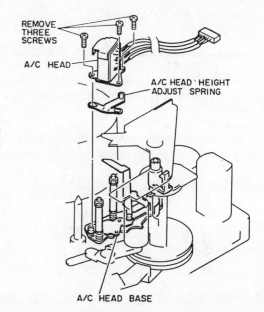

Fig. 9-16. Disconnect the A/C head cable wires and screws at the base of the head for quick removal. (Courtesy of Radio Shack)

FULL ERASE HEAD REMOVAL

The full erase head is usually located quite close to the head cylinder. The VCR cassette should be entirely open, because a chassis screw underneath must be removed to free the erase head. This head is held with two screws in some VHS chassis. Make sure the FE head is open or defective before removing it. Disconnect the connector to the head cable wires. The impedance roller assembly may hook into the FE head base assembly, it must be removed before the FE head is free (Fig. 9-17). Remove the one or two screws that hold the FE head to the main chassis.

Fig. 9-17. In some models the impedance roller must be removed before the FE head can be removed. (Courtesy of Radio Shack)

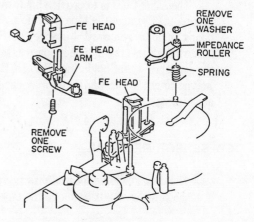

END SENSOR REMOVAL

The end sensor is close to the FE head in the tape path of the take-up reel assembly. Remove the one screw holding the end sensor (Fig. 9-18). Remove the end sensor cap. Unsolder the two points of the end sensor. The actual sensor device is located under a shielded cap on the metal bracket.

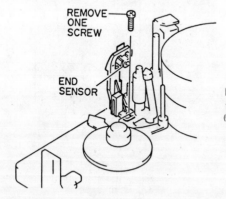

REMOVE ONE SCREW

END SENSOR

Fig. 9-18. Remove the screw to remove the end sensor.
(Courtesy of Radio Shack)

CASSETTE HOLDER SWITCH REMOVAL

The cassette holder switch is often mounted down inside the main VCR chassis. The cassette door and holder must be removed to get at the switch assembly. Unsolder the two switch wire connections. Remove the two screws that hold the switch in position. Remove the control rod. Pick up the switch, out of the chassis area. Replace the switch by reversing these procedures.

END LED REMOVAL

The END LED is to provide light, to indicate when the end of the tape is near during recording. Remove the tape transport mechanism. Sometimes, the flywheel FG circuit board must be removed, because the END LED is underneath it. Remove the three screws that hold the flywheel board assembly. Disconnect the wire connector. Remove the one screw that holds the END LED (Fig. 9-19). If the flywheel board must be removed to get at the LED, you may have to perform flywheel FG circuit board position adjustment.

DEW SENSOR REMOVAL

The dew sensor is located down on the metal base chassis, or sticks upward in the mechanism (Fig. 9-20). Remove the tape transport mechanism to get at the dew sensor.

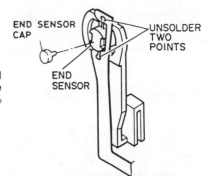

Fig. 9-19. Remove the screw holding the end sensor, and unsoloder it in two places to remove the sensor from this VHS-C model. (Courtesy of Radio Shack)

Fig. 9-20. The finger points to the dew sensor down on the base of the cassette transport assembly.

The END LED may have to be removed from some chassis before the sensor can be removed. Disconnect the connector wires (Fig. 9-21). Remove the screw that holds the dew sensor to the chassis. Reverse these procedures in replacing the new dew sensor.

SAFETY TAB SWITCH REMOVAL

Remove the cassette cover and holder assembly. Unsolder two points at the bottom of the safety tab switch. These two contact points are found underneath the switch

assembly (Fig. 9-22). Remove the screw holding the safety tab switch assembly to the main VCR chassis. The safety tab switch in the VHS-C and 8 mm cassette assembly is to prevent accidental erasure of the previous recording.

FLYWHEEL CIRCUITBOARD REMOVAL

Remove the tape transport mechanism in the VHS-C chassis. Unsolder six places on the flywheel FG circuitboard (Fig. 9-23). Remove the three screws holding the flywheel FG circuitboard. Disconnect connectors and cables. Flywheel circuitboard position adjustment should be made after replacing the board.

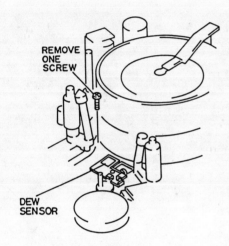

Fig. 9-21. Remove one screw to let the dew sensor free on a VHS-C camcorder. (Courtesy of Radio Shack)

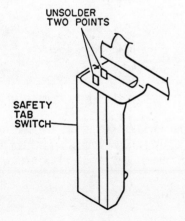

Fig. 9-22. Unsolder two terminals under the chassis before removing the tab switch.
(Courtesy of Radio Shack)

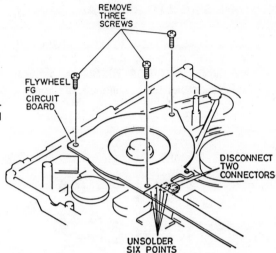

Fig. 9-23. Unsolder six places and remove 3 metal screws to remove the flywheel FG circuitboard assembly. (Courtesy of Radio Shack)

SUPPLY REEL SENSOR AND TAKE-UP SENSOR REMOVAL

Remove the tape transport mechanism from the VHS-C chassis. Unsolder four points or places on the supply reel sensor (Fig. 9-24). Remove the screw holding the supply reel sensor. Unsolder four places on the take-up reel sensor. Remove the screw holding the take-up reel sensor. The take-up reel LED and phototransistor are located on the bottom side of the 8 mm take-up reel assembly.

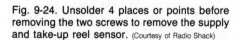

Fig. 9-24. Unsolder 4 places or points before removing the two screws to remove the supply and take-up reel sensor. (Courtesy of Radio Shack)

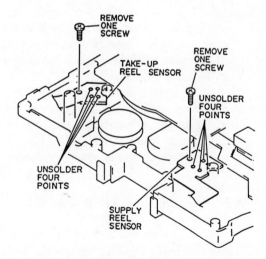

IMPEDANCE ROLLER REMOVAL

Remove the cassette holder to get at the impedance roller assembly. Remove the top washer of the impedance roller. Remove the spring between the impedance roller and the chassis (Fig. 9-25). Pull the impedance roller up. The impedance roller is near the cylinder head. Readjustment of the roller assembly may be necessary if tape curling occurs.

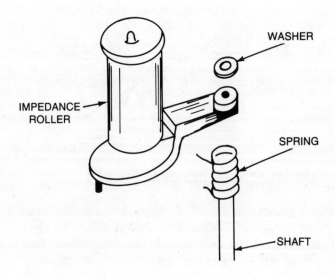

Fig. 9-25. Remove the small washer at the top of the impedance roller. Be careful not to lose the small spring when removing the impedance roller.

GUIDE ROLLER REMOVAL

The VHS guide rollers are held in position with a hex screw at the bottom of the guide assembly. These guide rollers are adjusted with height fixture adjustment plates. After replacement the height is adjusted with the screw or nut-driver at the top of the guide roller assembly.

The supply guide roller of the VHS-C cassette transport is removed by taking out one hex screw at the bottom of assembly (Fig. 9-26). The guide roller may be turned with a hexagon wrench to remove the guide roller from the guide roller base. Realignment of the guide rollers is done with a blank tape, and visually inspecting the tape path for signs of tape curling at any guide post.

TAKE-UP GUIDE ROLLER REMOVAL

Remove the cassette holder. Remove the screw holding the take-up guide roller. Turn the upper section of the guide roller using a hexagonal wrench to remove the guide roller from the take-up guide roller base in a VHS-C cassette transport assembly (Fig. 9-27).

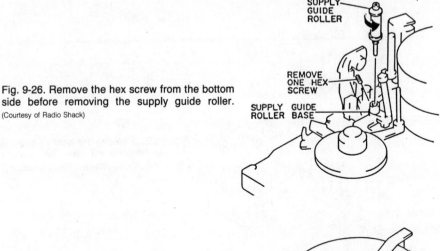

Fig. 9-26. Remove the hex screw from the bottom side before removing the supply guide roller.
(Courtesy of Radio Shack)

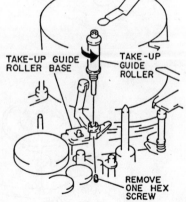

Fig. 9-27. Remove one hex screw at the bottom to free the take-up guide roller base component.
(Courtesy of Radio Shack.

PRESSURE ROLLER REMOVAL

Remove the cassette housing or holder. In some models remove the middle pole stopper. Remove the E-ring or "C" washer holding the pinch or pressure roller. An E-ring is used on some models to hold the pressure roller assembly to the base area (Fig. 9-28). Be careful not to lose the E-rings or small pressure spring.

SUPPLY REEL ASSEMBLY REMOVAL

Remove the cassette holder or housing to get at the supply reel disk. Remove the washer at the top and pull out the supply reel disk from the chassis. Note if there is a washer at the bottom of the supply reel in the VHS-C transport (Fig. 9-29). Remove

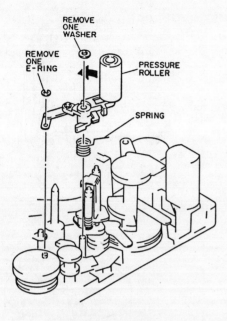

Fig. 9-28. Remove the washer and one E-ring to remove the pressure roller. Be careful not to lose the small spring. (Courtesy of Radio Shack)

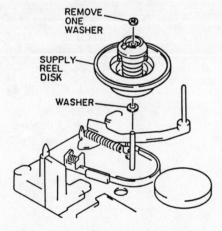

Fig. 9-29. Remove the washer at the top of the supply reel disk so the reel can be pulled off. Do not lose the small space washers underneath the supply reel. (Courtesy of Radio Shack)

the take-up reel in the very same manner. Readjust both reel disks to the same level from the chassis.

The take-up and supply reels in the 8 mm camcorder are moved in the very same manner. The capstan motor drives the reels through a conversion gear, timing belt, relay pulley, and pendulum gear. Both supply and take-up reel disks are driven by one pendulum gear assembly.

TAKE-UP GEAR, TAKE-UP REEL GEAR REMOVAL

Remove the cassette holder or housing. Remove the washer and pull out the take-up reel gear and pressure roller arm gear from the chassis in a VHS-C tape transport (Fig. 9-30). Remove the other washer and pull out the take-up gear assembly.

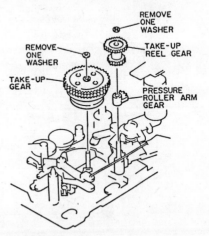

Fig. 9-30. Remove each washer from the top of the take-up gear and take-up reel gear. (Courtesy of Radio Shack)

SUPPLY GEAR AND SUPPLY SUB-GEAR REMOVAL

Remove the cassette holder or housing. Remove the supply reel disk assembly. Remove the washer at the top of the supply gear (Fig. 9-31). Remove the washer holding the sub-gear. Pull out the supply gear and supply sub-gear from the chassis. Replace the new gears in reverse order. Apply proper grease and a drop of light oil to the gear bearing pins.

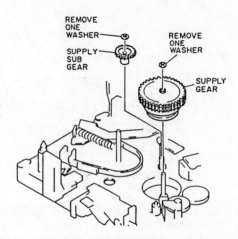

Fig. 9-31. Remove a washer at the top of the supply gear and supply sub-gear before they can be removed. (Courtesy of Radio Shack)

REEL DRIVE IDLER REMOVAL

Remove the cassette housing or holder. Remove the spring between the reel drive idler and the chassis (Fig. 9-32). Be careful not to lose the small spring. Remove the top washer and pull out the reel drive idler gear assembly.

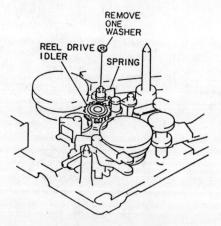

Fig. 9-32. Remove one washer at the top of the reel drive idler assembly for quick removal.
(Courtesy of Radio Shack)

CAPSTAN FLYWHEEL REMOVAL

Remove the entire tape transport mechanism. Remove the cassette holder or housing. Remove the FG circuitboard in the VHS-C camcorder. Remove the mechanism pressure switch assembly. Take out the pressure roller. Remove the A/C head arm. Remove the pressure roller arm, and then remove the three screws holding the capstan flywheel (Fig. 9-33). Finally, remove the capstan and pulley belts. Pull the capstan/flywheel assembly out of the bearing.

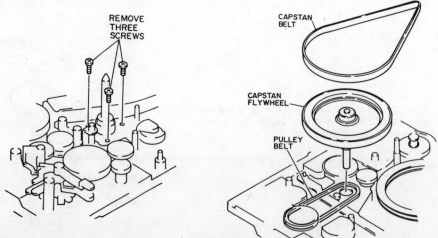

Fig. 9-33. Remove three screws and the capstan belt so the flywheel can be removed.
(Courtesy of Radio Shack)

CENTER PULLEY REMOVAL

Remove the tape transport mechanism. Remove the pulley belt. Take out one or two screws that hold the center pulley in the chassis, in other VHS-C cassette transports, remove the top washer and pull the center pulley up (Fig. 9-34).

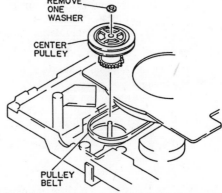

Fig. 9-34. Remove the washer to pull off the center pulley assembly. (Courtesy of Radio Shack)

SUPPLY GUIDE ROLLER BASE REMOVAL

Remove the tape transport mechanism to get at the cassette parts. Remove the cassette housing or holder. You may find the cylinder motor drive circuit has to be removed in some models. Remove the V-stopper block (Fig. 9-35). Take out the screw holding the supply guide roller base and plate spring. Remove the supply roller base in the direction of the arrow. Be careful not to lose the leaf spring located under the roller base plate assembly.

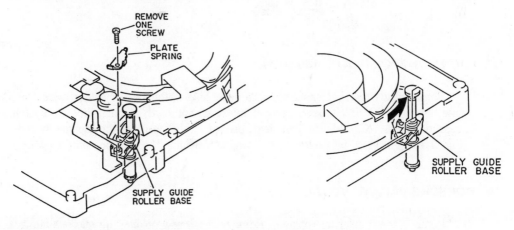

Fig. 9-35. Remove the supply guide roller in two easy steps. (Courtesy of Radio Shack)

TAKE-UP GUIDE ROLLER BASE REMOVAL

Remove the tape transport mechanism. Remove the cassette holder (Fig. 9-36). Remove the flywheel FG circuitboard. Take out the mechanism state switch. Remove the pressure roller. Remove the A/C head arm. Take out the cam gear. Remove the pressure roller arm. Take off the capstan flywheel. Remove the screw holding the take-up roller base and place spring.

In other VHS-C camcorders remove the cassette holder, the lower cylinder, wire clamp plate, the cylinder motor drive circuitboard, flywheel FG circuitboard and the capstan flywheel to get at the take-up guide roller base assembly. Remove the screw holding the take-up guide roller base. Be careful not to lose the leaf springs located under the roller base plate.

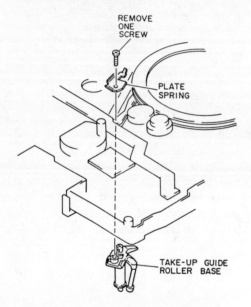

REMOVE
ONE
SCREW

PLATE
SPRING

TAKE-UP GUIDE
ROLLER BASE

Fig. 9-36. Remove the screw holding the take-up guide roller base from the cassette transport chassis. (Courtesy of Radio Shack)

TENSION CONTROL PLATE REMOVAL

Remove the cassette transport and cassette holder, the lower cylinder, wire clamp plate, flywheel FG circuitboard, cylinder motor circuitboard, mechanism slate switch, pressure roller, A/C head arm, cam gear, pressure roller arm and the capstan flywheel (Fig. 9-37). Finish up by removing two washers holding the tension control plate.

MICROPHONE JACK REMOVAL

Remove the regular microphone. Remove the screw holding the microphone jack circuitboard (Fig. 9-38). Unsolder the microphone jack from the circuitboard to install

a new one. In some camcorders the external microphone jack is located behind the large microphone assembly.

Fig. 9-37. Remove the two small washers on the top side of the tension plate for easy removal.

Fig. 9-38. Remove the screw holding the microphone jack board to a VHS-C camcorder. Unsolder the microphone jack from the board assembly. (Courtesy of Radio Shack.)

CAPSTAN MOTOR REMOVAL

Locate the capstan motor on the cassette transport assembly, after removing the tape transport mechanism. Move the middle pole lever out of the way in some models. Remove the capstan belt from the capstan motor. Usually, two small screws are holding the capstan motor to the transport chassis. Disconnect the plug and cables to the motor assembly.

LOADING MOTOR REMOVAL

The loading motor is found in one corner of the cassette transport mechanism. Disconnect the wire connector from the base area. Remove the three screws holding

the loading motor to the transport base assembly (Fig. 9-39). In some models the loading motor drives a gear or belt assembly to load and unload the cassette.

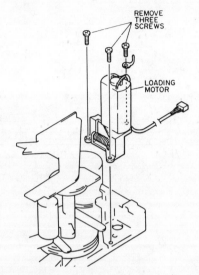

Fig. 9-39. Remove three screws to remove the loading motor assembly from the cassette chassis.
(Courtesy of Radio Shack)

FOCUS MOTOR REMOVAL

Remove the lens block assembly. Remove the screw and open the auto-focus circuitboard in the direction of the arrow (Fig. 9-40). Disconnect the connector and motor cable. Remove the two screws holding the focus motor to the lens block assembly. Reverse the procedure to replace the new focus motor.

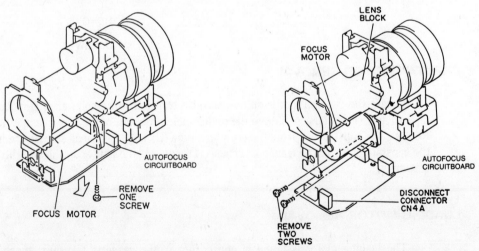

Fig. 9-40. Remove the auto-focus circuitboard and the two screws holding the auto-focus motor to the lens assembly. (Courtesy of Radio Shack)

ZOOM MOTOR REMOVAL

Remove the lens block assembly. Remove the two screws holding the zoom motor (Fig. 9-41). The zoom motor has a gear at the end to drive the zoom lens assembly.

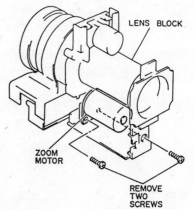

Fig. 9-41. Remove two screws holding the zoom motor to the lens block assembly.

(Courtesy of Radio Shack)

10

Separate Component Checks

No response from the indicator lights may mean a malfunction in the camcorder or a defective indicator. There are many sensors, indicators, and switches that may fail after many hours of use. Sometimes these components are bumped or broken, if the camcorder accidentally takes a fall. You may be able to repair these functions, just in knowing how they operate, performing tests and knowing how to replace them.

VIEWFINDER LEDs AND LAMPS

The LED indicators are located inside the camcorder case. Removing both rear and front plastic panels uncovers a lot of indicator lamps and components (Fig. 10-1). Each LED indicator operates with a particular switch or part function. These same LED indicators are found on the camera without the electronic viewfinder.

Battery Alarm LED. The red battery LED may begin flashing when the battery is getting weak for camcorder operation. Usually, the instrument is placed in record/pause or stop mode. If the camcorder will not operate with the battery alarm LED flashing, check for a low battery. The battery must be recharged. In some viewfinders the fully charged battery is indicated "E-F". If the LED does not flash with a weak battery, suspect a defective battery alarm circuit or LED. Check the voltage at the LED terminals. The LED can be checked with the diode test of the DMM (Fig. 10-2).

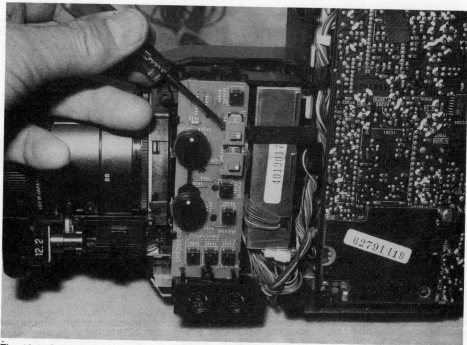

Fig. 10-1. Camcorder indicators and switches are shown with the cover removed.

Fig. 10-2. Block diagram of viewfinder, battery, standby, record, run, and tape-end LED connections.

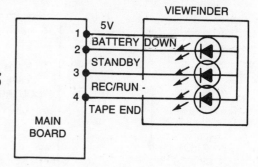

Dew Indicator. The dew light will flash constantly when the camcorder is turned on, but does not operate, this means excessive moisture near the tape heads. The dew sensor is located right on the main chassis in the VCR section (Fig. 10-3). As moisture increases, the resistance of the dew sensor increases, and the voltage applied to the trouble detection IC increases. Clipping a 1k-ohm resistor across the dew sensor should make the circuit operative, and indicate the dew sensor circuit is working. Quite often the dew sensor can be removed by taking out one screw.

Eject LED. When the eject button is pressed, the cassette lid or cover should open with the light lit. Sometimes this assembly is slow loading and unloading. Do not push

Fig. 10-3. Dew sensor located on the main VCR chassis.

the cover to load it, if it is operated by motor. Often the eject switch is connected directly to the power supply distribution IC (Fig. 10-4). Check the eject switch contacts with the ohmmeter, if the switch is erratic or intermittent with the power disconnected.

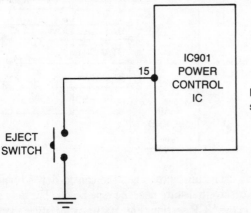

Fig. 10-4. Block diagram of the eject switch connections.

Loading LED. The loading LED will come on while loading is in progress. This LED is not found in some camcorders. Check the voltage across the LED. Replace the LED if normal voltage is found across the terminals.

Power On LED. The red power light will come on when the power switch is on. In some cameras, if a cassette is not loaded, the power light will come on briefly and then

power off. The power switch and LED operate into the control IC (Fig. 10-5). Suspect a defective power switch or control IC when the power switch is turned on and nothing happens. Check the voltage at the power switch terminals. If the power is on with no indicator light, check the voltage across the power LED.

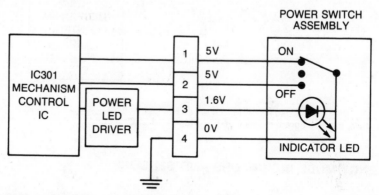

Fig. 10-5. Block diagram of the power-on switch assembly.

Record Stand-By LED. The recording stand-by LED will be on during recording stand-by, with a loaded cassette. If the standby LED does not come on, suspect a defective LED or voltage from the mechanism control IC. Measure the voltage across the standby LED (Fig. 10-6). Normal voltage indicates a defective LED.

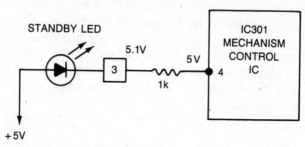

Fig. 10-6. Circuit diagram of the standby LED circuit.

Recording LED. The green recording LED lights at the beginning of the recording process. The light will flash when the tape end of a recording is finished from the tape end alarm circuits (Fig. 10-7). The run recording tape end LED can be operated directly from the mechanism IC. Check the voltage across the record LED to determine if the LED or the circuit is defective.

Rec-Pause LED. The record-pause LED may be the same as the standby-record mode.

Tape End LED. The tape end LED will light when the tape is close to the end of the recording. In some units the end of tape in SP mode is 2 to 3 minutes, and the EP mode

is 2 to 3 minutes and 20 seconds. The tape end LED may be the same LED as the Rec-Run LED. The tape end sensor assembly is found in the emergency indicators.

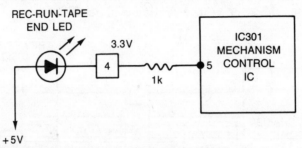

Fig. 10-7. Block diagram of the Rec-Run, tape-end LED circuit.

EMERGENCY MODE INDICATORS AND SENSORS

The emergency mode indicators and sensors are provided to prevent damage to the instrument in the event failure occurs. The different sensors are fed into a system control microprocessor which shuts down the camcorder. The emergency indicators can be found in the EVF.

Supply End and Lamp Sensor. When the tape reaches its end, while moving forward in fast-forward, play, or forward search modes, the clear end of the tape indicates through a LED lamp and supply sensor (Fig. 10-8). The supply end sensor supplies voltage to the comparator and mechanism control IC. When detected it enters the stop mode.

The supply end sensor assembly is not operating if excess tape is found wrapped around in the VCR section. The supply end sensor is located in the tape path, and can be removed with the removal of one or two mounting screws (Fig. 10-9). Check the voltage across the end sensor LED. Measure the voltage applied to the photocell supply end sensor assembly.

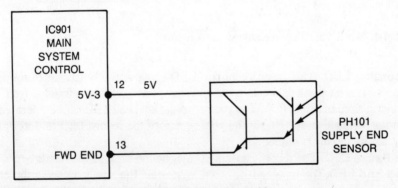

Fig. 10-8. Block diagram of the supply end sensor assembly.

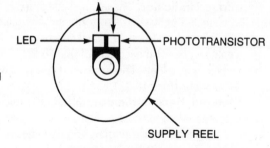

Fig. 10-9. Location of the supply-end reel sensor assembly.

BOTTOM VIEW

Supply Reel Sensor. The supply reel sensor detects reel pulses from rotation of the supply reel. This operation of detection may show up in the EVF screen display. The supply reel sensor is attached to the bottom of the supply reel assembly. Check the voltage across the diode terminals 5 and 6 of PG 901. Note that in this model the supply and take-up LED's are in series with the B+ voltage source (Fig. 10-10). No voltage indicates a defective control IC or circuit, and normal voltage without the supply reel sensor indicates the LED is open.

The photo LED section can be checked with the diode test of the DMM. Check the photo-transistor section in the same manner.

Take-Up Reel Sensor. The take-up reel sensor is fastened to the bottom of the take-up reel assembly. The supply reel pulse signal is used to produce a tape counter display, and warn of the end of the tape on the EVF. If the take-up reel is erratic, intermittent, or stops, the tape stops immediately. Check the take-up reel with the same methods as the supply reel sensor (Refer to Fig. 10-10).

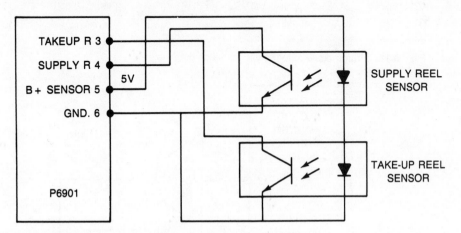

Fig. 10-10. Block diagram of the supply and take-up reel sensors.

Infrared Indicator. The infrared unit found in the camera is used in the auto-focus system to bounce a light signal from the subject, and bring the camera automatically in focus. The infrared diode can be checked like any diode, with the diode test of the DMM. Take a voltage check on each side of the diode to common ground, to determine if the correct voltage is present. The infrared diode is driven by a transistor with a signal from the AF module (Fig. 10-11).

Clogged Head Indicator. In some camcorders a clogged head detection system indicates when excessive dust has clogged up the tape head gap. When it's too great neither playing nor recording can be done. A caution indicator light comes on when this occurs (Fig. 10-12).

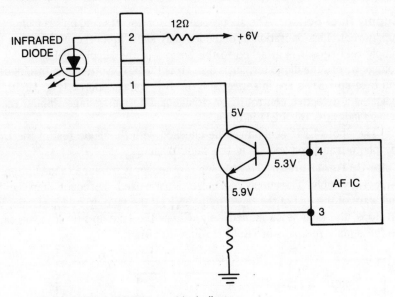

Fig. 10-11. Infrared diode automatic focus block diagram.

Fig. 10-12. Block diagram of the clogged head indicator.

CRITICAL SWITCHES

The key input function switches consist of rewind, reset, play, display, pause, stop, reverse, and fast-forward. The start/stop, VCR-camera, and speed switches work directly from the system control or mechanism control IC. The mechanism or mode switch applies signals to the system control microprocessor. The indentation at the rear of the cassette touches the tab switch, sensing when the cassette can be recorded.

Mechanism Switch. The mechanism or mode switch applies signals to the system control IC. One signal is placed when the unloading condition is ended, placing the camcorder in stop mode. The mechanism state switch also inputs mode signals to the system control to indicate the state of the mechanism. The mechanism state control switches can be checked with a low ohmmeter measurement across the switch contacts, with the power removed (Fig. 10-13). Check for voltage at each switch terminal with the power on and the mechanism state switch off.

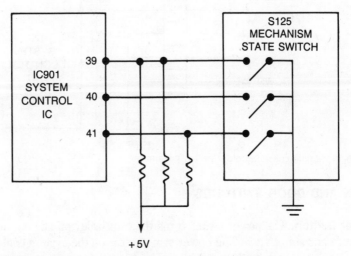

Fig. 10-13. Block diagram of the mechanism state switch assembly.

Safety Tab Switch. The safety tab switch indicates when the cassette may be recorded, to prevent accidental erasure of a recorded cassette. With no tab in position, the switch closes and lets the cassette be recorded on (Fig. 10-14). Terminal 9 of IC 901 is grounded when the tab switch is closed. Always, check the tab switch setting when the camcorder refuses to record. Check the tab switch (in the camcorder) continuity with the ohmmeter.

Cassette Holder Switch. The cassette holder switch indicates when the cassette is up or down. If the cassette is up, the system goes into stop mode. Switch continuity can be checked with the low range of the ohmmeter. There are two switches in some models (Fig. 10-15). Often, the cassette switch assembly is mounted at the bottom chassis side of the cassette holder assembly.

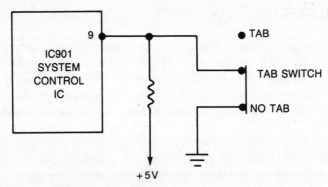

Fig. 10-14. Simple block diagram of the tab switch.

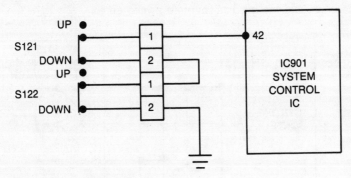

Fig. 10-15. Simple cassette holder switch assembly.

FUNCTION AND DOOR SWITCHES

Power Switch. The power switch turns the camcorder off and on, and is referred to as a start and stop switch. The power switch turns on the system control IC processor (Fig. 10-16). The power indicator light comes on when power is applied to the camcorder.

Eject Switch. The eject switch is usually found on the function switch assembly. The eject switch works in conjunction with the eject LED. A voltage is applied to the control system when the eject switch is pushed or grounded (Fig. 10-17). Intermittent or erratic eject operation is caused by a dirty or worn eject switch.

VCR-Cam Switch. The VCR or camera switch places either one in operation mode. Actually, the VCR-Cam switch grounds pin 11 of the system control IC when it is turned to camera operation (Fig. 10-18). Check the switch with a low ohmmeter continuity from ground to one side of the switch as you push it back and forth with the power off.

EP/SP. Slow and standard play speeds are selected with the EP/SP switch. This switch grounds out terminal 63 of the system control IC in SP mode (Fig. 10-19). A low voltage measurement should be taken from the switch terminals in EP mode.

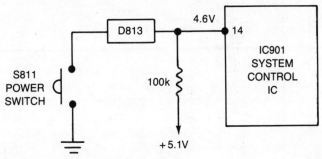

Fig. 10-16. Block diagram of the power switch assembly.

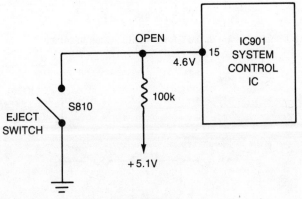

Fig. 10-17. Block diagram of the eject switch assembly.

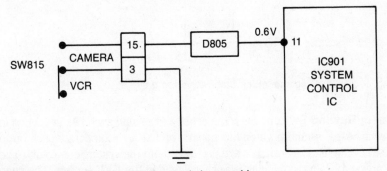

Fig. 10-18. Block diagram of the VCR-Cam switch assembly.

Start-Stop Rec Switch. The start /stop/record switch grounds pin 8 of the system control IC. A positive voltage is fed to rec sw terminal 8. Check the switch contacts with the switch pressed using continuity ohmmeter tests. Measure the voltage at the high side of the switch with the switch open (Fig. 10-20).

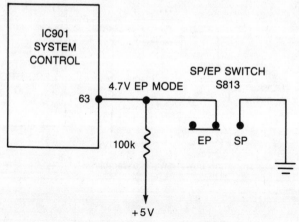

Fig. 10-19. Block diagram of the SP/EP mode switch assembly.

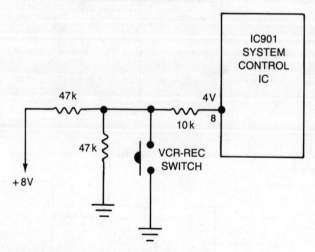

Fig. 10-20. Block diagram of the Start/Stop/Record switch.

Reset/Rewind Switch. Both the reset and rewind switches are found in the function switch board assembly. Often functional switches are momentary push-button types (Fig. 10-21). The function switches are tied directly to the system control IC. The reset switch is pressed when the counter is not displayed in the EVF screen. The rewind or review switch operates during a recording pause. The rewind enters into reverse VCR operation, and in some units goes right into normal play mode when the reversing procedure is completed.

FFWD/REW Switch. When either the fast-forward or rewind switch is pressed during play mode, forward or reverse search is entered. Pressing the play switch resumes the play. Refer to Fig. 10-21.

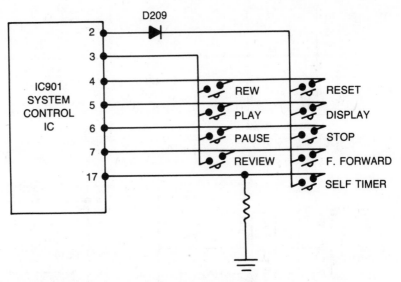

Fig. 10-21. Block diagram of the function switch input switches.

Review Switch. Normally, the review switch operates during recording pause. The scenes are reviewed after the cassette is reversed, and in play mode.

Play and Display Switch. In play mode the VCR section is playing back the recorded cassette. Both switches are found in the key matrix circuit in the VHS and VHS-C camcorders.

Self-Timer Switch. Some camcorders have a timing switch that is used only in the camera mode. The unit starts to record when it is pressed once. When it is pressed twice, the timer switch starts to record after a few seconds delay, and continues until the tape is completed or stopped. When pressed a third time the self-timer mode is released. Refer to Fig. 10-21.

MISCELLANEOUS CAMCORDER SWITCHES

All camcorder switches are checked in the same manner, with the low-ohm continuity test.

Close-up Switch. The close-up switch is used when shooting subjects within 2 feet of the camcorder. This close-up switch can be found on low priced units (Fig. 10-22).

Zoom Switch. The zoom switch has two positions, telephoto and wide. The zoom switch may connect to a switch driver IC that provides voltage to the zoom motor terminals (Fig. 10-23). Telephoto is for far away shots, and wide angle is for close picture taking.

Lens Door and C-In Switch. These two switches are wired in series and connect to the system control IC (Fig. 10-24). When the lens door is closed the lens switch is open, and the lens switch is closed when the lens door is open in some 8 mm models. The lens door switch is located in the camera section.

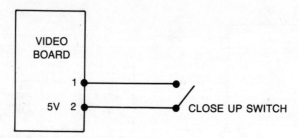

Fig. 10-22. Block diagram of the close-up switch.

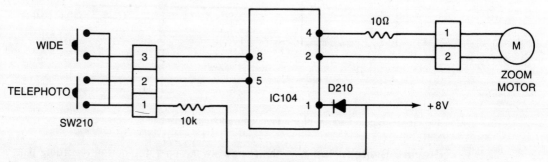

Fig. 10-23. Block diagram of the zoom motor switch assembly.

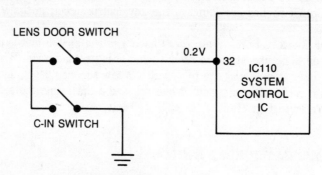

Fig. 10-24. Lens door switch block diagram.

Sepia Switch. The sepia switch is found in some models of the 8 mm camcorder. When sepia switch SW22 is turned on, Q201 is turned on (Fig. 10-25). The sepia high (H) signal is applied to the matrix module to generate the sepia signal.

CCD Switch. You will find a CCD switch in some camcorders. The switch ties to the system control IC in the servo section (Fig. 10-26). Check the voltage at the switch and at pin 20 (+ 5V).

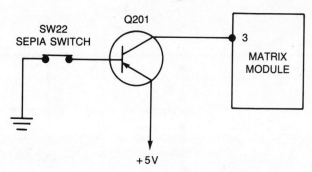

Fig. 10-25. Block diagram of the sepia color switch found in some 8 mm cameras.

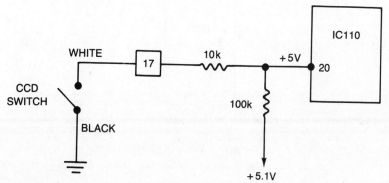

Fig. 10-26. Block diagram of the CCD switch found in some 8 mm camcorders.

MISCELLANEOUS COMPONENT CHECKS

Many electronic components can be checked in minutes with the VOM or DMM. A few are the battery connections, external battery jack, earphone jack, fuses, and microphone connections.

Checking Fuses. When nothing lights up on the camcorder, suspect a blown fuse. If the camcorder quits or will not operate with the ac adapter charger unit, look for the low amp fuses. There may be up to three fuses in the ac adapter (Fig. 10-27). Remove and check each fuse with the low range ohmmeter ($R \times 10$). You should have a direct short across the fuse if it is normal.

Fuses can vary from 1.2 to 3 amps. The line fuse can vary from 1.2 to 2 amps at 250 V. The charger adapter chemical fuse can vary from 2 to 3 amps at 102 ° C to 126 ° C.

In the camcorder, the power block diagram may show one or two fuses (Fig. 10-28). Often, these fuses have a 1.25 amp to 2 amp rating. Replace these with the exact same amperage as the original fuse. Look at the end of the fuse for correct amperage. Do not bypass the fuse with a small wire or tin foil. If the fuse keeps blowing out, check and see if there is a short on that dc line. Always have a spare fuse on hand.

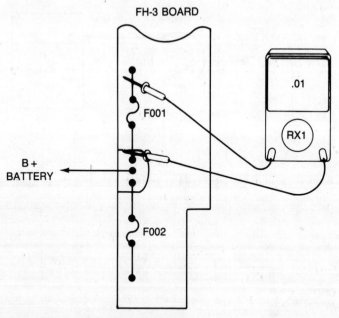

Fig. 10-27. How to check fuses with the ohmmeter.

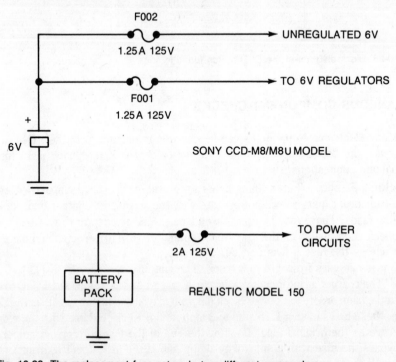

Fig. 10-28. The replacement fuse set-up in two different camcorders.

Battery Terminals. Broken or poor condition battery terminals can result in intermittent or no camcorder operation. Inspect battery terminals each time the batteries are replaced. Keep slip-on type battery contacts clean at all times. Clean them up with alcohol and cloth. Avoid dropping the small battery pack.

External Battery Jack. Often, the external battery jack is a self-shorting type input (Fig. 10-29). The regular battery connections are switched out of the circuit when the battery jack or charger/adapter is plugged into the external jack. If the camcorder plays with the regular battery, and not with the power plugged into the external jack, check the battery pack or charger output voltage.

Next, inspect the external jack for poor contacts and wire connections. Sometimes these small wires break right off at the jack terminals. Inspect the male plug for broken or torn cable connections. If the battery pack operates and the regular battery does not, after the battery pack or adapter is removed, suspect a shorting terminal inside the jack. Spray the inside of the jack with cleaning fluid, and work the male plug back and forth to clean up the contacts. Replace the external jack if it cannot be cleaned up or repaired.

Earphone Jack. An external earphone jack is found in some camcorders to monitor the sound during recording, playback, or while in monitor mode (Fig. 10-30). The impedance may be up to 600 ohms. Intermittent sound from the earphones may be caused by a poor cable or jack on the earphones. Sometimes the earphone cord will break right at the male plug or at the base of the earphone. Check out the continuity of earphone cables with the low ohmmeter scale.

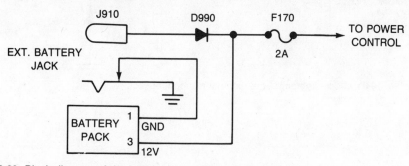

Fig. 10-29. Block diagram of the exterior battery jack connections.

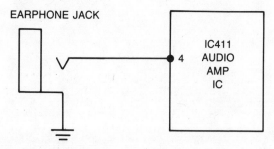

Fig. 10-30. Typical earphone jack connections.

Inspect the earphone jack for poor connections or bad seating. Clean up the contacts by spraying cleaning fluid down inside the earphone jack. Clean off the male phone jack with cleaning fluid and cloth. Check the earphone jack for a broken plastic support.

Remote Control Jack. The remote control jack is built-in in some camcorders. Usually, the control jack is mounted on the front of the camcorder. Inspect and clean it up like the earphone jack. Do not overlook the remote control cable for intermittent or no operation.

External Microphone Jack. When the external microphone is used, the built-in microphone is cut out of the input circuit (Fig. 10-31). External bias voltage is applied to the microphone from the recording circuits. Check the external jack connections when the internal microphone operates, and the external microphone does not. If the internal microphone does not operate after using the external one, suspect a shorting contact. Clean up the inside shorting terminals with cleaning spray.

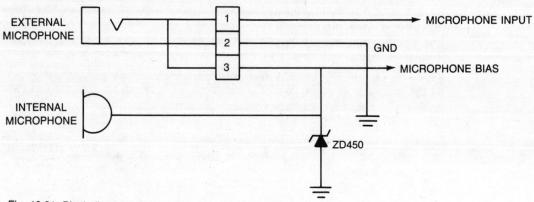

Fig. 10-31. Block diagram of the external microphone jack.

11

Motor Operations
and Problems

The drum or cylinder capstan, loading, auto focus, iris, and zoom motors are found in the large VHS cameras. Some 8 mm camcorders have only the drum, capstan, and loading motor. The drum and capstan motors may require complicated servo and drive circuits, while the loading and focus motors are simple dc motors (Fig. 11-1).

A defective motor can be checked with continuity ohmmeter tests, voltage measurements, and external voltage applied to the motor terminals. Simple ohmmeter continuity tests can be made with the low-ohm range of the VOM or DMM. Check the applied voltage across the motor terminals from dc or power IC driver circuits. Apply external voltage to the suspected motor with the motor terminal leads removed from the motor circuits, to determine if the motor or the circuit is defective.

THE DRUM OR CYLINDER MOTOR

The drum or cylinder motor rotates the drum or tape head assembly at a high rate of speed. The drum motor is driven from a drum/capstan main servo section and IC motor drive circuit. Usually, the drum motor circuits are quite complicated and have 8 to 15 connections from the MDA unit to the drum motor. The drum motor is a 3-phase uni-directional current-flow brushless motor (Fig. 11-2).

IC204 contains the drum, capstan speed, and phase servo circuit. It activates the drum speed and phase error signals when they deviate from the drum FG and PG signals.

Fig. 11-1. Here is a typical motor found in camcorders.

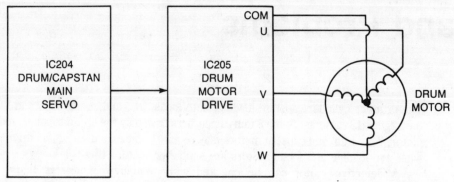

Fig. 11-2. The main servo IC provides a signal to the drum motor drive (IC205) which rotates the three-phase-current brushless drum motor.

It also activates the capstan speed and phase error signal when they deviate from the capstan FG signal.

The FG pulse or signal determines the proper speed-control voltage for the cylinder or drum motor. To stop the cylinder motor rotation in Stop, Rewind, or Fast Forward, the motor drive voltage is reduced to zero by grounding one of the terminals of the motor amplifier IC (Fig. 11-3).

The 3-phase direct drive drum motor features high efficiency for producing the torque required for tape wrap, while minimizing power consumption. Three Hall elements are located at 120° positions for detecting the rotor position. The Hall IC's are controlled from a signal processor IC. The motor is driven by eight magnetic poles (Fig. 11-4). The drum motor is driven from a motor drive IC, power transistors, or servo processors.

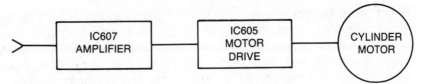

Fig. 11-3. The cylinder or drum motor drive voltage can be reduced to zero in IC605 to stop the motor at once.

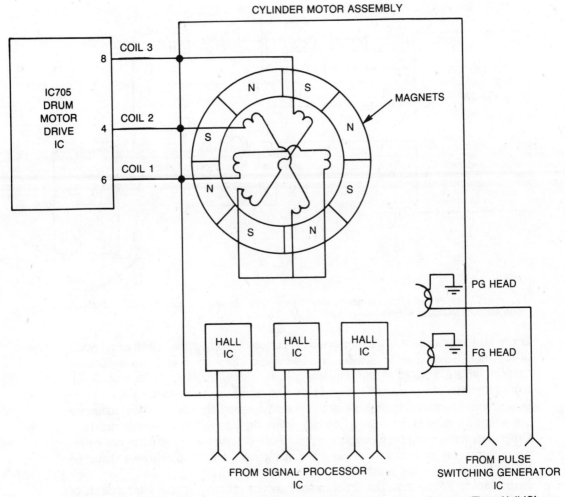

Fig. 11-4. The cylinder or drum motor is driven by a motor drive IC, power transistor, or a servo processor. Three Hall IC's are located at 120° for detecting the rotor position.

8 mm Drum Motors. The 8 mm camcorder drum motor is either a 3-phase or two-wire dc type. Often, each motor is powered by a drum motor IC component (Fig. 11-5). In some drum motor circuits, the MDA control board has up to 13 terminals, while in simple circuits only two wires are connected to the drum motor. Most 3-phase motors are of the brushless motor type. The drum motor windings can be checked by low-ohm continuity tests across each winding. The resistance of all windings should be the same or lesser resistance. The low dc voltage measurement may be taken from the common terminal to ground.

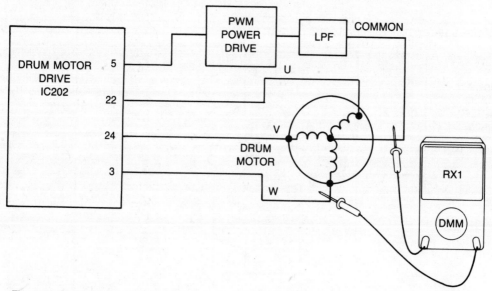

Fig. 11-5. Check the three motor windings with the low ohmmeter RX1 range of a VOM or DMM. An open field coil indicates a defective motor.

Drum Motor Removal. All motors found in camcorders are rather small and delicate in operation. Some drum or cylinder motors come complete with both top and bottom sections and are replaced as one complete unit. In others, the top cylinder must be removed from the motor assembly (Fig. 11-6). The complete drum assembly is removed by disconnecting the cable plugs going to the chassis assembly, and removing mounting screws and the drum base assembly. If handy, follow the manufacturers' service literature. Otherwise, write down each component, and mark its location, so all parts can be replaced in reverse order. Drum cylinder and motor replacement adjustments should be left up to the camcorder technician.

Drum Motor Problems. The drum motor may not operate, appear intermittent, or race during record mode. Check the dc-dc converter voltage within the drum start circuits. Measure for correct voltage on the motor drive IC. Measure voltages applied to drum motor components from the power supply circuits. Suspect the motor drive IC, if you have a racing drum assembly during record with normal playback mode. Intermittent drum operation is caused by a defective drum motor.

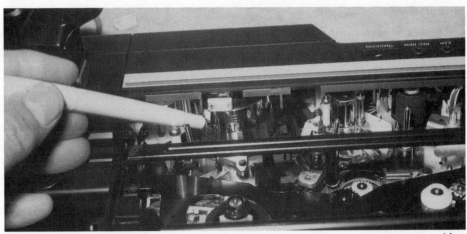

Fig. 11-6. Here is a close-up view of a drum assembly. The top cylinder head must be removed from the bottom motor assembly when replacing the drum motor.

THE CAPSTAN MOTOR ASSEMBLY

The capstan motor moves the tape across the tape head assembly with the motor driving the capstan/flywheel assembly. The capstan motor is either belt or gear driven to the various mechanical assemblies, supplying tape movement in Play, Record, Rewind, Fast Forward and Search modes (Fig. 11-7). In some camcorders the capstan motor also provides the Rewind, FF, Idler shaft and nloading procedures. The motor speed varies by applying different dc voltages to the motor terminals.

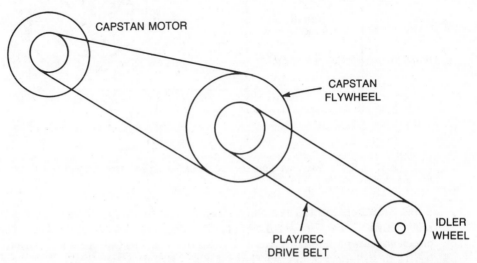

Fig. 11-7. The capstan motor drives a capstan flywheel and idler gear assembly with two different belts.

The capstan motor drive circuit consists of a signal from the servo unit to a capstan drive motor IC, which in turn applies power to a three-coil winding in the motor assembly (Fig. 11-8). The motor drive IC also controls the speed of the capstan motor. In some circuits the capstan three-coil windings are driven by power output transistors in the MDA board.

In the capstan motor control circuits, the speed control error voltage increases with faster capstan motor rotation, and decreases with slower rotation. In the phase control system, the error voltage decreases with advanced phase, and increases with delay phase.

The conventional two terminal motors operate from the servo IC and capstan driver (Fig. 11-9). The same servo IC component may drive the drum motor and drum driver IC. Ohmmeter and voltage continuity measurements of the motor field coils will determine if the motor is open or if improper voltage is applied to the motor.

The capstan motor may consist of a stationary field coil embedded within the motor mounting plate. The capstan rotor consists of a rotating magnet with a long capstan drive shaft. Some of these motors have a thrust screw at the top of the assembly and a thrust end-bearing (Fig. 11-10). The rotor magnet or armature may have a V-belt pulley at the bottom of the rotating magnet to rotate the capstan belt of a clutch pulley assembly.

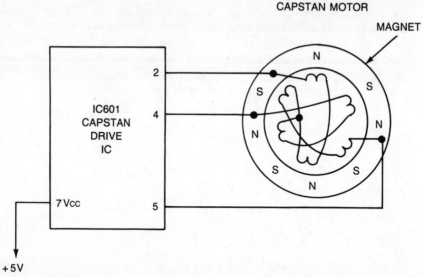

Fig. 11-8. Here IC601 drives the 3-phase winding of the capstan motor. The same IC may control the speed of the motor.

8 mm Capstan Motor. The 8 mm camcorder capstan drive motor consists of a capstan motor drive IC, PWM power drive, and LC filter. This capstan motor is a 3-phase bi-directional current-flow brushless motor (Fig. 11-11). The capstan motor drive (IC-205) has 11 to 15 terminals to drive the motor and Hall devices.

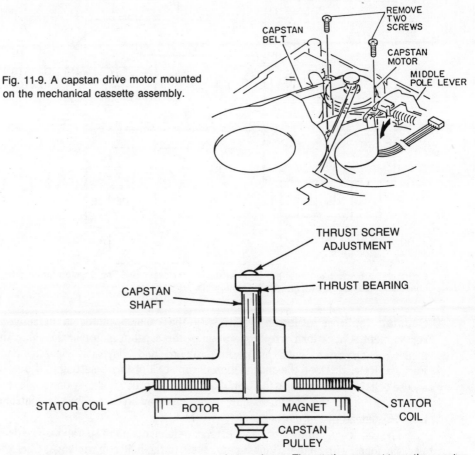

Fig. 11-9. A capstan drive motor mounted on the mechanical cassette assembly.

Fig. 11-10. The capstan motor may come apart in two pieces. The rotating magnet turns the capstan shaft and pulley.

Capstan Motor Removal. Often, the entire cassette assembly must be pulled before the capstan motor assembly can be removed. A belt cover or plate must be removed to get at some motor mounting screws. Remove the capstan belt. Remove the two or three screws holding the motor to the metal upper deck. Unplug or pull off the motor terminal cable wires. You may have to remove several small components to get at the capstan motor assembly.

The capstan motor may come apart in two separate pieces with the stator and capstan rotor assembly in some camcorders. Remove the screws holding the metal belt cover. Carefully pull out the capstan rotor. Remove the stator assembly and its three mounting screws. Unplug the stator cable wires. Install the new stator unit with the three mounting screws. Be careful when inserting the rotor magnet assembly into the bearing holes, the magnet rotor pull-force is great and may pull the rotor out of your hands. Adjust the thrust screw for end-play at the capstan top side bearing.

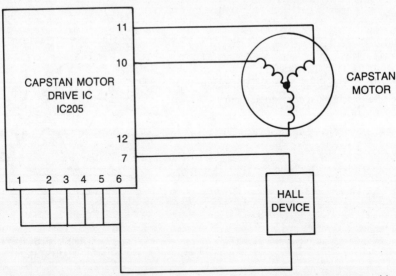

Fig. 11-11. A block diagram of a 8 mm capstan motor assembly. The capstan motor drive (IC205) controls the capstan motor and Hall IC elements.

Capstan Motor Problems. Make sure the capstan motor is defective before replacement. Check for correct operation of the capstan motor in the three different modes of operation, such as normal Record and Playback, Search, and Fast-Forward/Rewind. Does the malfunction occur in all of these settings? If not, suspect a loose belt, slippage, or oil on the belt, if defective operation is in only one mode. Improper Rewind, FF, idler shift, and unloading operations may be caused by the control mechanism IC instead of the motor.

The capstan motor may be dead, erratic, or intermittent in operation. The dead motor is easily found with continuity ohmmeter tests of the field coil windings. Check for voltage applied to the motor terminals with the low-voltage range of the VOM or DMM (Fig. 11-12). Measure the voltage applied from the power supply to the speed control or capstan motor drive IC. Rotate the flywheel by hand to determine if the capstan bearing is dry or frozen. This control voltage from the servo IC to the MDA board may be 0 at reverse, 2.5V in forward, and 5 volts in the stop modes.

Erratic or intermittent capstan motor operation may result from a defective speed control or capstan motor drive IC. Critical voltage measurements on the suspected IC will determine if it is defective. Dry or worn capstan motor bearings may cause erratic rotation. Do not overlook a defective capstan motor for erratic or intermittent operation.

THE LOADING MOTOR

The loading motor is used for loading tape, ejecting the cassette mechanism, releasing the brakes, engaging the fast-forward/rewind idler gear assembly or the playback gear

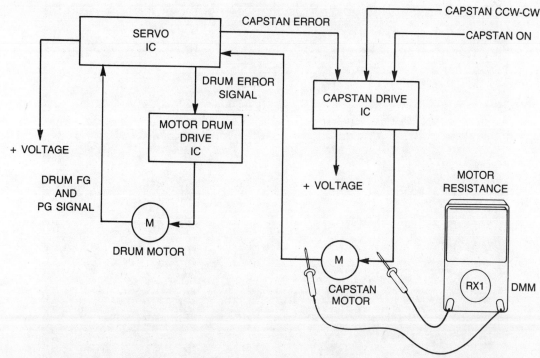

Fig. 11-12. The servo IC controls both operations of the drum and capstan motor. Take continuity resistance field measurements and voltage measurements on the drive IC components to determine if the motor is defective.

assembly (Fig. 11-13). In some camcorders the cassette must be loaded before the unit can be turned on. The loading motor is found in the higher priced camcorders, while the capstan motor does the loading functions in other models. Often, the loading motor is controlled by the servo control or system control IC. The simple loading motor has only two terminal wires for operation.

A correct polarity of voltage is applied to the motor terminals in loading and unloading modes. The motor wires may be shorted to ground, within the system control IC in the braking mode, so the motor stops at once. In some camcorders when the loading is not completed, the loading motor automatically reverses direction and unloads the tape into the cassette. If power is not applied to the loading motor, ejecting the tape is not possible, unless the case is removed and the hold latch is removed.

Loading Motor Circuits. The loading motor receives the loading and unloading voltage from the motor drive control IC, which in turn is controlled by the system control IC or main CBA board (Fig. 11-14). The loading drive component is transistors or another IC. No voltage is applied to the loading motor terminals until the load button is pressed. A positive voltage fed to the loading motor terminal provides the loading while a negative voltage unloads the tape.

Fig. 11-13. This photo shows the motors mounted inside the camcorder main chassis.

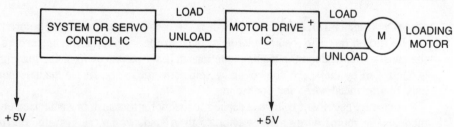

Fig. 11-14. The simple loading motor has two connecting wires from the motor drive IC. The positive voltage provides load, while a negative voltage unloads the tape.

8 mm Loading Motor Circuit. The simple loading or CTL motor in the 8 mm camcorder has two or three wires connected to the motor (Fig. 11-15). Usually, a common ground wire is fastened to the motor belt assembly (pin 2). The loading motor may have a .1 μF capacitor across the loading motor terminals to eliminate noisy operations.

Loading Motor Removal. The loading motor in most camcorders is easily removed. Disconnect the motor cable plug. Remove two screws holding the motor in position from the opposite side of the assembly. Remove the loading motor from the chassis. Reverse the procedure in replacement of the loading motor.

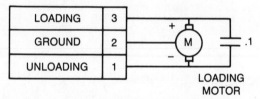

Fig. 11-15. In the 8 mm loading motor, two wires carry the negative and positive voltage, providing clockwise and counter-clockwise rotation, using a center ground wire.

Loading Motor Problems. The loading motor may be dead or operate intermittently. The dead motor is located with voltage measurements across the motor terminals in either load or unloading procedures. Take a continuity ohmmeter test, if voltage is found at the motor terminals. Check the load motor drive IC and transistors performing in-circuit voltage and junction transistor tests with the DMM. Measure the supply voltage at both system servo control and motor drive IC terminals.

The loading motor may have a worn gear at the motor shaft assembly. Broken or jammed, worn gear assemblies can cause erratic and intermittent loading operations. A defective mechanism state or mode switch and trouble sensors will prevent proper loading. The mechanism state switch controls the proper mode to the system control IC, which provides power to the loading motor in the correct direction and speed.

THE IRIS MOTOR

The amount of light applied to the imaging device (chip or tube) is regulated by the iris, which shuts and opens in response to the brightness of the scene or picture you are taking with the camcorder. If too much light gets into the lens assembly, the picture may be washed out. Likewise, if not enough light is applied, the picture is too dark. The automatic iris mechanism applies the correct amount of light to the camcorder sensitive device. Some camcorders have an override control to compensate for the automatic iris in difficult lighting scenes.

The iris mechanism is controlled by an iris meter system, circuitry, manually, or with a motor. The iris mechanism is called a meter system, consisting of an iris mechanism which mechanically connects the brake and drive coils, acting like the iris motor operation (Fig. 11-16). The iris meter assembly may look like the small iris motor assembly.

The automatic iris motor circuits are controlled somewhat like the meter system. The optical signal is optoelectrically connected by the CCD images and fed to a processing circuit. A motor IC drive component controls the iris motor rotation and setting of the iris. Two sets of coils are found in the automatic iris motor (Fig. 11-17). The circuits are quite similar in both VHS and 8 mm camcorders.

Iris Motor Problems. Most iris motor problems relate to defective drive circuits or motors. Check the motor coils with a low-resistance (RX1) measurement for normal continuity. Take voltage measurements on the drive coil terminals. Measure the supply voltage fed to the iris motor drive transistors and IC components.

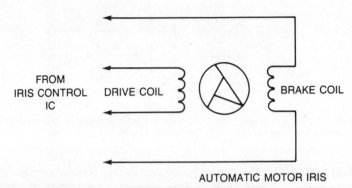

Fig. 11-16. The motorless iris circuit consists of a drive and a brake coil in a regular iris meter system. The meter drive assembly may look like a regular motor assembly.

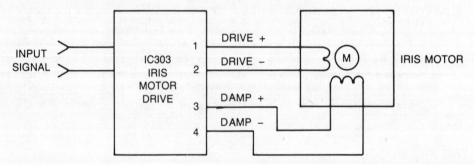

Fig. 11-17. Here two sets of coils are found in the iris motor circuit driven by a motor drive IC (IC303).

The iris may stick fully open or closed. Check the operation of the CAM sensor switch, which controls the motor direction when the iris appears stuck. Check each switch in reversing procedures. Make sure the microswitches are not open, using a (RX1) ohmmeter test across the switch terminals. Follow the manufacturers adjustment of the microswitches for complete action.

Iris Motor Removal. The iris, AF, and zoom motors are located on the optical assembly (Fig. 11-18). Often, the lens unit and master lens holder must be removed before the iris motor can be dismounted. Two to four small screws hold the iris motor in position on the optical assembly.

The Auto Focus Motor. The auto focus motor controls the focus ring using a gear-shaft arrangement. Cheaper camcorders use fixed or manual focus control. The servo system controls the auto focus motor with either, a sonar system burst of sound against the subject and back, or a infrared light bounce system. The infrared transmitting diode beams the light to the subject and bounces back to a movable detector block, which senses the servo amp and focus motor. Some optical systems have focus override, in case you do not want to focus on the center subject.

The auto-focus (AF) motor is controlled directly by a motor drive and regulator IC (Fig. 11-19). Check the motor continuity with the (RX1) ohmmeter range of the VOM or DMM. Measure the dc voltage applied to the motor terminals for a possible defective

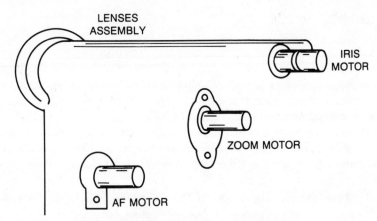

Fig. 11-18. The iris, AF, and zoom motors are located on the optical lens assembly. The lens and master lens holder must be removed before the motors can be removed.

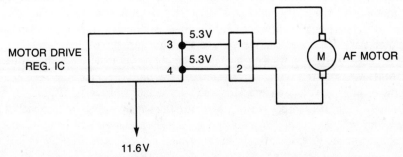

Fig. 11-19. The auto focus (AF) motor is driven by voltage from a motor drive and regulator IC. These two terminal motors are easily checked with continuity and voltage measurements.

control IC. Re-check the supply voltage terminal on the motor drive IC. The AF motor is located right on the focus ring assembly.

You may find the electronic viewfinder is out of focus. A separate focus and brightness control are found on the viewfinder picture assembly. Usually, the focus control for the viewfinder is adjusted at the factory. If the picture in the viewfinder is out of focus, locate the separate focus control, use a plastic screwdriver to bring the picture in focus, so not to damage the miniature controls.

Removing the AF, Iris and Zoom Motors. To remove the motors:

- Remove the lens unit held by three or more screws.
- The zoom motor can be detached by removing 2 screws.
- Remove the master lens holder before removing the four screws of the iris motor.
- Remove the lens unit and AF-CBA unit before removing three screws holding the auto-focus (AF) motor.

MODE CONTROL MOTOR

In some camcorders only three different motors operate the entire operational mechanism. A capstan motor operates the tape movement process and the drum motor turns the drum head. The mode control motor operates all the other mechanical functions. In other camcorder mechanisms the loading motor operates most mode operations. The mode or loading motor is one and the same.

Although the mode motor is easily checked electrically, removing the motor is another problem. The mode motor is located underneath the cam switch assembly and lock arm assembly, you must disengage several springs, and remove the cam and arm gear assembly before you can get at the motor mounting screws. Usually, the mode motor is removed with it's own worm gear assembly (Fig. 11-20). It would be cheaper and easier to have the camcorder technician remove and replace the mode control motor if it is found buried under many mechanical components, or follow the manufacturers removal procedures.

Mode Motor Circuits. The mode motor is controlled by the mechanism processor and a motor drive IC component (Fig. 11-21). The motor operates FWD and REV with mode sensors controlling the process. Zero voltage is found on the motor terminals, until the motor drive IC provides drive voltage in either direction.

Check the motor winding for open conditions with the RX1 range of the VOM or DMM. Measure the voltage applied across the motor terminals while it is in operation. Low or improper voltage indicates a defective motor drive IC (IC305) or mode signal from the mechanical processor IC. Measure the supply voltage at terminals 2 and 9 (10.3 V). Low voltage on pin 9 indicates power supply problems or a leaky IC305. Check the voltages on all IC305 terminals to determine if the motor drive IC is leaky.

THE ZOOM MOTOR

Most camcorders have zoom lenses that permit a person to zoom in on a subject without falling out of focus. The power zoom lens, automatic focus, and automatic iris keep the picture in focus when zooming in and out with the camcorder. A small motor operates the zoom lens assembly for easy operation. Some camcorders may have both minimal and power zoom functions. The standard zoom ratio is around 6:1 in camcorders, although you may see 3:1, 8:1, 10:1 and 14:1 ranges in different video cameras.

The power zoom motor is located on the photo-optical assembly of the camcorder. The two-wire VHS zoom motor is driven with a drive motor IC and transistors, or from the CBA board (Fig. 11-22). The 8 mm zoom motor is driven by a motor drive IC with a zoom telephoto and wide angle button (Fig. 11-23). The auto focus and zoom motors are controlled from the CBA motherboard. In some zoom motor assemblies a slip clutch arrangement prevents the motor from stalling at either end of the zoom range. The zoom motor is bolted to the auto focus assembly with one or two small mounting screws.

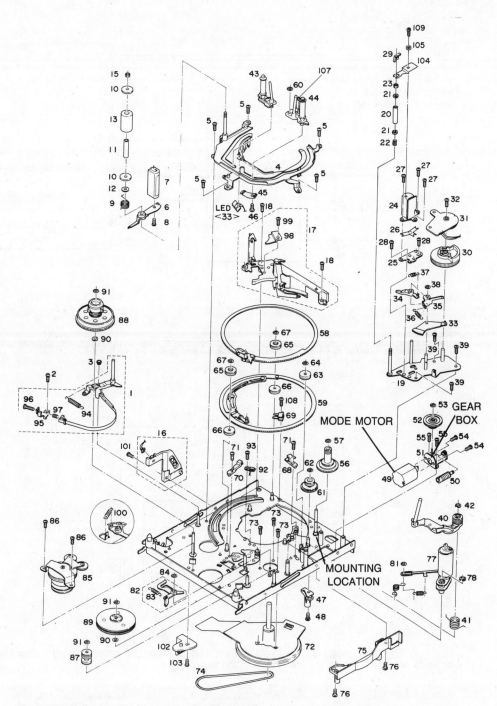

Fig. 11-20. Follow the manufacturers chart removal of the mode motor (49).

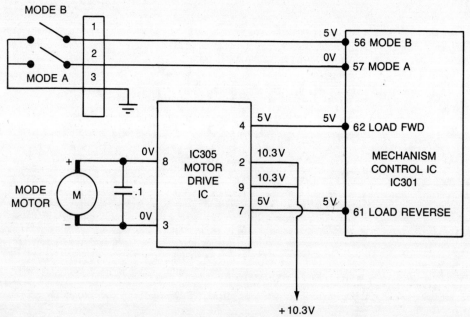

Fig. 11-21. The mode motor has a simple two wire connection to the motor drive IC. A signal from the mechanism control IC (IC30l) provides control voltage to the motor drive IC.

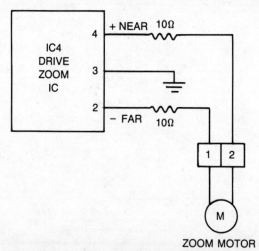

Fig. 11-22. The zoom motor is driven from a motor drive IC (IC4). The zoom motor may take a few seconds before the correct picture is seen in the viewfinder.

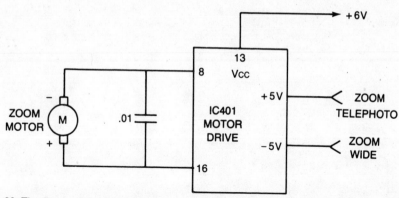

Fig. 11-23. The 8 mm zoom motor circuit is a voltage controlled IC providing a negative and positive voltage to the zoom motor for near and far zoom pictures.

12

Adjustments You Can Make

Most mechanical and electrical adjustments are made after replacing defective components. Of course, focus, color, contrast, and brightness adjustments can be made to improve the picture. Difficult adjustments are left out of this chapter because expensive service jigs, lighting and pattern boxes, special tools, and test equipment are needed to perform them. For the most difficult mechanical or electrical adjustments, take the camcorder to the manufacturers service depot or the local camcorder technician.

MECHANICAL ADJUSTMENTS

All mechanical components found in the camcorder are located on the top-side of the chassis. Most of these adjustments can be made by removing the front door panel or the cassette loading assembly (Fig. 12-1). The RCA VHS front panel can be removed by taking out the rubber inserts and two metal screws. The whole panel pulls off to view the entire top chassis. Most of the mechanical adjustments can be made with a long-nose pliers, small screwdriver, and a test cassette.

VHS MECHANICAL ADJUSTMENTS

Grounding Plate Check. In some camcorders, check the center-line alignment of the grounding plate and shaft center. Make sure the clearance toward the connector is less than 1 mm (Fig. 12-2).

Fig. 12-1. Remove the rubber strips and two small metal screws to remove the RCA CPR300's front panel.

Fig. 12-2. How to adjust the pressure plate assembly found in some VHS camcorders.

Thrust Screw Adjustment. The thrust screw is located at the top of the capstan drive area of the capstan motor assembly (Fig. 12-3). The thrust screw at the top should be adjusted after replacing the rotor capstan shaft or oiling the bearings. Do not lose the thrust bearing if the screw is taken out of the assembly. Tighten the thrust screw until the capstan rotor starts to turn, then tighten it another 240-270°.

Reel Table Adjustment. If the reel table has been replaced or removed for cleaning, try to place the reel back in its original place (Fig. 12-4). Confirm the measurement at the top of the reel to the base chassis and compare with the other take-up reel. These reels must be in line with the tape guide rollers for proper tape movement (Fig. 12-5). Some camcorders use a special light jig for this purpose.

Fig. 12-3. Adjust the thrust screw after removing the motor rotor assembly for replacement or clean up.

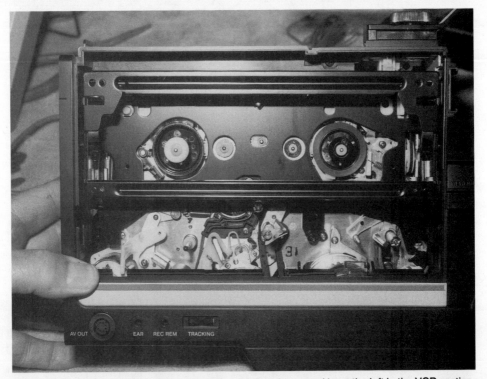

Fig. 12-4. The supply reel is located to the right, and the take-up reel is on the left in the VCR section.

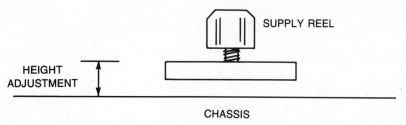

Fig. 12-5. Align the supply reel to the same height as the take-up reel from the chassis base.

Brake Confirmation. If slack appears in the tape after the stop button is pressed, suspect poor braking. Clean off the supply and take-up gear assemblies with cloth and cleaning fluid. The braking is accomplished with pressure applied by the brake against the supply and take-up gear in some models (Fig. 12-6). The brake pad should lay flat and in-line against the two gear assemblies. If not, make sure the control plate and rod are not bent out of line. Load the camcorder with a cassette. Place it in rewind mode and press the stop button. No slack should appear in the tape after clean-up and proper rod alignment.

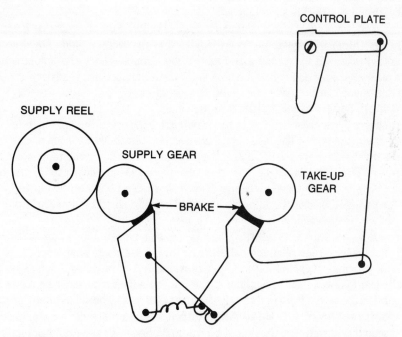

Fig. 12-6. Check the brake area on the supply and take-up gears in the VHS camcorder.

Tape Guide-Post Adjustment. If curling or creasing of tape at the top or bottom of the guide-post is noted, adjust the tape guide-post (Fig. 12-7). The guide-post should be adjusted with the screw at the top, so the tape lies between the two hubs of the

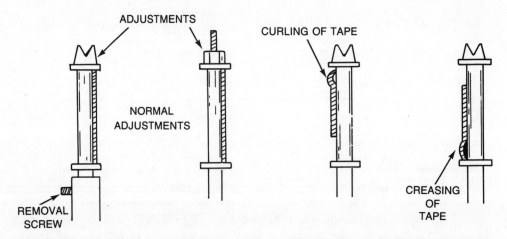

ADJUSTMENTS

CURLING OF TAPE

NORMAL
ADJUSTMENTS

REMOVAL
SCREW

CREASING
OF
TAPE

Fig. 12-7. Adjust the tape-guides and rollers when the tape bunches or curls up in the tape path of the VHS camcorder.

tape-guide assembly. Usually, all tape guide rollers and guides are adjusted to the same height with a thickness height jig.

You can roughly adjust all tape guides and rollers from the cassette holder for correct height. Most tape guide-posts are adjusted at the factory, and should not be touched unless taken off for cleaning and lubrication. Double-check the adjustment by playing a blank cassette, and notice the tape path. If curling appears, readjust each post. Precise adjustment can be made later with the oscilliscope.

Rough Tape Travel Adjustments. Check the tape for proper tape path travel by loading a blank cassette. Press the play button. Notice if the tape is in full contact with all tape guide-posts. The tape should have no creases or slack at each post. The impedance rollers should move freely, if not, they are dry, binding, or the tape is not touching the roller. The tape should be perpendicular to the longitudinal axis of the heads, when crossing erase on the A/C heads. The tape should be centered top to bottom on the head when crossing the full erase head. The tape should follow the lower edge guide surface of the cylinder.

Back-Tension Adjustment. The back-tension adjustment is done at the factory, and is not likely to require additional adjustment. Back-tension adjustment is properly made with minimum skew error. Improper tension adjustment shows picture displacement in the line following head switching. Back-tension adjustment must be made with a back-tension cassette. Follow the manufacturers back-tension adjustment procedures.

Confirmation of A/C Head Adjustment. Unless the audio control head (A/C) is replaced this adjustment should not be made. Notice if the tape runs along the lower edge of the control head. If it doesn't, turn the adjustment nut at the rear of the A/C head assembly. Rotate the nut clockwise to lower the head, or counterclockwise to raise it.

Confirmation of A/C Head Tilt Adjustment. Play back the tape and check for tape running between the two hubs of the post nearest the A/C head. If the tape is running high, rotate the screw at the top of the post counterclockwise (Fig. 12-8). In case the

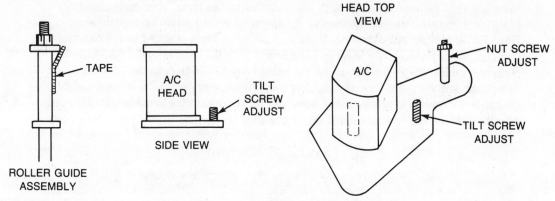

Fig. 12-8. If the tape is running high or low on the roller guide next to the A/C control head, readjust the tape head tilt screw.

tape is running low, adjust the screw clockwise. A/C head and azimuth adjustments should be done with an oscilloscope and an alignment tape.

Mechanism State Switch (Mode). Make sure the control cam is in the unloaded state. Check the marking on the mechanical state switch circuitboard and the triangular markings on the rotor, to see if they are aligned as shown in Fig. 12-9.

Pressure Arm Position. Check to see if the pressure roller arm is engaged with the pressure roller bar when it is in the unloaded state (Fig. 12-10). If it is not, remove the screw on the pressure roller arm and reset the teeth of the two components.

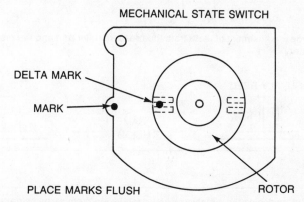

Fig. 12-9. Make sure the mark on the metal stamping and the delta mark are flush for the correct mechanical state switch (mode) adjustment.

8 MM MECHANICAL ADJUSTMENTS

The 8 mm mechanical and electrical adjustments are similar to those of the VHS camcorder. All tension and brake adjustments should be done according to the

manufacturers recommendations with test instruments and jigs. If in doubt about the mechanical adjustments, let the camcorder specialist do the following adjustments.

Reel Table Height Adjustment. If the reel table has been replaced or removed for cleaning, notice if the reel table is the same height from the chassis as the take-up reel. Both reel tables or spindles should be the same height from the chassis (Fig. 12-11). Sometimes space washers are missing after reel replacement, and this will make a slight change in the reel table height. Make sure both turntables are the same height. Do not lose the small space washers found under the reel assembly.

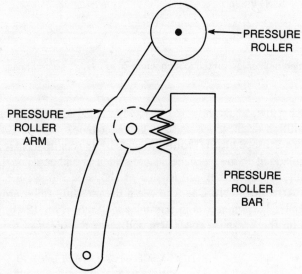

Fig. 12-10. Proper adjustment of teeth from the pressure roller arm and the pressure roller bar in the VHS camcorder.

Fig. 12-11. After replacing the supply or take-up reel, keep them at the same height from the chassis base in 8 mm camcorders.

Tape Running Check. Place the camcorder in playback mode. Notice if the tape is curled at the top or bottom of the guide rollers (Fig. 12-12). Double-check the guide rollers closest to the cylinder or drum. If the tape is bunched up at either guide-post, readjust the guide-post. In some of these guide-posts a small lock screw must be adjusted at the bottom area. Move the guide-post only slightly up or down to correct the tape path.

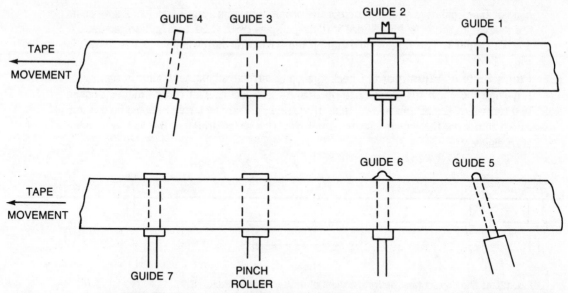

Fig. 12-12. The 8 mm running check of the tape path to insure no curling or creasing of the tape from the cassette.

Tape Drive Adjustment. After replacing the cylinder motor or components in the tape path, check for correct tape movement. Play back the tape and check for warped or spill-over on the guide-posts (Fig. 12-13). If a gap exists between the tape and cylinder

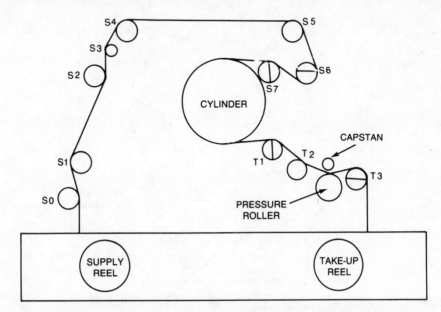

Fig. 12-13. The 8 mm tape path of the cylinder and different guide assemblies with the capstan and pressure roller location with respect to the supply and take-up reels.

head or tape spill-over occurs, correct the problem by adjusting S7 or T1. These posts are nearest to the cylinder. Notice if the tape spills over at S1 to S7. If so, adjust S7, T1, T2, and T3. The tape should run on the post with the cylinder head as shown in Fig. 12-14.

Pinch Stroke Adjustment. Check the pinch stroke adjustment after replacing or removing the pinch roller for clean up. Place the camcorder in record mode. Loosen two screws on the pinch arm assembly (Fig. 12-15). The pinch roller should be 0.3 mm to 0.5 mm from the capstan shaft. If not, insert a screwdriver in the slot and widen accordingly.

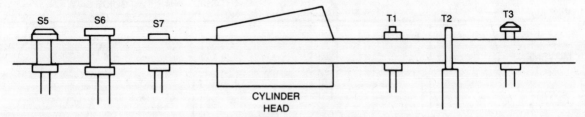

Fig. 12-14. The correct tape path movement of an 8 mm camcorder.

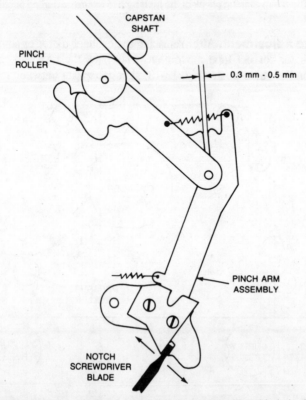

Fig. 12-15. Adjusting the 8 mm pinch stroke adjust with a screwdriver blade in the notched area of the pinch arm assembly.

VHS ELECTRICAL ADJUSTMENTS

Many of the electrical adjustments for the camcorder are made with precision instruments and equipment. Accurate electrical adjustments are made with the camcorder, ac adapter, light box, television monitor, and test jigs. Usually these adjustments are made after part replacement. There are still a few electrical adjustments that can be made with the digital voltmeter (DVM or DMM).

VHS Voltage Adjustment. This adjustment is made to set the camera voltage adjustment. You should know the camera operating voltage furnished by a service manual for the right camcorder (Table 12-1).

Table 12-1. A typical VHS/VHS-C operating voltage chart.

Camcorder	Model	Operating Voltage
JVC	GR-C7U	8V.
Minolta	C3300	5V.
RCA	CPR100	9V.
Realistic	150	9V.

Locate the voltage test-point and adjust the voltage control for the required voltage. Make sure the cap is over the lens assembly. For example, the correct 9-volt adjustment is made for the RCA CPR100 camera (Fig. 12-16). Connect the DVM to pin 6 of P61401. Adjust the 9V adjust control (RT1401) for 9.0 volts \pm 0.1 volts. Make sure the EVF connection is removed during this adjustment.

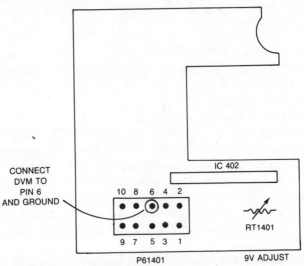

Fig. 12-16. How to make the 9-volt adjustment in the RCA CPR100 camcorder and location of the 9V adjust control.

Electronic Viewfinder Focus Adjustment. Locate the EVF focus control in the camcorder. Some manual focus adjustments are found on the bottom side of the eyepiece. Adjust the picture in the viewfinder. The eyepiece focus control does not effect the focus of the camcorder. Aim the camera at a resolution chart or focus card. Adjust the EVF focus control for sharpest picture.

EVF Picture Tilt Adjustment. If the picture is tilted in the viewfinder screen the deflection yoke is out of adjustment. Align the camera with lines that are level or horizontally perfect. Loosen the screw holding the deflection yoke (Fig. 12-17). Observe the picture in the EVF. Move the deflection yoke until the picture is level. This is the same procedure as tilt or level adjustments of the television, except the deflection yoke is a lot smaller in size.

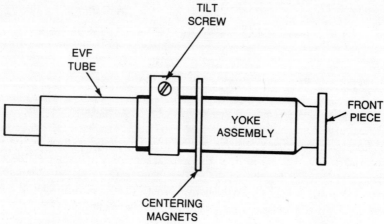

Fig. 12-17. The tilted picture in the electronic viewfinder (EVF) can be readjusted with the tilt screw on the end of the yoke assembly.

EVF Centering Adjustment. When the picture is off to one side and not perfectly centered, adjust the centering magnet, located by the yoke assembly. Adjust the centering magnets until the center of the picture as viewed by the camera, is positioned in the center of the EVF screen.

EVF Vertical Size Adjustment. If the picture in the EVF shows black at the top or bottom, the vertical size control should be adjusted (Fig. 12-18). This adjustment determines the size of the picture in the EVF display. Aim the camera at a resolution chart or picture, line up the camera, and adjust the vertical size control.

EVF Brightness Adjustment. This adjustment determines the brightness of the picture in the EVF display. If the picture is too bright or too dark, readjust the brightness control. Another method is to aim the camera at a gray-scale chart, and adjust the brightness control so the black and white portions of the chart displayed in the EVF match those displayed by the monitor.

EVF Control Adjustment. This adjustment is found in some EVF viewfinders located on the viewfinder assembly (Fig. 12-19). The adjustments can be made outside the EVF

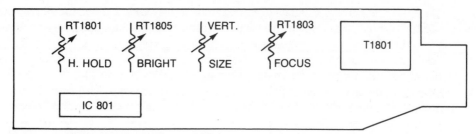

Fig. 12-18. The different adjustment controls found on a realistic 150 model of the electronic viewfinder. (Courtesy of Radio Shack)

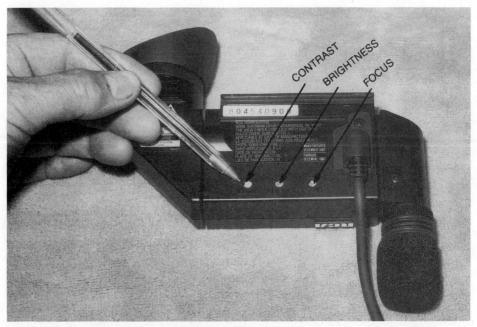

Fig. 12-19. The contrast, brightness and focus controls of the electronic viewfinder (EVF) are found at the bottom side of an RCA CPR300 camcorder.

case. Adjust the contrast control for best contrast of the picture in the EVF screen.

Audio Playback Gain Adjustment. If the audio level is too high or low, adjust the level control for adequate volume. Connect a millivoltmeter to the audio output and ground. Load the camcorder with an alignment tape and play it back at 1 kHz audio signal. Adjust the audio gain control for the correct level of the camcorder.

Over-Discharge Level Adjustment. This adjustment determines the over-discharge detection level. In some camcorders, when the battery voltage drops to a specified level, the VCR will automatically shut off. When the over-discharge detection level is set below 10.9V, the battery service life will be reduced in a Realistic 150 model. When the voltage is adjusted higher than 11.6V, the usable time per charge is shortened.

Apply the correct voltage to the external battery jack and set the SP/EP switch to EP. Load the camcorder with a blank cassette. Place the instrument in record mode. Press the display button to indicate the battery level meter. Adjust the over-discharge level control so that the battery level indicator shows that the battery is fully charged.

AC Adapter/Charger Voltage Adjustment. Connect a 20-ohm 10-watt resistor across the output terminals of the ac adapter/charger. Set the camera-charge switch to camera position. Connect the DVM or DMM across the positive and negative terminals (Fig. 12-20). Adjust the adapter voltage control to the correct operating voltage of the camcorder. If the oscillation sound is heard from the adapter, adjust the adapter voltage control until it stops.

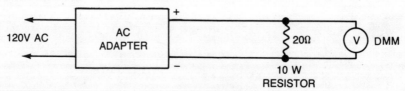

Fig. 12-20. How to connect a 20-ohm 10-watt resistor across the ac adapter output terminals for accurate voltage adjustment.

AC Adapter/Charger Current Adjustment. This adjustment sets the charge current to the specified value. Set the camera/charge switch to charge. Connect a 10-ohm 10-watt resistor across the positive and negative charge terminals (Fig. 12-21). Place a 270 or 220 μF capacitor (50 volts or more) across the large resistor. Connect the DMM across the resistor. Adjust the charge current control to the exact battery operating voltage of the camera. If the battery operation voltage is 6 volts, set the current voltage adjustment to 6V ± 1V. Likewise, if the camera battery operation voltage is 12 volts, set the current voltage adjust to 12V ± 1V.

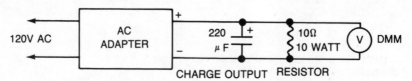

Fig. 12-21. How to connect a 10-ohm 10-watt resistor and a 220 or 270 μf capacitor across the output current voltage of the ac adapter.

8 MM ELECTRICAL ADJUSTMENTS

Many of the 8 mm electrical adjustments are similar to the VHS adjustments. Extreme care must be exercised in making electrical adjustments of these small cameras. Other than the 8 mm electrical adjustments shown here, all other 8 mm adjustments must be made with the correct test equipment, measuring devices, and test jigs.

8 mm Voltage Adjustment. Plug in the ac adapter and place camcorder in the stop mode. Some voltages are adjusted in the stop mode, while others use the record mode. Adjust the operating voltage of the 5-volt adjust to read 5.00 \pm 0.05V on the DVM or DMM.

The 5-volt power supply adjustment in the Olympus VX-8010 model is to place the DVM at test point TP1001. Place the camcorder in record mode. Adjust VR1001 (5V adjust) to 4.73 V \pm 0.025 V. For the 16-volt adjustment in the same camcorder, place the DVM or DMM at test point (TP1004), and adjust VR1002 (16-volt adjust). Rotate VR1002 until the meter reads 15.5V \pm 0.05V. Both adjustments are made in the record mode. Follow each manufacturers voltage adjustment according to the service manual.

13

Simple Repairs You Can Do

There are many simple repairs you can do without digging too deeply into the camcorder circuitry. Determine if the problem is operational or if actual trouble exists. Knowing how your camcorder operates can save a lot of valuable time and nuisance repairs. Most camcorder problems are caused by our own handling and know how. Knowing when difficult repairs should be left alone can save unnecessary repair problems.

If you're having operation difficulty, check the simple test list before digging into the camcorder. Sometimes, with correct operation and a check off list procedure, your camcorder problems are erased (Table 13-1). Check the beginning test list for simple problems related to power, recording, playback, tape transport, and other miscellaneous problems. Some of these camcorders have a microcomputer control device which might act up due to external noise and interference, preventing the camcorder from function properly. Try disconnecting the power supply, battery, or ac adapter from the camcorder. Reconnect it and try once again. Go over the camcorder operation control again before determining which route you should take.

WILL NOT TURN ON

Check for a lighted power on or standby LED to indicate if the power is turned on. No light may indicate a defective power on circuit, batteries, ac adapter, connections, or power cords. Try another battery. Determine if the fault lies in the battery or ac adapter operation and troubleshoot that operation. If both operations are dead, suspect a defective OFF/ON switch or internal power circuits. Check components in the power on circuits with a VOM or DMM (Fig. 13-1).

Table 13-1. Check camcorder problems with this preliminary trouble checklist.

PROBLEM	CHECK
No power	Battery pack installed AC adapter correctly installed Battery charged Cassette in camcorder Power switch ON REC safety switch
Cassette installed but no power	Cassette tab missing REC safety switch defective Power LED on Loading motor audible
Will not record	Faulty safety tab switch contacts REC/Standby required to be pushed first
While recording camcorder unloads, then shuts off	Tape end Defective tape end switch
Recording color different than actual color	Inspect white balance setting
External microphone does not record	Inspect microphone switch
No playback while tape is running	TV/Video switch setting should be set to Video
No picture in television screen	TV/receiver set to CH 3 or 4
Noise bars in picture	Reset tracking control
Playback picture blurred and noisy	Dirty video head Worn head
Noise in picture Grainy picture	Dirty video heads, use head cleaning cassette Worn head Defective cassette
Tape stops during FFWD/REW	Display set to M or memory Time set on memory
Will not FFWD/REW	Tape fully wound Bad drive belt
Dew light flashing	Moisture in camera, let set 1 hour
No function available with more than one or two indicators on	Low battery charge, recharge or replace
Cassette starts to load but immediately shuts off	Cassette at end of tape Tape not engaged with SP guide-pole Another infrared source

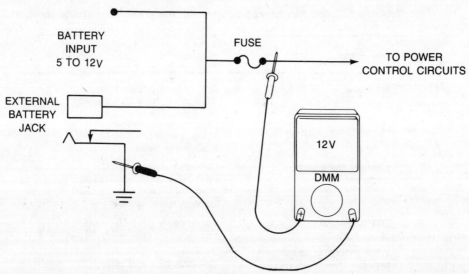

Fig. 13-1. Measure the battery or ac adapter voltage after the protection fuse to determine if the correct voltage is applied to the power on circuits.

NO POWER TO CAMERA

Set the select switch to camera position. Notice if the electronic viewfinder lights up. Does the camcorder work on playback modes? Suspect the power source to either operation. If playback mode is normal, suspect power problems to the camera section. Check the camera/playback switch with continuity tests. The power LED should be on, if power is applied from the ac adapter or batteries.

NO POWER

Does the power LED light up? If not, check the camcorder out on both batteries and ac adapter operation. Some camcorder circuits will shut down when the battery is a few volts low. Others eject the tape. Suspect the battery, if the unit works on the ac adapter and not with the battery. Try another battery. This is where the spare battery comes in handy. See Chapter 14 for ac adapter repair if the camcorder works on batteries and not on an ac source.

Check the fuse if either power source has no power effect (Fig. 13-2). Notice if the eject operation is working. Replace the fuse with one of the same amperage if it is found to be open. Measure the dc voltage at the fuse terminal to decide if voltage is present at this point. Press and hold down on the power switch after locating a defective fuse. Overloading conditions occur in the camcorder if the fuse repeatedly blows or opens.

Fig. 13-2. Remove the fuse and check the continuity with the low ohm range of the VOM or DMM. A normal fuse reading is below 1 ohm.

BATTERY WORKS, AC DOESN'T

Make sure the ac adapter is firmly locked into place on the backside of the camcorder (Fig. 13-3). Check the ac adapter contact points for possible poor or damaged connections. Measure the voltage at the ac adapter output voltage terminals. Sometimes, the small interlock must be pushed before voltage output exists (Fig. 13-4). Inspect for breakage or poor contact points. For further ac adapter repair see Chapter 14.

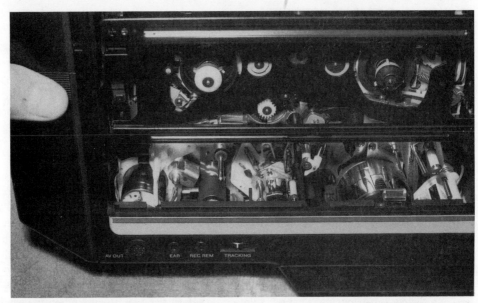

Fig. 13-3. Check the mounting of the battery. If not fully seated and locked in place, the battery terminals may not engage the camcorder contacts.

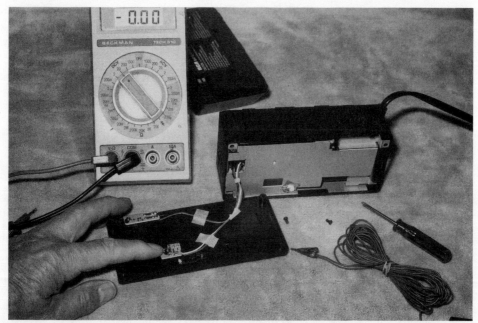

Fig. 13-4. Inspect the ac adapter for interlocks that prevent accurate output voltage measurements. Short out or defeat the interlock to check the output voltage.

AC WORKS, BATTERY DOESN'T

Try substituting another battery. It's always wise to have a fully charged spare battery on hand. On some camcorders, the unit will come on and shut down with a low battery. Sometimes the battery need only be 1 volt low to cause it to shut down. Check the output voltage of the battery pack with the DMM. Inspect the battery terminals. Check the battery plug and cables when the external battery pack will not operate the camcorder.

NO POWER IN RECORD

When inserting a cassette, if the record (REC) safety switch is on briefly, and opens after the cassette is inserted, suspect a defective safety switch. The power LED may come on briefly and turn off. Sometimes cassette ejection is dead. Check the safety switch on back of the cassette and see if it is missing. The cassette cannot record with the insert removed or missing. Is the dew light blinking? Let the camcorder set until the light goes out.

Notice if the loading motor starts up for a moment. Check the eject lever position on the cassette housing. Suspect a defective safety or power switch when the cassette is inserted, power LED lights briefly and then shuts down with a good battery or ac adapter. Check the power switch with continuity tests using the ohmmeter.

CAMCORDER INOPERATIVE

Suspect a defective CPU or loading motor drive IC if within 10 seconds after loading a cassette, the power and standby LED's are on, then the camcorder unloads, and emergency lights come on. The cassette may automatically eject in some models. Suspect a defective dc-dc converter inside the camcorder if the power LED does not light, and the unit is completely inoperative. Do not try to service the CPU or IC components unless you know how to do it. Take it to the camcorder specialist or back to the manufacturers' repair depot.

NO VIDEO RECORDING

Check the cassette. Try another cassette. Notice if the scene is recorded in the viewfinder. Check the video heads for clogged or excessive oxide. Clean up the tape heads. Is the tape at the end? Rewind the cassette. Make sure the select switch is in camera mode. Reset the record mode. Check for the correct recording voltage source. The FM signal, squelch, luma, and recording IC's should be checked by the camcorder expert.

WILL NOT RECORD BUT YOU CAN SEE IN THE VIEWFINDER

The camcorder may operate in a monitor mode, and not record what is seen in the viewfinder. Make sure the record buttons are functioning. Does the record indicator light come on? Most camcorders indicate they are recording with the record indicator light on. Check for the green light in the viewfinder. Place the camera/playback switch in camera position. Press the record button again, and then press pause mode. Now press the record button. Clean up the video heads on the drum or cylinder assembly. Make sure the cassette is loaded properly.

CAMERA WILL NOT GO INTO RECORD MODE

The most obvious solution is a missing safety tab at the rear of the cassette. Does the record indicator light come on? Either cover the opening with tape, or try another cassette. If the battery LED is blinking, try another battery or charge the battery. Notice if the tape is moving. Check the safety tab lever sticks in one position (Fig. 13-5). In some camcorders the REC/STBY button must be pushed first.

NO COLOR RECORDING

The camcorder will record in black and white but no color in the picture. Extensive troubleshooting, oscilloscope, and voltage measurements should be left up to the

camcorder repairman. Check the white balance setting of the color in the picture if it is greatly different than the actual subject colors. Check the Auto/Manual color switch setting. If the color is off a little, adjust the color balance control, until you get the most natural picture with the camcorder connected to a monitor. Measure the color IC supply voltage.

Fig. 13-5. Check the safety lever and switch contacts when the recorder will not record on the VHS-C camcorder.

NO RECORDED AUDIO

Check the microphone and cables with a normal colored picture and no sound. Double-check the microphone by inserting the external microphone into the external microphone jack. The built in microphone is dead when the external microphone operates. Do you get sound in the earphone? Clean up the audio control head. Measure the bias voltage at the audio head. If an oscilloscope is handy, check the bias waveform at the audio control head. Take a continuity ohmmeter test of the audio head to see if it is open. Check for accurate voltages on the audio IC.

TELEVISION PROGRAM CANNOT BE RECORDED

Inspect all connections between the television and camcorder. Make sure all cable connections are tight. Flex the cables for possible breaks or poor connections (Fig. 13-6).

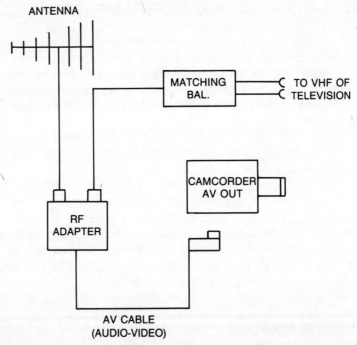

Fig. 13-6. Check the A/V cable and television connections when there is no recording from the television.

Double-check all button settings on the camcorder. Reconnect the television cord. Inspect and check for the correct cables placed on the RF adapter, if it is used. If the camcorder records normally, but will not from the television, check the cable wires with the ohmmeter for continuity of each wire.

DIFFERENT RECORDED COLOR THAN ON TELEVISION

Recheck the televisions' color and tint controls. The camcorder may need more light. Make sure the white sensor is not covered up. Make sure the white balance lock is off on the camcorder.

PICTURE DOES NOT APPEAR ON TELEVISION

Check for the correct channel on the television set. Make sure the converter is set at the video position. Check for a possible defective RF-converter or cable connections. Make sure the video/television selector on the television is set in video position. Inspect the video/output audio cord for poor connections or damage.

CAMCORDER WILL NOT RECORD FROM THE VCR

Double-check the audio/video output cables of the camcorder to the audio/video-in jacks on the back of the VCR. In some camcorders the white male plug is the audio connector, and the yellow connector is the video. Make sure these cable connectors are not reversed. Check the connection to the audio/video-output jack (AV out) on the camcorder. Make sure the camcorder is recording. If so, check the record buttons on the VCR machine.

NO VIDEO PLAYBACK

Make sure the tape is moving in the cassette. Take a peek at the viewfinder for a picture. Do you have audio and no video? Make sure the camcorder is set in playback mode. Press the play button. Suspect problems in the video circuit or tape head when there is no video output. Check the video heads and clean them up. Measure the playback voltage source line for correct voltage. Checking the FM, switching, and IC components should be left up to the camcorder technician.

NO AUDIO PLAYBACK

Notice if the video is normal in the electronic viewfinder. Do you hear sound from the earphone? Check the playback line-voltage source. Most camcorders have one large audio IC. Take critical voltage measurements of the sound IC. Clean up the audio control heads.

DRUM AND CAPSTAN MOTORS DO NOT ROTATE

Suspect a defective servo IC, or common voltage source when both motors fail to rotate. In some small camcorders these two motors are fed from a common servo dc-dc converter IC, (Fig. 13-7). Measure the common voltage source to the dc-dc converter IC. If voltages are fairly normal, suspect a defective dc-dc converter IC.

VIDEO LEVEL TOO HIGH/LOW

Check the auto/manual iris control setting. If the subject appears too dark in front of a bright background, turn the iris control counterclockwise to make the subject brighter. The iris control in some camcorders can be moved clockwise to fade out the picture entirely. Measure the luminance-voltage supply source for correct voltage. Check to make sure the iris motor is operating. If the picture is too dark, place the Shutter/Normal switch in normal position. Only use the shutter for outdoor slow motion action.

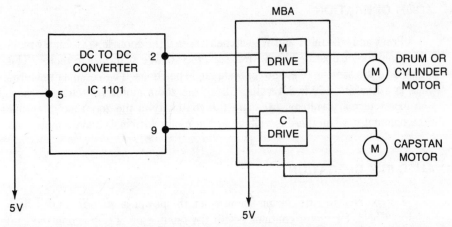

Fig. 13-7. Suspect a dc-dc converter IC when both the drum and capstan motors will not rotate. In some camcorders both motors work from the converter source.

NO AUTO-FOCUS

Set the camcorder to auto focus. Does the lens assembly move when changing to different scenes? Can you hear the focus motor rotate? Suspect slipping or broken gears if the focus motor is operating, but there is no movement. Measure the voltage applied to the focus motor. Check the focus motor IC voltage when no voltage is found at the focus motor terminals. Measure the focus motor continuity with applied voltage and motor movement (Fig. 13-8). Make sure the focus sensor assembly is not covered up on the front part, below the lens assembly. Try switching to manual focus under difficult conditions.

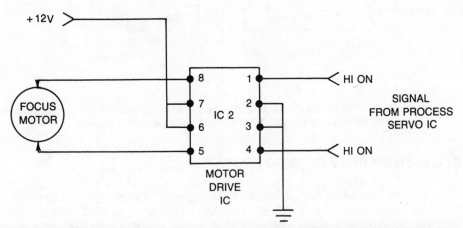

Fig. 13-8. Check the focus motor continuity with the ohmmeter at the motor terminals and voltage applied to the motor. Turn off the camcorder for any ohmmeter measurement.

NO ZOOM OPERATION

Press and hold the T and W switches to see if the zoom lens assembly moves. Does the zoom motor operate? If not, measure the voltage at the zoom motor. This voltage should be the same in telephoto or wide angle positions. The zoom motor terminal voltage in a Realistic 150 is 8.4 volts. Check the zoom motor IC voltages when there is no motor terminal voltage. Measure the continuity of the zoom motor terminals with the ohmmeter when there is voltage at the motor terminals and no motor movement.

NO AUTO-IRIS OPERATION

Do you hear the iris closing sound when the power shuts off? If not, check the iris motor. Check for motor continuity with the ohmmeter. Try pointing the camera at a bright subject, and notice if the iris opening changes. Check the voltage from the IC to the iris motor (Fig. 13-9).

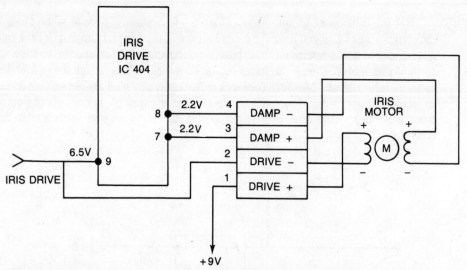

Fig. 13-9. Check for correct voltage applied to the iris motor movement. A low continuity measurement across each winding, 3 and 4 and 1 and 2 may indicate a normal winding.

CYLINDER OR DRUM DOES NOT ROTATE

The cylinder or drum is rotated by the cylinder or drum motor. The drum or cylinder motor operates from a signal or voltage of the drum-servo IC (Fig. 13-10). Check the voltage source feeding the cylinder ICs. You may find a 5V and 12V source to the servo ICs. The cylinder or drum motor operates in play and record mode. The drum

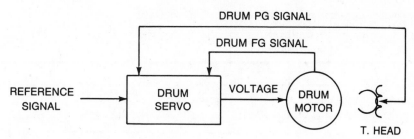

Fig. 13-10. Check the voltage at the drum motor for no rotation. No voltage may indicate the drum or cylinder servo IC is defective.

or cylinder is usually controlled by the mechanism or servo IC. Check voltages on the cylinder motor drive IC, and compare them to the schematic diagram (Fig. 13-11). If voltage is present at the motor terminal, check each motor winding for open conditions. Check voltages on the dc-dc converter IC found on some chassis.

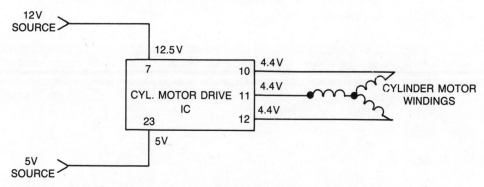

Fig. 13-11. A defective cylinder motor drive IC can place incorrect or no voltage on the cylinder motor windings.

CAPSTAN MOTOR DOES NOT ROTATE

Notice if the tape rotates in FFWD or REW modes. Can you hear the motor rotate? Often the capstan motor contains a motor belt that runs from the motor to the capstan/flywheel assembly. Inspect the belt. The belt may be off or broken. The capstan motor is controlled from the mechanism and servo IC. The capstan motor when controlled by the mechanism IC operates REW (rewind), FFWD, idler shifting, and unloading. The servo IC controls the operation of record and play modes.

Check the main voltage source feeding the capstan motor ICs if the motor will not rotate. Measure and compare voltages on the capstan drive IC, (Fig. 13-12). In some capstan circuits the control reverse voltage is 0V, 2.5V in forward, and 5V in stop mode. If voltage is present at the motor terminals and drive IC, check motor continuity with the ohmmeter.

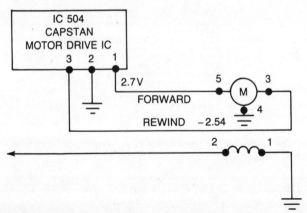

Fig. 13-12. Here is a block diagram of the typical capstan motor with a different voltage applied for rewind or forward modes.

ERRATIC MOTOR OPERATION

With any dc motor, monitor the dc voltage applied to the motor terminals, and notice any voltage change when the motor appears erratic. If voltage is intermittent, check the motor drive IC or speed control circuitry. Lightly tap the motor while operating it, and notice the change in speed. Replace the intermittent motor. Servo speed problems should be tackled by a camcorder specialist.

NO ERASE

When the pictures and audio seem to be a jumbled mess, check for no erase problems. Although these problems are rather rare, the erase circuit or tape head can be defective in the tape path. Check for voltage on the flying erase head (Fig. 13-13). Monitor the bias voltage with an oscilloscope, if handy. Measure the continuity of the FE head with the ohmmeter. Check the bias oscillator circuits for poor audio recording.

HORIZONTAL SYNCHRONIZATION LOSS IN PLAY MODE

Horizontal drifting in play mode can result from drum or cylinder comparison signals of the servo driving the motor. Faster or slower speeds than normal result in horizonal drifting. Check the voltage source feeding the servo and drive ICs. Monitor drum or cylinder motor voltage for a change. The cylinder or drum speed control IC may be defective. Inspect the cylinder or drum motor for changing speeds. Clean up the drum pick-up head.

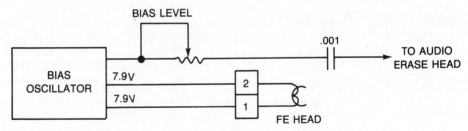

Fig. 13-13. The typical flying erase head is excited with a bias oscillator applied to the FE head winding.

NOISY PICTURE: HORIZONTAL JITTERS IN PLAY MODE

Remove the cassette and insert a commercial recorded cassette, or one that is known to be normal. Adjust the tracking control. Clean up and inspect the pick-up head. The control head may be defective or clogged with oxide. Check voltages on the cylinder motor and drive IC. Suspect a defective intermittent cylinder motor.

NOISY PICTURE IN PLAY MODE

The noisy picture is caused by a faster or slower speed of the capstan motor. Random noise is caused by a defective video head, clogged head, or recording amplifier. This noise may be in sections of the picture, indicating one video head channel is defective or dirty. Clean up the video heads and notice the difference. Inspect the video heads for worn areas where the tape runs. Check the voltage applied to the capstan motor for fast or slow speeds. A defective capstan motor will speed up or slow down (Fig. 13-14). Replace the capstan motor.

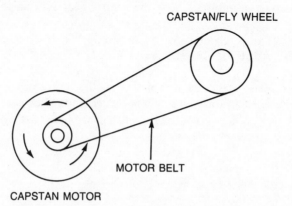

Fig. 13-14. A noisy picture may be caused by a change of speed of the capstan motor. Replace the motor if it changes speed with normal applied voltage.

PART OF THE PICTURE IS NOISY

If part of the picture is noisy, try another cassette. Reset the tracking control. Clean up the tape heads. One or more tape heads may be clogged, causing sections of the picture to be noisy. Inspect the heads for worn places. The whole head assembly must be replaced when one head is excessively worn.

THE WHOLE PICTURE IS NOISY

Check the video heads for clogging oxide build up when the whole picture is noisy. Inspect the video heads for worn spots. Suspect a defective recording amplifier section. If recording from a VCR or television and the pictures are noisy, adjust the tracking. Tape may be worn, try another new cassette. Check the connecting cables for poor connections.

GRAINY PICTURES

If your picture is grainy, try another cassette known to be good. Try another cassette that was recorded on another VCR. Readjust the tracking control. Suspect dirty video heads, and inspect the head for worn areas. Clean up the heads and try again.

VERTICAL JITTERS

Insert another cassette recorded by another VCR and place the camcorder in play mode. Readjust the tracking control. The tracking reset control may need adjustment by the camcorder repairman. Check the control head IC voltage.

PRERECORDED CASSETTE IS NOISY

Make sure this cassette is normal. Try another prerecorded cassette and see if it is noisy. Sometimes you may pick up a noisy recording. Readjust the tracking control. If it is in the camcorder, the control head and control IC must be checked with a blank tape by the camcorder technician.

IMAGE NOT CLEAR AND SHARP

Remove the lens cap and clean up the lens area, especially if you have been shooting pictures outdoors (Fig. 13-15). Inspect the lens or protective filter for something smeared

or spilled on the glass area. Check for moisture on the lens. Carry a camera lens cleaning kit along in the camcorder tote bag. Check the manual focus.

Press the on/off button to auto focus if no focus frame appears. Remember, dark objects may absorb infrared light—use manual focus.

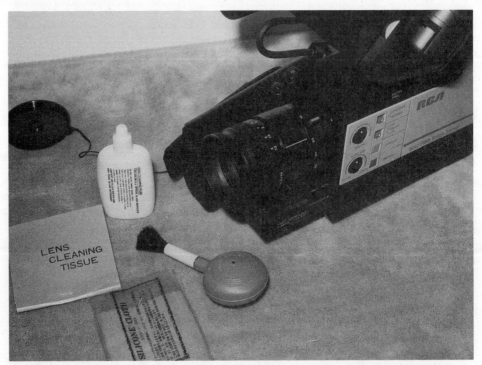

Fig. 13-15. Clean up the lens or filter assembly especially after using the camcorder outdoors.

IMAGE LOOKS OVEREXPOSED

Check the white balance set up. Manually change the setting of the iris control. Excessive light leads to overexposure. Use an ND filter to reduce light intensity. In some camcorders a backlight compensation button is pressed during recording of subjects in bright light, to bring out details of the image or subject. Check for the white balance switch on the front of some camcorders to select the correct color temperature during bright indoor and outdoor shots.

WHITE BALANCE DRIFTS DURING CLOSE-UPS

Check the close-up switch setting. Inspect the close-up switch for poor contacts. Take a continuity ohmmeter measurement across the switch terminals (Fig. 13-16).

Fig. 13-16. Check for dirty switch contacts or poorly-soldered lead connections if the white balance drifts during close-up shots.

Inspect the switch wires and pc board for poor soldering. Measure the voltage source feeding the IC that the close-up switch operates from. Suspect a defective IC if all tests work out.

NO SCENE APPEARS IN VIEWFINDER

Is the camcorder power button on? Recheck to see if the lens cover is on. Remove the lens cover with the palm of your hand flat against the cover and turn it counterclockwise. Slide the lens cover door open in some models. Check the faze out button position. Place the unit in Stop mode. Press the record button to enter the record/pause mode. Check the electronic viewfinder cable to the camcorder. The cable may be loose or unplugged (Fig. 13-17). Suspect a defective electronic viewfinder if the camcorder records, and there is no picture in the viewfinder.

TAPE TRANSPORT STOPS DURING FFWD OR RECORD

Re-check the memory function on the tape counter, if it is set for a certain time. Press the memory or reset button. Inspect the capstan for rotation. Suspect a broken belt from the capstan motor to the capstan/flywheel assembly. Give the capstan motor pulley a spin. No movement indicates a frozen capstan motor bearing. Check the capstan motor voltage and continuity if the motor does not rotate. Inspect the idler pulley. Make sure the pendulum pulley is engaging the take-up and supply reel assembly during FFWD or record modes.

Fig. 13-17. With the power on, and no light in the electronic viewfinder (EVF), inspect the plug or see if it is unplugged from the camcorder.

NO ON-SCREEN DISPLAY

Notice if all screen indicators are off in the screen display. Reset the power switch and press the display switch. Inspect the EVF for no picture. Try another battery (Fig. 13-18). Insert the ac adapter and see if the display comes on or connect an external battery pack to the external battery jack. Check the voltage source supplied to the on-screen display IC (Fig. 13-19). If only the battery display does not come on, apply dc voltage to the external battery jack.

Fig. 13-18. If the display does not light up in any operating mode, try another battery.

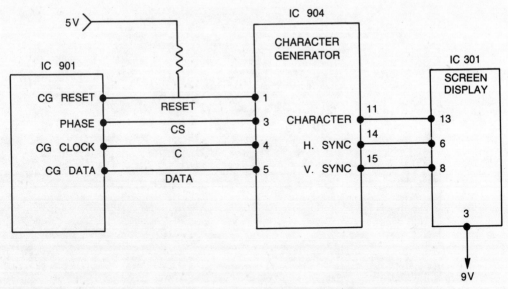

Fig. 13-19. Measure the voltage applied to the screen display ICs with no panel indication.

INPUT KEY SWITCH NOT OPERATING

If the input key switch does not operate, check the following settings:

- Check the VCR and camera key.
- Check FFWD, Stop, Display, Reset, Reverse, Pause, Play, and Rewind.
- Press the function key.
- Check the camera keys.
- Set the selector switch to camera.
- Check Rewind, and the VCR/REC switch.

Check the line voltage source to the key display IC (Fig. 13-20). Measure the voltage on the key IC. Suspect a defective key button if only one display is defective.

DETECTION INDICATORS INOPERABLE

If none of the detection indicators operate, suspect a defective detect circuit IC (Fig. 13-21). Measure the supply voltage on pin 8 of IC901. For no tape end indication, check the dew indicator and take-up reel pulses. Suspect a defective IC901 if all indicators are off. Go over all trouble indicators to see which ones are not functioning. Check the individual indicator when only one is not operating.

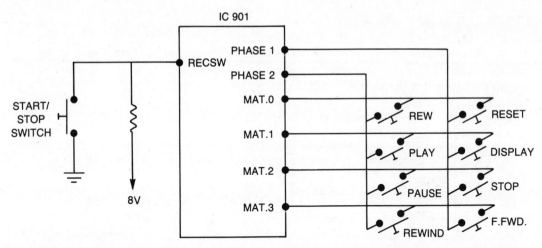

Fig. 13-20. Check the supply voltage source and take a continuity test of the switch function when only one or two modes do not operate.

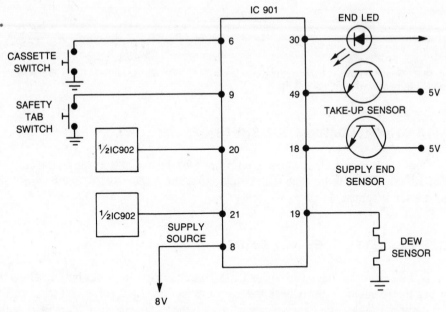

Fig. 13-21. A typical block diagram of the trouble sensor circuits. Measure the voltage source (pin 8) of detector IC901.

POWER LED IS NOT WORKING

Suspect improper voltage or a defective LED when power is turned on but the camcorder LED is out. Measure the voltage across the LED. Check the LED like any diode, check it with the DMM (Fig. 13-22).

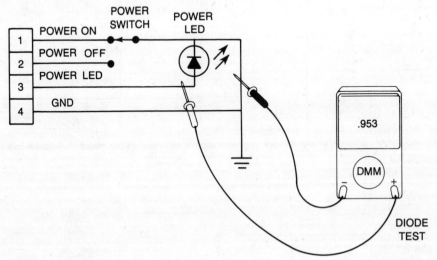

Fig. 13-22. Test the power LED with the diode test of the DMM. Measure the voltage applied across the LED terminals when it will not light.

CASSETTE STARTS LOADING BUT SHUTS OFF

Does the tape end indicator come on? Check for the end of the tape on the cassette (Fig. 13-23). Notice if the tape is not engaged at the guide pole. Check to see if the end sensor is activated.

INSERTED CASSETTE DOES NOT EJECT

Is the power on? Does the power LED light up? Press the eject button. Does the loading motor begin to run? Check the eject mechanism. Look for a bent lever or one that is out of line. Measure the voltage applied to the loading motor if there is no motor rotation (Fig. 13-24).

CASSETTE HOUSING DOES NOT MOVE

Check for a bent or damaged cassette housing mechanism. Check the take-up loading ring to see if it is in contact with the housing eject lever. Does the take-up pole base

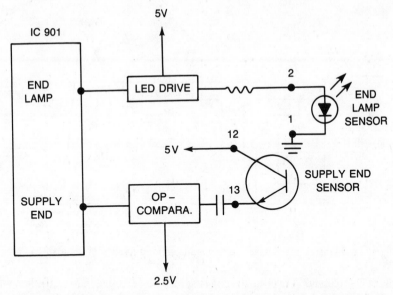

Fig. 13-23. Check the cassette indicator circuits if the tape is at its end and there is no indication.

Fig. 13-24. Check the loading motor voltage and perform continuity ohmmeter tests of the winding when it does not eject the cassette.

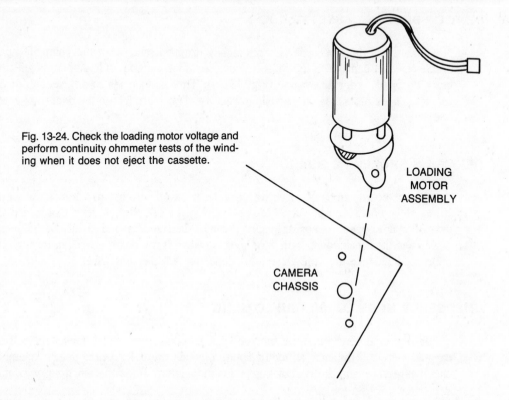

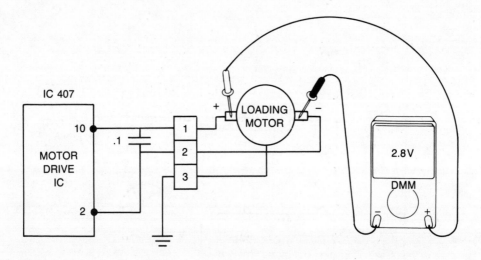

Fig. 13-25. Measure the loading motor voltage with no rotation of the loading motor.

return completely? A take-up loading ring may be defective. Check the line voltage source at the loading motor IC (Fig. 13-25). Measure the continuity of the loading motor windings.

BENT OR BROKEN CASSETTE DOOR

Sometimes the camcorder is accidentally dropped, and often the point of impact creates cabinet damage. If the cassette door becomes bent out of line or damaged after being dropped, order a new one (Fig. 13-26). This also applies to any section of the cabinet. These parts may take awhile to receive. Try to straighten the door until a new one arrives.

REPAIRING BROKEN PC BOARD

The pc board can be repaired with regular hook-up wire bridged across the wiring traces, if the board breakage is not too severe (Fig. 13-27). Always, treat that camcorder delicately, if dropped from great heights it can be damaged beyond repair. Carefully solder across the break points with bare hook-up wire. If the board is broken through the entire middle, take it to the camcorder depot for a repair estimate.

EMERGENCY MODE LOADING/UNLOADING

In reel emergency mode, if the reel disk does not turn, check for rotation of the capstan motor. If the capstan motor rotates, check the belt, center pulley assembly, clutch assembly, and the reel disk-gear for movement. Does the pinch roller contact

Fig. 13-26. When the camcorder is dropped on a hard surface, a bent or broken cassette door may occur. Remove and repair the door, if possible.

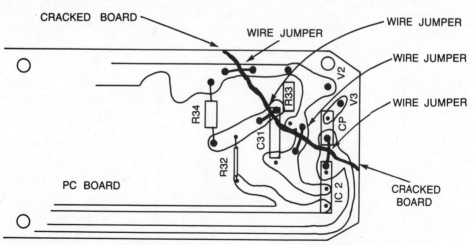

Fig. 13-27. Try to repair the broken pc board by bridging the broken wiring with bare hookup wire. Forget the repair if it is cracked down the middle of the large servo board.

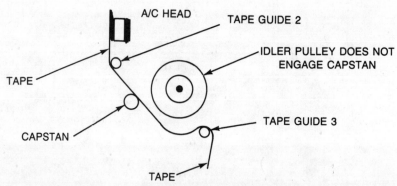

Fig. 13-28. Make sure the idler pulley is right against the capstan and tape when the reels do not move.

the capstan (Fig. 13-28)? If not, check the loading gear, take-up loading ring, and the pinch roller arm assembly. With a normal pinch roller, suspect a defective capstan motor if there is no rotation. If the reel disk turns in the record mode, suspect a defective supply reel or circuits.

DEW SENSOR INDICATION

Dew sensor problems can place the camera in Stop mode or not let the camcorder start up. Of course, the drum or cylinder does not rotate during loading. The unit may come on for a few minutes and then shut off the power. A defective dew sensor or sensor IC will cause this condition. The dew sensor element resistance increases as moisture increases, developing an increase in voltage to the sensor IC901 (Fig. 13-29). Check the dew sensor for high resistance. Measure the supply source voltage to the comparator IC902. In some 8 mm models the dew sensor works directly from the system control IC.

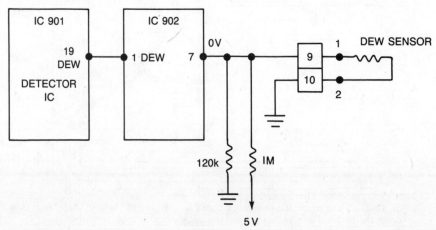

Fig. 13-29. Check the dew sensor resistance and the indicator circuits when the dew indicator will not shut down.

Notice if the dew sensor LED is on. Wait until the camera reaches room temperature, and the dew indicator should go out. Suspect a defective sensor IC if the dew sensor LED stays on all the time.

REMOVING A JAMMED CASSETTE

Usually the cassette cannot be ejected when it is jammed. Sometimes a momentarily stopped take-up reel will let tape spill out. The excess tape may be all over the insides of the VCR assembly. A worn or deformed pinch roller can cause tape to bunch up and spill out. In many cases, the cassette door cannot be opened.

Remove the cassette cover to look over the tape problem. In some units the cassette can be removed by taking off the "C" or "E" washer from the loading gear. Turn the gear counterclockwise. Rotate the gear to the point just prior to ejection. Be careful with the door or cassette housing assembly. Turn the gear to eject mode. Rotate the take-up gear to return the tape to the cassette. Carefully remove the tape and cassette. Whatever the method used to remove a stuck cassette, be careful not to damage the door or housing.

CASSETTE PROBLEMS

The videocassette may be defective when brand new. The tape may be wound in a wavy fashion, tight or loose, and produce feed or rewind problems. The tape may be noisy creating lines across the picture. Uneven speed problems may result with a poor grade of tape. Always, keep the loose tape rewound before inserting the cassette. If the plastic covering of the cassette is cracked or broken, do not use it. Simply try another cassette.

NO EVF RASTER

Make sure the electronic viewfinder cable is plugged into the camcorder with no brightness on the screen. Readjust the brightness and horizontal hold controls. Check the voltage source feeding the EVF, if missing, inspect the regular power supply source. Measure the voltage on the small CRT (Fig. 13-30). These voltages may vary from unit to unit. Be sure your voltmeter will go high enough to measure the anode voltage.

Often, the horizontal and vertical oscillator waveforms are found in one large IC with video and sync circuits. Check the supply voltage feeding the large IC (Fig. 13-31). If an oscilloscope is handy, take vertical and horizontal waveform readings at pins 2 and 16. Take voltage measurements from the horizontal drive transistor with no high voltage or raster.

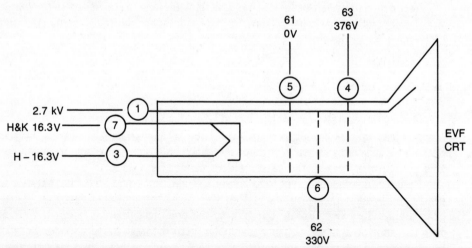

Fig. 13-30. Here are the typical voltages found on the CRT of the electronic viewfinder. Be careful measuring the 2.7 kV at pin 1 with low-priced VOMs or DMMs.

Be careful when working around the EVF. Sometimes the small CRT is broken when the camcorder is dropped on the sidewalk or any hard surfaces. Take the EVF unit to the camcorder service depot for an estimate. If the unit is separate from the camcorder, a new EVF unit may be cheaper to purchase than to have it repaired. Get a repair estimate.

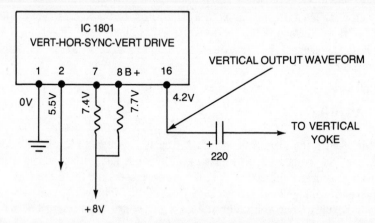

Fig. 13-31. Check the voltages on the large vertical/horizonal sweep IC with no brightness on the EVF screen.

14

AC Adapter Problems

Just about every camcorder comes with an ac adapter, so you can operate the unit from the power line. In fact, some camcorders have a car battery adapter that allows the camcorder to be operated from the cigarette lighter. Every camcorder can be operated from a battery or battery pack source. Some of the ac battery adapters slide right on the back-side of the camcorder, while in others the power source cables the correct voltage from the ac adapter to the camcorder.

The ac adapter is often combined with a battery charging device. Besides operating the camcorder from the power line, the adapter unit can be used to charge up nickel-plated batteries. The battery pack conveniently slips right into the charger and ac-dc adapter. The ac adapter may have shut down circuits and overcharging detection devices to protect the camcorder or adapter.

8 MM AC ADAPTER BLOCK DIAGRAM

Just about every camcorder has a different operating voltage supplied by the ac adapter. The voltage can be 5, 6, 8.5, and 9 volts. The dc-dc converter can supply several different voltages, and may be located in the ac adapter or inside the camcorder itself. The dc-dc converter circuits can supply 5, 6, 8.5, 9, 12, 18, and 20 volts dc for the camera circuits.

The small ac adapter-charger may have a power transformer, protection, switching, constant voltage, constant current charging, and protection circuits (Fig. 14-1). Other power adapters consist of a power transformer, rectifier, switch control, charge-adapter control, indicator-switching, and timer control circuits. You may find some small ac adapter chargers do not have a power transformer in the input circuits. Most ac adapters have a voltage adjustment in the output circuits.

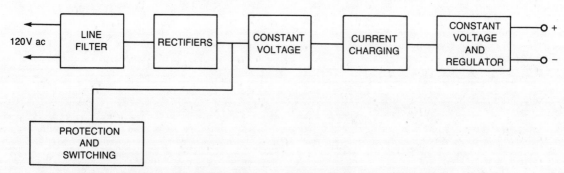

Fig. 14-1. 8 mm block diagram of a simple camcorder ac adapter-charger.

Noise Filter/Rectifier Circuits. The ac input circuits may consist of a noise filter network with a bridge rectifier (Fig. 14-2). The bridge rectifier is found in one unit. The ac passes through the noise filter network to the bridge rectifier component. Here the ac is rectified to dc and filtered with a large filter capacitor.

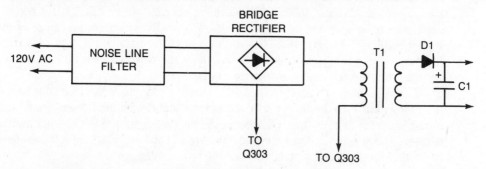

Fig. 14-2. Block diagram of the input circuits of the ac adapter unit.

Switching Circuits. The dc voltage is fed to the primary winding of T1 and Q303, where it is alternately switched with the output at pin 1 of IC101 and converted to pulse current. When current flows through transformer (T1), voltage will appear at the secondary winding of T1 and D2 (Fig. 14-3). C2 and L2 filter the output dc voltage.

As power is turned on, the start up circuit (Q101 and Q202) is turned on with voltage applied to pin 8 of IC101. A PWM signal (50 kHz) is found at pin 7 of IC101, it passes through drive circuits Q4 and Q5 and base switching transistor Q303.

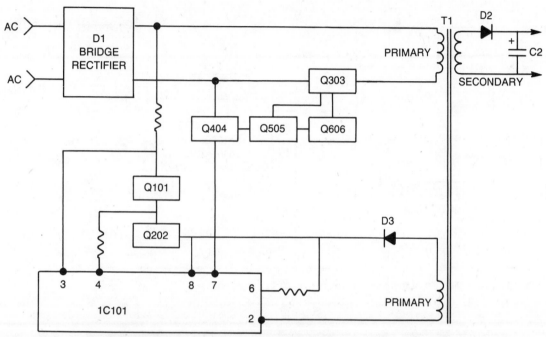

Fig. 14-3. 8 mm block diagram of switching circuits of the ac adapter.

When IC101 is activated, the voltage at the primary winding and D3 is applied to pin 8 of IC101. Q606 applies a reverse bias to the base of Q303 to reduce switching loss. The start-up circuit stops at pin 4 of IC101 with a bias voltage. The voltage level at pin 3 of IC101 becomes low (L), turning off Q101 and Q102.

Constant Voltage Circuits. The error amplifier inside IC202 tends to regulate the output voltage during operation (Fig. 14-4). ZD3 provides a positive reference voltage, and a negative reference voltage is found at pin 6 of IC202, preset with VR1.

If the output voltage rises at the positive terminal (+), the error amplifier voltage increases, causing a drop in the error amplifier output, which increases the current flowing through photodiode PHC101 via D3. An increase of current at PHC101 increases voltage at pin 12 of IC101. The shortening of pin 7 of IC101 becomes low, driving Q404 on and shorting out Q303 to the on position, dropping the output voltage. When the output voltage drops, it is raised to the constant voltage level (+6V).

Constant Charging Current Circuits. The error amplifier in IC202 tends to regulate the current at a constant value (Fig. 14-5). During charging the voltage across ZD3 provides a reference voltage at the positive (+) terminal.

The charging current is converted into a voltage when it flows through R31 and applies a negative (-) reference voltage at pin 2 of IC202. The charging current is constant at 1.2 amperes. The charging terminal C is high (H) with Q10 and Q9 turned off. This increases the error amplifier reference voltage at pin 1 of IC202, turning D8 off.

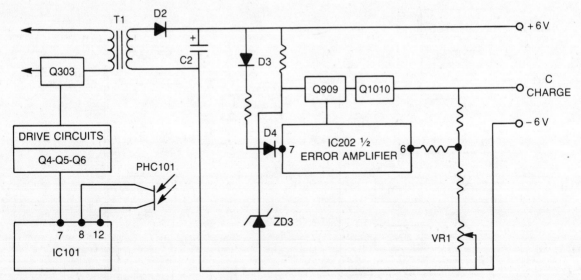

Fig. 14-4. Block diagram of the constant voltage circuit in the ac adapter.

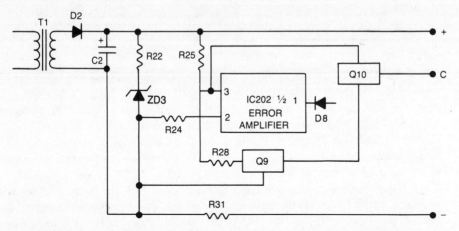

Fig. 14-5. Block diagram of the constant charging current circuit in the ac adapter.

Protection Circuit. When over-current is noted at pin 5 of IC101, the current is converted at Q303. If the current at pin 5 exceeds the VR1 set value, the latch circuit inside IC101 triggers and stops putting out a PWM signal (Fig. 14-6).

If the secondary side of the television is shorted, or excess current is pulled from the ac output adapter, the voltage applied to D2 drops and PHC202 goes off because the voltage appearing across ZD2 drops, and PHC202 is open to increase the Q808 base voltage. This lowers Q808 output voltage, Q5 is turned off and Q303 stops the switching operation. When Q808 starts, the base of Q707 is turned on. The complete shut-

down of the protection circuit begins. The short or overloaded output circuit in the camcorder tied to the ac adapter voltage must be repaired before connecting to the adapter unit.

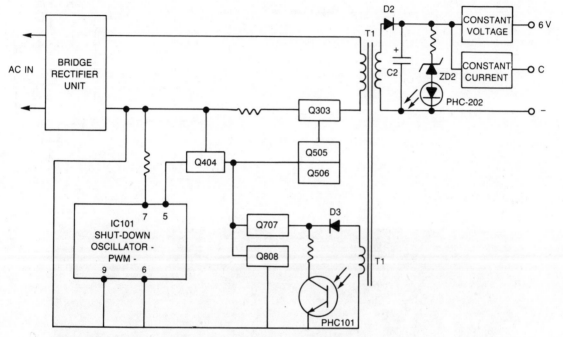

Fig. 14-6. Block diagram of the charger protection circuits in the ac adapter unit.

VHS-C ADAPTER BLOCK DIAGRAM

The VHS-C ac adapter is quite similar to the 8 mm adapter, different voltages are provided according to the individual camcorder. The ac adapter consists of the input circuit with a line noise suppressor for surge current prevention, bridge rectifier, flyback converter, and a transformer (Fig. 14-7). The secondary or adapter circuit contains the pulse transformer, rectifier, filter protection, dc-to-dc inverter, switch control, and regulation circuits. Charger/adapter circuits consist of a charger/adapter control, charge switch, timer, and indicator-switch assembly (Fig. 14-8).

Primary or Input Adapter Circuit. Fuse (F101) protects the circuits from abnormal input voltage and currents. The input line noise filter consists of a choke-coil in each line, with several bypass capacitors. Thermistor TH1 prevents surge current from

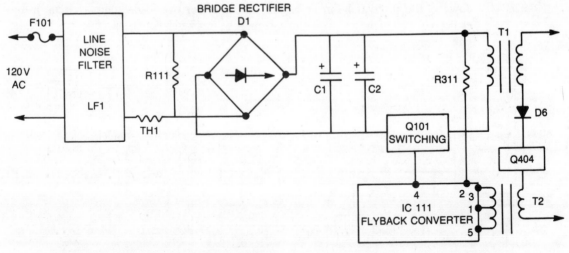

Fig. 14-7. VHS-C ac adapter input circuit block diagram.

Fig. 14-8. Inside view of the ac adapter unit.

entering filter capacitors C1 and C2. The ac input voltage is rectified by a bridge rectifier and input capacitors (C1 and C2) provides an adequate filtering network.

The inverter is a flyback converter (IC111) using Q101 as a switching transistor. When current starts to flow to IC111 through R311, Q101 starts oscillations. The high frequency voltage is applied to the primary winding of T1, and voltage is developed in

the secondary winding of T1. This voltage is applied between D6, Q404, and the secondary of T2. Positive feedback with pins 1, 3, and 5 of IC111 is tied to the primary of T2 and Q101 continues to oscillate.

The Secondary Adapter Circuits. When power is applied from the pulse transformer, secondary (T1) is rectified by D4 (Fig. 14-9). The ripple voltage is smoothed out with L3, C10, and C11. LED (101) lights up when power is applied. When the VCC voltage (pin 12) exceeds approximately 3V, the oscillator circuit of IC222 oscillates at approximately 80 kHz.

All circuits are controlled by the regulated 14V dc at the output terminals, when switch (SW301) is turned to the adapter position. The detected voltage is compared to the reference voltage by IC222. The pulse signal with pulse-switch modulation is from pin 16 of IC222 and applied to switching transistor (Q505). The PWM pulse controls the switching transistor with the secondary winding of T2, controlling the output voltage to a regulated 14 volts. VR2 adjusts the regulated 14 volts.

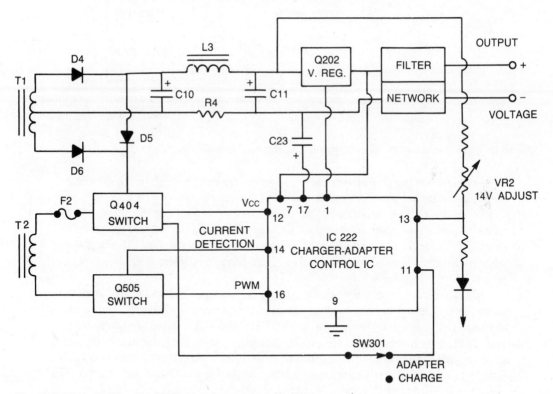

Fig. 14-9. Block diagram of a VHS secondary adapter circuits.

VHS Charger/Adapter Circuit. This particular charging constant output current is 1.2A or 0.7A with the battery switch S2 turned off. When the battery is inserted the sense switch (S3) automatically sets to charge position. The PWM pulse from pin 16 of IC222 is fed to switching transistor (Q505) and drives switching transistor (Q404)

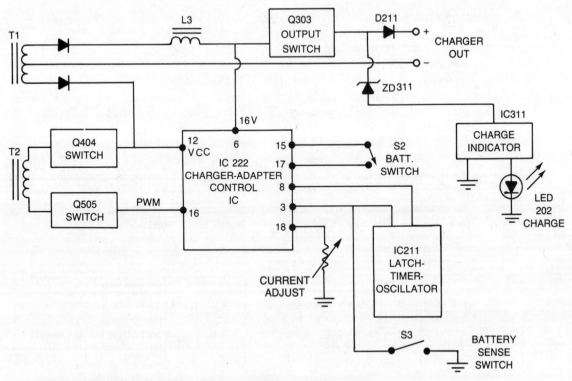

Fig. 14-10. Block diagram of the VHS charger circuit of the ac adapter unit.

in the primary winding of T2 to control a constant output current (Fig. 14-10). The charger output is controlled by Q303 and is on during the charge mode.

When the charger is operating, no output voltage is found at the adapter voltage terminals, since switching transistors (Q202) is turned off. Diode D211, in series with the positive charger terminal prevents battery current from entering the power supply adapter circuits. If the 16 volts at pin 6 of IC222 becomes higher, Q303 is switched off with no output charger voltage.

IC211 begins to operate when the battery is inserted for charging, the latch timer stops charging after 1 ½ hours. During charging, the charge LED 309 is lit. After charging is completed, the voltage over 16V turns ZD311 and IC311 on, and switches off the LED 202 to indicate charging is completed. A charge timer is not found in many ac charge adapter units, and you must follow the manufacturers' charging methods and correct time. If components overheat or break down in the secondary circuit, thermal fuse (T3) opens up for circuit protection.

CAR BATTERY ADAPTER/CHARGER

The car battery voltage is supplied to the adapter unit by plugging into the cigarette lighter socket. The 12-volt car battery is converted down to 9 volts with a dc to dc

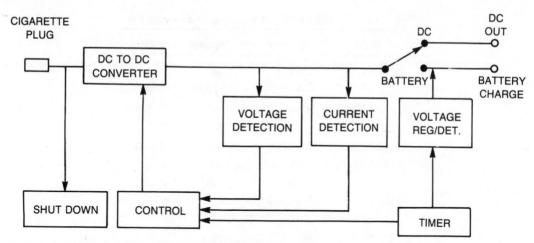

Fig. 14-11. Block diagram of a car battery charger/adapter unit.

converter circuit (Fig. 14-11). The car adapter circuit contains a shut down, control, voltage detector, current detector, timer, and dc to dc converter.

When the input voltage falls below 10 volts, the shutdown circuit begins to operate, and shuts down the charger adapter, protecting the car battery. The voltage detection circuit regulates the output voltage to not exceed twice the output voltage during charging, and 12 volts during camcorder operation. The current detection circuit regulates the charging current during battery charging and camcorder operation. It also provides circuit protection from overloaded conditions. Voltage detection and timer operation indicate the correct voltage, and shut off the charging operation after several hours of operation.

VOLTAGE OPERATION

You may find that each camcorder can be operated with a different voltage source (Table 14-1). The battery voltages range from 6 to 12 volts. The ac adapter voltage is usually higher than the battery voltage. The charging voltage measured at the cable terminals, without a load, is much higher. For instance, the camcorder may operate with a 6.5-volt source from the adapter, except in charging the voltage may exceed 10 volts.

ADJUSTMENT OF VOLTAGE SOURCES

The camcorder voltage adjustments are made at the adapter/charger, inside the camcorder, or both. The adapter output voltage should be adjusted for the correct battery operating voltage. For instance, the Realistic 16-851 model operates from a 12-volt battery source and the ac adapter output voltage should be adjusted for 14V dc. In a Cannon CA-E2A model, the battery source is 6-volts dc and VR1 in the adapter unit is adjusted

Table 14-1. Operation voltages of the various camcorders.

Name	Model Number	Voltage	Format
Cannon	CA-E2A	6V	8 mm
JVC	GR-C7U	9.6V	VHS-C
General Electric	9-9605	12V	VHS
Minolta	C3300	9.6V	VHS-C
Mitsubishi	HS-C20U	9.6V	VHS-C
RCA	CPR100	12V	VHS-C
Realistic	16-851	12V	VHS-C
Sony	CCD-M8E/M8U	6.3V	8 mm

so the voltage is 6.5 volts ± 0.5 volts at the adapter output cable with no load. The charging voltage for the same adapter is approximately 10.5V dc at 1.25 amperes.

The output voltage of some adapter/charger units is made with a resistor tied across the output terminals, while others are adjusted with the camcorder as the load (Fig. 14-12). The resistor acts as a load with the camcorder disconnected. Adjust the adapter output voltage to about 1 volt over the battery voltage or to manufacturers specifications. Plug in the camcorder and let it operate in CRT mode. Check the voltage at the camcorder, it should be equal to the battery voltage. Some adapters have a charging current adjustment. Follow the manufacturers' electrical battery and charger voltage adjustments for your model of camcorder.

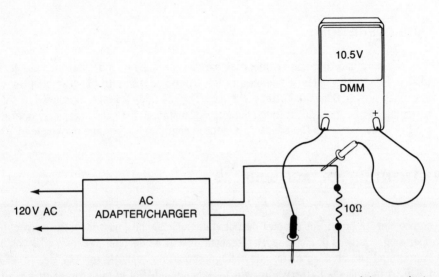

Fig. 14-12. The 10-ohm resistor acts as a load to adjust the voltage output of the ac adapter.

CHECKING POWER CORDS AND CABLES

Most ac adapter units slide on the backside of the camcorder, in place of the battery. Clean up the slip-pressure contact points of the camera and adapter when the camcorder cannot be operated from the power line. Inspect the contact points for broken or bent areas. Take a dc voltage measurement at the output terminals.

Remove the power pack and top cover from the power adapter. Check each fuse. Some ac adapters have up to three different fuses. Check the suspected fuse on the low-ohm scale of a VOM or DMM for open-circuit conditions. Check for ac input voltage (120V ac) at the bridge rectifier. No ac voltage at this point indicates a defective ac plug and cable. Check each side of the line up to the ac connections of the bridge rectifier. The defective on/off switch may be open. Suspect a broken wire at the ac plug or where it plugs into the ac adapter. Continuity checks of each wire with the ohmmeter may locate a break in the dc cable to the camcorder.

KEEPS BLOWING FUSES

Suspect a shorted bridge rectifier if the line fuse will not hold. Check across each diode for leakage. Sometimes, one or two diodes become shorted and leaky in the bridge rectifier. The whole component must be replaced if all the diodes are in one unit. Replace it with the ordinary 3-amp television bridge rectifier. Sometimes, a line varactor hit by lightning causes the fuse to blow.

If the diodes are good, and the fuse still blows, check the filter capacitors and corresponding circuits for overloaded conditions. A low resistance measurement under 1k ohms across the filter capacitor indicates a leaky capacitor (Fig. 14-13). Often, the dc to dc inverter will shut down if a component is leaky in the secondary circuits.

RANDOM TRANSISTOR AND DIODE TESTS

A quick method to check for a leaky or shorted diode or transistor is to make a random check with each semiconductor on the pc board. Switch the DMM to diode or transistor test, and check the resistance across each diode. This diode test can check zener and LED diodes besides regular fixed diodes. Reverse the test leads when a diode shows a low resistance measurement. Remove one end of the diode from the circuit when a low measurement is noted in both directions.

Most transistors can be checked with a common base check to the collector and emitter terminals for leakage or open conditions. Like the diode, the good transistor should only have a low resistance in one direction. No measurement between the base and emitter or base and collector indicates the transistor is open. Most of the transistors found in the ac adapter are NPN types.

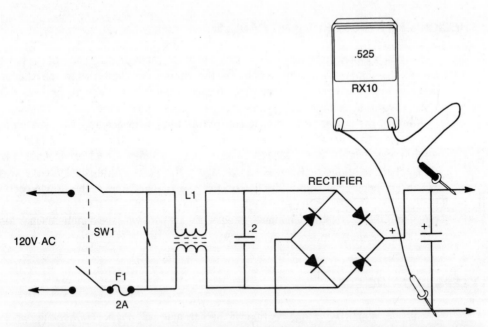

Fig. 14-13. Quick low ohm tests indicate a leaky filter capacitor, diode, or overloading components. Remove the positive lead from the bridge diodes to break up the circuit and easily locate the leaky component.

CHECKING ICs AND OTHER COMPONENTS

Critical voltage measurements taken on each pin of the suspected IC may indicate a low voltage measurement caused by a leaky IC. Check especially for correct voltage at the supply voltage pin (VCC) of the suspected IC. If the voltage is extremely low, suspect a leaky IC. Remove the pin lead from the pc board with solder-wick. Take a resistance measurement to ground and free the pin of the IC for a low reading. Often, a low resistance measurement (under 1k ohms) indicates a leaky IC.

Transformer windings can be checked with an RX10 ohmmeter measurement. A low continuity measurement may indicate the winding is normal. No measurement indicates the winding is open. Critical components such as transformers and ICs should be ordered directly from the manufacturer.

The photocoupler enclosed in one component can be checked with the diode test of the DMM (Fig. 14-14). Check the diode side, like any diode. The normal diode terminals will indicate a low measurement, and no reading with reversed test leads. The transistor side can be checked in the same manner across terminals 3 and 4. A low resistance measurement indicates the photo-transistor is leaky.

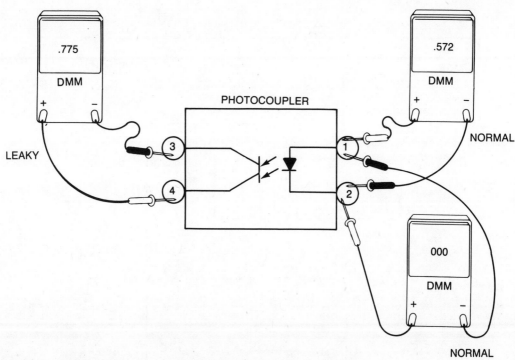

Fig. 14-14. The photocoupler can be checked with the diode test of the DMM.

WILL NOT CHARGE

Suspect a defective switch assembly when the ac adapter operates the camcorder, but will not charge up the battery. Check the charge/adapter switch for poor or dirty contacts (Fig. 14-15). Test each set of switching contacts with the low-ohm scale of the VOM or DMM.

Check the slip-in contacts of the battery and charger. Clean off contacts with a piece of paper towel. Check for a good ground connection. Measure the charging voltage at the battery contact terminals with the battery removed. Sometimes, an isolation diode (D1) is found in series with the positive battery lead, so the battery does not leak back into the adapter while charging. Test the diode for open or high resistance measurement with the diode test of the DMM.

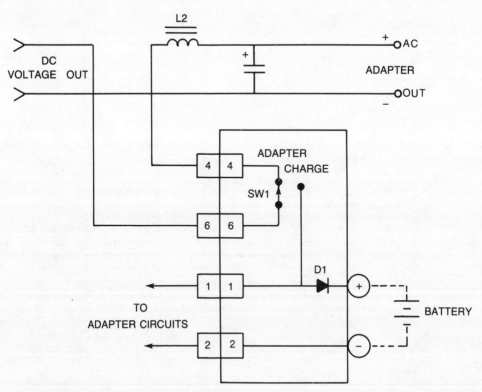

Fig. 14-15. Suspect a dirty or broken adapter/charge switch (SW1) when there is power using the ac adapter, but it won't recharge the battery.

Appendix A:
Abbreviations

Here is a list of manufacturers' most-used abbreviations to help understand the various camcorder circuits.

AC	Alternating Current	ALC	Automatic Level Control
ACC	Automatic Color Control	ALM	Alarm
A/CTL	Audio Control	ALU	Arithmetic Logic Unit
ADC	Analog to Digital Convertor	AM	Amplitude Modulation
ADD	Adder	AMP	Amplifier
ADJ	Adjusting	ANT	Antenna
ADUB	Audio Dubbing	APC	Automatic Phase Control
AE	Audio Erase	APL	Average Picture Level
AEF	Automatic Editing Function	A/S/M	Audio/Servo/Mechacon
AFC	Automatic Frequency Control	ASSY	Assembly
AFT	Automatic Fine Tuning	ATT	Attenuator
AGT	Automatic Gain Control	AUD	Audio
AH	Audio Head	AW	Automatic White
AHD	Audio High Density Disc	AUX	Auxiliary
AL	After Loading	B	Base, Blue

BAL	Balance	CD	Count Down
BATT	Battery	CE	Chip Enable
BBD	Bucket Brigade Device	CF	Ceramic Filter, Correct Focus, Color Frame
BCD	Binary Coded Decimal		
BEG	Beginning	CFG	Capstan Frequency Generator
BF	Behind Focus, Burst Flag	CFVSEL	Capstan Frequency to Voltage Converter Select
BFP	Burst Flag Pulse	CH	Channel
BIT	Binary Digit	CHG	Charge
BLK	Black, Blanking	CHROMA	Color
BLU	Blue	CLK	Clock
BNC	Bayonet Connector	CLR	Clear
BOT	Beginning of Tape	CMD	Command
BPF	Bandpass Filter	CMOS	Complementary Metal Oxide Semiconductor
BRK	Brake		
BRN	Brown	CNT	Count, Counter
BRT	Brightness	COL	Color
BT	Band Tuning	COM	Common
BUFF	Buffer	COMB	Combination, Comb Filter
B/W or BW	Black and White	COMP	Comparator, Composite, Compensation
C	Color, Capacitance, Collector	CONN	Connector
CAL	Calibration	CONV	Converter
CAP	Capstan, Capacitor	CP	Circuit Protector, Clamp Pulse
CAR	Carrier	CPC	Capstan Phase Control
CRR	Carrier	CPU	Central Processing Unit
CASS	Cassette	CTC	Crosstalk Channel
CC	Cassette Compartment	CTL	Control
CCD	Charge Coupled Device	D	Drum, Digital, Diode, Drain
CCT	Circuit	D/A	Digital to Analog
CDS	Cadmium Sulphite	DAC	Digital to Analog Converter

DB	Decibel		EXP	Expander
DC	Direct Current		EXT	External
DD	Direct Drive		F	Farad, Fuse
DEC	Decoder		FADV	Frame Advance
DEMOD	Demodulator		FDP	Fluorescent Display Panel
DET	Detector		FE	Full Erase
DEV	Deviation		FET	Field Effect Transistor
DFRS	Drum Free Running Stop		FF	Fast-forward, Flip Flop, Front Focus
DG	Differential Gain		FG	Frequency Generator
DISCR	Discriminator		FI	Field Index
DL	Delay Line		FIX	Fixed
DLY	Delay		FM	Frequency Modulation
DOC	Dropout Compensator		FMA	FM Audio
DOD	Dropout Detector		FR	Field Recording, Frame, Fusible Resistor
DP	Differential Phase		FREQ	Frequency
DPC	Drum Phase Control		F-V CONV	Frequency to Voltage Converter
DYAC	Dynamic Aperture Control		FWD	Forward
E	Edit, Emitter		FWDS	Forward Search
EDP	Electronic Data Processing		G	Green, Gate Grid
E-E	Electric to Electric		GCA	Gain Control Amplifier
EF	Emitter Follower		GEN	Generator
EMP	Emphasis		GND	Ground
EN	Enable		GRN	Green
ENC	Encoder		GRY	Gray
ENV	Envelope		H	Horizontal, High, Henry, Hour
EO	Error Out		HB	High Brite
EOT	End of Play		HBF	Horizontal Burst Flag
EP	Extended Play		HD	Horizontal Drive
EQ	Equalizer		HG	Hall Generator
ES	Electronic Switch			
ESNS	End Sensor			

HPF	Highpass Filter	MIC	Microphone
HZ	Hertz	MIN	Minimum
IC	Integrated Circuit	MIX	Mix, Mixing
ID	Identification Pulse	MM	
IF	Intermediate Frequency	or MMV	Monostable Multivibrator
IFR	Infrared	MNOS	Metal Nitride Oxide Semiconductor
IFT	Intermediate Frequency Transformer	MOD	Modulator, Modulation
IMS	Images	MOS	Metal Oxide Semiconductor
IND	Indicator	MPX	Multiplex, Multiplexer
INH	Inhibit	MR	Magnetic Resistor
INS	Insert	MS	Mode Select
INT	Internal, Interrupt	MUT	Muting
INV	Inverter	NAND	Not-And
I/O	Input/Output	NC	Not Connected
IR	Infrared	NFB	Negative Feedback
L	Low, Left	NLN	Non-Linear
LCD	Liquid Crystal Display	NO	Normally Open
LED	Light Emitting Diode	NOR	Normal, Not-Or
LIM	Limiter	NR	Noise Reduction
LIN	Linearity	OP	Operation
LL	Low Light	OP-AMP	Operational Amplifier
LLD	Low Light Detector	ORN	Orange
LOAD	Loading Cassette	OSC	Oscillator
LP	Long Play	PB	Playback
LPF	Lowpass Filter	PBLK	Pre-Blanking
LSB	Lower Sideband	PC	Pulse Counter, Photocoupler
M	Motor	PCM	Pulse Code Modulation
MAX	Maximum	PD	Phase Detector
MDA	Motor Drive Amplifier	PG	Pulse Generator
MECHACON	Mechanism Control	PGM	Program

PHS	Photo Sensor		REV	Reverse
PI	Photo Interrupter		REV S	Reverse Switch
PIF	Picture Intermediate Frequency		REW	Rewind
PLA	Programmable Logic Array		RF	Radio Frequency
PLL	Phase Locked Loop		R/P	Record/Playback
PLS	Pulse		RPT	Repeat
P or POS	Position		RS FF	RS Flip Flop
			RST	Reset
P-P	Peak to Peak		RT	Rotary Transformer
PR	Pinch Roller		RUN	Running
PREAMP	Preamplifier		RY	Relay
P/S	Pause/Still		SAW	Sawtooth, Surface Acoustic Wave
P.SET	Pre-Set		SC	Subcarrier, Simulcast
PSC	Pulse Swallowing Control		SCH	Search
PU	Pickup		SEL	Select
PUT	Programmable Unijunction Transistor		S or SENS	Sensor
PW B	Printed Wiring Board		SEP	Separator
PWM	Pulse Width Modulation		SF	Source Follower
PW or PWR	Power		SFF	Short Fast Follower
			S/H	Sample and Hold
Q	Quality Factor		SIF	Sound Intermediate Frequency
R	Red		SN	Signal to Noise Ratio
RA	Resistor Array		SOL	Solenoid
RAM	Random Access Memory		SOS	Sound on Sound
R/B	Red and Blue		SP	Standard Play
REC	Recording		S PLS	Sampling Pulse
REF	Reference		SR	Supply Reel
REG	Regulator, Regulated		SREW	Short Rewind
REM	Remote		S/S	Slow/Still
REMOCON	Remote Control Unit			

SSG	Sync Signal Generator		UNSW	Unswitched
SSNS	Start Sensor		V	Volt, Vertical
STD	Standard		VACT	Video Action
SUP	Supply		VCO	Voltage Controlled Oscillator
SW	Switch		VCXO	Variable Control Crystal Oscillator
SWD	Switched			
SYNC	Synchronization		VD	Vertical Drive
SYSCON	System Control		VF	Viewfinder
T	Target		VIF	Video Intermediate Frequency
TAL	Tally		VLT	Violet
TBC	Time Base Connector		VR	Variable Resistor
TC	Time Code, Tension Control		VS	Video and Sync
TEN	Tension		VSCH	Variable Search
TF	Thermal Fuse		V/T	Video/Television
TIM	Timing		VXO	Variable Crystal Oscillator
TK or TRK	Tracking		W	Watt
TNR	Tuner		WARN	Warning
TP	Test Point		W & D	White & Dark
TPZ	Trapezoid		W BLK	Wide Blanking
TR	Transistor, Trimmer		WHT	White
TRANS	Transformer		WV	Working Voltage
T/T	Tuner/Timer		XTAL or X.TAL	Crystal
TU	Take-Up		Y	Luminance
UL	Unloading		YEL	Yellow
UNREG	Unregulated		ZFE	Zero Frame Editing

Appendix B:
Glossary

ac—Alternating current, current supplied from the ac wall plug or outlet. The camcorder is operated from the power line with the ac adapter or power pack.

acc—Automatic color control. A switch that sets the color level on many television receivers and video monitors.

afc—Automatic frequency control. The afc circuit locks the television or FM receiver to a station with the strongest signal.

afm—Audio frequency modulation, a method that provides a wide range of sound recording in both Beta and VHS systems.

agc—Automatic gain control. Like the auto or home radio, a certain signal level must be maintained. The camcorder agc controls the signal level at all times.

AM—Amplitude modulation. The regular broadcast band from 550 to 1600 kHz for AM stations.

antenna—A device to pick up the signal for best television reception. The antenna consists of a yagi type for picking up a far away station. The auto antenna is a simple outside dipole or one molded in the windshield.

apc—Automatic phase control. A circuit that keeps the color and luminance signals in phase to prevent jittery or wavy pictures.

aperture—A hole in the camera with the amount of light controlled by the iris. The smaller the number, the larger the size of the hole in the camera.

aspect ratio—The ratio of height to length.

audio—The sound we hear from the speakers. The sound is recorded at the top of the video tape.

automatic rewind—A process that automatically brings the videocassette back to the beginning in some VCRs and camcorders.

automation—Automatic operations performed by the camcorder.

A/V—Audio/video systems or jacks.

azimuth—The angle of the tape head with the tape. The tape must run in a straight line with the tape head to prevent poor quality recording or playback. Re-adjustment of the tape head is found at the side of the tape head.

band—A range of broadcast frequencies such as the AM band (550-1500 kHz) and the FM band (88-108 MHz).

barrel distortion—Lines that bend in the recording picture with the appearance of looking through a barrel.

Beta—One of the first tape formats provided by Sony Corporation. The Beta cassette will not play on a VHS VCR, nor will a VHS cassette play with the Beta VCR machine.

bias—A bias voltage is applied to the audio tape when recording to reproduce higher frequencies.

black matrix—A picture tube with black surrounding each bead of color on the face of the CRT to bring out a brighter, more clear, high definition picture.

boom—A long arm or pole which holds a microphone suspended over the subject.

burn—A permanently burned area may appear on the front of the tube found in the early cameras. Keep the lens cover over the camera at all times on a video camera using a tube as the pickup device.

cable—The television signal is brought through a cable system instead of the antenna. Cables are used to tie the camcorder, VCR, and television receiver together to play back the recorded cassette.

camcorder—A separate camera and recorder were used in the early video days. Now both are found in one unit. The camcorder is found in the VHS, VHS-C, and 8 mm and Beta formats.

camera—A device with a lens and a pick up tube (CCD and MOS), to pick up the subject, it is transformed to electronic signals and placed on tape to be replayed by a camcorder or video camera.

camera cap—A device to place over the lens opening to protect the lens and pickup device when the camcorder is not operating.

capstan—The capstan is a shaft that revolves to move the tape from the cassette across the tape head. Usually, the tape is held against the capstan with a rubber pinch roller.

capstan servo—The electronic control circuit which controls the capstan motor with proper speed in relation to the video drum, tape, and drive capstan.

cassette—A two reel holder which dispenses video or audio tape. The video tape comes in three different formats, VHS, Beta, and 8 mm.

cassette cleaner—A cassette with dry or liquid material to clean the heads and tape paths of a VCR or audio cassette player.

CATV—Color television signals come through a cable to the house from a cable company are called cable TV or CATV. You must pay for these signals instead of using your own outside antenna.

CCD—Charge-coupled device. A solid-state chip which picks up the subject much as the vidicon tube did in the early cameras.

character generator—A small device that generates titles and numbers on video tape electronically.

chroma—Chrominance or color. The three primary colors are red, green, and blue.

chromium dioxide—A compound used in making video and audio tapes.

closed circuit—A television system with a camera and receiver connected together by microwave or cable. Production broadcasting uses closed-circuit methods.

coaxial—A shielded cable with a solid conductor in the center of the cable. The shielded cable prevents outside spurious signals from entering the television or recorded picture.

color burst sensor—A color burst sensor found in the VCR tells when the burst signals are present and can be edited out of the old black and white movies.

color system—The National Television Standards Committee (NTSC) system for American television uses 525-lines and a 60 field, while the United Kingdom supports a Phase Alteration Line (PAL) and the French (SE CAM) system uses a 625-line/50 field format. The European system is not compatible with the U.S. system.

color temperature—Kelvin is the unit of color temperature. The degree of heat needed to produce a perfect black body to emit light. The higher the temperature, the bluer the light; the lower the temperature, the redder the light.

comet tailing—When the camera or object moves, red or blue streaks trail a bright object.

common—A common ground is found in most electronic circuits. A common point to return the electronic circuit.

consistency—The nonvariation in quality among different batches of tape.

continuous loop—A tape system in which the endless loop is repeated, such as the early telephone answering machines.

contrast—Comparing the bright and dark areas of the picture. Too much contrast results in a dark picture while a real light contrast is washed out looking.

control track—The cue or sync track at the bottom of the tape. The control signal is recorded to automatically correct the tape speed.

convergence—To position the three colored beams on the front of the color tube, they are focused through a shadow mask, on each colored bead for the best picture.

counter—A means of pinpointing a starting and stopping point on the tape.

crosstalk—Audible or visible interference found in the audio or videocassette player. Improper adjustment of the tape head in the audio cassette produces crosstalk.

CRT—Cathode ray tube, found as a picture tube in the television receiver. The electronic viewfinder of the camcorder may have a tube for viewing the scene.

cue—To start and stop the tape at a certain position upon the tape.

dB—Decibels. A measurement of sound.

dc—Direct current. The battery powering the camcorder.

degausser—An electromagnetic ring of wires to clean up color impurities of the shadow mask of the picture tube. The magnetic poles of the earth and man-made devices magnetize the shadow mask producing impurities in the color picture.

depth of field—The range of focus at the desired lens opening. The higher number of the camera provides a greater depth of field. The lower number provides a wide opening, producing a narrow depth of field.

dew sensor—A device with circuitry that automatically tells you the dangerous level of moisture in the camera. The camcorder should not be used while the dew sensor is flashing or on.

diffusion filter—A filter applied to the front of the lens to give a soft appearance.

digital—A digital VCR has special effects such as freeze-frame, picture in picture, and solarization.

diode—A semiconductor that will prevent current from flowing in only one direction. A rectifier.

dipole—Rabbit ears are a simple dipole. The dipole element of the television antenna is the rod where the cable or flat lead-in wire is attached.

dropout—Little white streaks cross the picture as the recorded tape is played. Often, dropouts occur at the beginning and end of the tape. Dropouts are caused by poor or contaminated tape.

drum—A cylindrical component with heads that record the video picture.

dub—To transfer the image and sound from one tape to another or to change various sections of the recording. Sound is dubbed on the tape at a later date.

dynamic range—The range from the softest to the loudest sound that can be recorded. The larger the number, the wider the dynamic range.

edit—To add or delete scenes from the videocassette tape.

eject—To release the videocassette from the VCR, camcorder, or audio cassette player.

EP—Extended play. Refers to the speed where six hours of recording may be done on a T-120 VHS cassette.

erase—To remove material or scenes from the audio or videocassette.

erase head—The erase head removes all previously recorded material from the tape as the camcorder, camera, or VCR is recording new material.

E/V—Electronic viewfinder. The tube and circuits are similar to a small television set. Some camcorders have the electronic viewfinder while others have an optical viewfinder.

fast-forward—A means to make the tape move faster in a forward mode. Usually, the take-up reel pulls the tape out in a faster mode than when playing or recording.

fast search—The VCR or camcorder is operated at a faster speed so you can see the recorded material.

ferri-chrome—A compound of chromium and iron dioxide material to produce high-quality video and audio tapes.

ferric oxide—An iron compound used in manufacturing video and audio tapes.

flagging—Bending at the top or bottom of the picture. In the television camera flagging occurs most often at the top of the picture.

flutter—Audio distortion.

flutter—Uneven speeds in tape causing a wavy picture or sound.

flyback—The horizontal transformer found in the television receiver or electronic viewfinder.

flywheel—A large wheel found on the end of the capstan drive assembly. Most flywheels are rotated with a drive belt.

FM—Frequency modulation removes most of the pickup static in radio reception.

foot-candle—The unit of light intensity.

foot-lambert—(FTL) the unit of measurement of brightness. One foot lambert is equal to $1/\pi$ foot-candles per square foot.

formulation tape—The actual magnetic compound deposited on the recording tape.

frame—A single picture. The VCR may have a device to stop the tape to view individual frames.

frequency response—The dynamic range that a medium may record (Decibels). The normal frequency response of audio cassette tape is from 20 to 20,000 Hz, while the average frequency response of videocassette tape is from 45 to 12,000 kHz.

f stop—The setting of the lens opening. The larger the number the smaller the opening, and the smaller the f-stop the larger the lens opening.

fuse—The fuse protects the circuits inside the television set, VCR, audio cassette and camcorder.

ghost—One or several images alongside of the original. Television signals bouncing off of various subjects produce ghosts in the picture. Improper cable hookups may produce several lines in the picture.

glitch—Interference that may flash on the screen of a video or audio recording.

ground—Earth or a common reference point in the circuit.

ground plug— A three-prong ac plug which has a large prong grounded to protect the operator.

hardware—The VCR is referred to as the machine and software is the cassette that plays in the VCR.

harmonic distortion—Unwanted sounds or overtones found in music.

head—The electromagnetic component that records, erases, or plays back in the VCR, camcorder, or audio cassette player.

helical scan—The diagonal system which places video high frequencies upon the tape. The tape head spins at an angle to the cassette tape.

hertz (Hz)—The measurement of frequency equal to one vibration. 1000 cycles per second equal 1 kHz.

hi-fi—High frequency placed on the tape.

high Z—High impedance. A crystal microphone has high impedance, while a dynamic microphone has low impedance output.

horizontal resolution—The more horizontal lines there are, the sharper the picture. European scanning has 625 lines, while the U.S. contains 525 lines.

HQ—High quality. Usually, a camcorder or VCR with HQ specifications produces a higher quality image in chrominance and luminance noise reduction, and white-clip circuits.

hue—The tint of a color picture. The tint control in a television receiver varies the hue of the colored picture.

IC—Integrated circuit. A chip with many different components in one body, used extensively in consumer electronic products.

IF—Intermediate frequency. The IF transformer found in the radio or television receiver is between the tuner and detector circuits.

image lag—When the camera is moved quickly from one subject to another, producing a ghost or streak on the screen.

impedance—The unit of ac resistance. The output impedance of the amplifier must match the speaker impedance. The cables used to connect the television antenna and VCR to the receiver have 75-ohms and 300-ohms impedance. The round shielded cable is 75 ohms while the flat wire is 300 ohms.

index—The electronic marker found on the tape. A point for fast rewind, record, or play.

infrared remote—A hand-held remote control unit that controls the television, VCR, video disc, and audio disc players. The infrared remote transmits infrared beams of light that are picked up by a receiver and control circuit.

interference—Static or noisy unwanted signals.

ips—Inches per second. The speed of the tape during recording and playback.

iris—The opening of the lens assembly. The iris or aperture controls the amount of light entering the camera.

kinescope—Refers to the television picture tube. Also, sometimes called a CRT.

lag—A trace of light behind a moving object or when the camera is moved quickly from one scene to another.

LCD—Liquid crystal display. Found in audio and video products.

lead-in—The flat wire or cable that brings in the television signal to the back of the receiver.

LED—Light emitting diodes. Found throughout the camcorder and VCR as indicators.

lens—A piece of curved glass which lets focused light pass through it striking the film in a camera, pickup tube, or solid-state device in the video camera or camcorder.

load—To place a videocassette into the VCR or camcorder.

LP—Long play. The T-120 videocassette will play four hours of program material.

L-125—A Beta cassette with 15 to 45 minutes playing time.

L-250—A Beta cassette with 1 to 1½ hours playing time.

L-500—A Beta cassette with 2 to 3 hours playing time.

L-750—A Beta cassette with 3 to 4 hours playing time.

L-830—A Beta cassette with up to 5 hours playing time.

luminance—Brightness. The luminance circuits are found in the camcorder, VCR, and television receivers.

lux—Measurement of light sensitivity. A camcorder with a 7 Lux is more sensitive than one with a 20 Lux low setting.

M loading—The tape from a VHS format is wound around the heads in an M-like fashion.

macro—The macro lens is used to take close-up pictures.

MDS—Multipoint distribution system. A cable pay television system with scrambled signals.

ME—Metal evaporated tape. Metal tape is found in the 8 mm videocassette.

microwaves—Electromagnetic waves with a small wavelength, such as satellite transmission, and those found in the microwave oven for cooking.

monitor—The television set is called a television monitor when connected to the VCR. A monitor may resemble a television set, without the tuner and direct hookup to input video signals.

MOS—Metal oxide semiconductor. The electronic solid-state chip used to pick up the picture instead of a tube. Rentax, Radio-Shack, and RCA have MOS pickup devices in their camcorders.

MP—Metal particle. Found in the 8 mm videocassette tape.

MTS—Multichannel television sound. The television or VCR with an MTS decoder will allow you to hear stereophonic broadcast format.

muting—A circuit that blanks out video or audio signals in recording or playback.

newvicon—A tube pickup device used in the early home video cameras.

NiCad—Nickel-Cadmium. The battery made up of nickel-cadmium material can be charged over and over again.

noise—A distorted, unwanted signal in audio and video systems. Noise may appear intermittently or all the time in a poor recording.

NTSC—National Television Standards Committee. The committee who sets standards in the television industry.

ohm—Unit of electrical resistance. Resistors are rated in ohms.

oscilloscope—Referred to as a scope. The electronic technician uses the scope to help locate correct waveforms in electronic circuits.

overscan—Portions of the picture you do not see at the edges of the picture tube.

PAL—Phase alteration line. The 625 line color television system found in Great Britain.

pause control—The pause control is used to stop the recording or playback of an unwanted program. The pause control should not be left in too long on the VCR or camcorder.

PCM—Pulse code modulation. The method used in 8 mm video-stereo system.

PET—Polyethylene Tesphthalate (Mylar). The plastic base used for recording tape.

pixel—Picture element. Thousands of tiny light-sensitive spots found on the CCD pickup device.

play—The play button is pushed when you want to watch what was recorded.

power supply—A voltage source that supplies power to the VCR or camcorder. Often, the power supply circuitry changes ac to dc voltage.

probe—The DMM or VOM has test probes to check voltage or resistance in various circuits.

programming—The VCR may be programmed for so many hours or days of monitoring the television signal.

rainbow effect—Wiggly colored lines found in pictures with poorly erased previous programs.

random access—Provisions to tune the tuner in a scan mode or going through the channels at random.

record—To put audio or video material onto the tape or disc. The camcorder and VCR record on tape, while the video disc player records on a disc.

resolution—The clarity of the picture. The higher the number in horizontal lines, the better the resolution. The American system has 525 lines.

rewind—Bring back the tape to a starting position.

RF—Radio frequency. The frequency at which radio and television frequencies are broadcast. External RF energy found in the picture or sound is caused by a strong unwanted signal feeding into the radio or television receiver.

Saticon—A popular pickup device used in home video cameras.

scanning—There are 525 scanning lines in the U.S. system and 625 scanning lines in the United Kingdom broadcast system. Scanning television programs may be accomplished with the electronic remote control.

search—The videocassette or videodisc player may have speed search, cue, and review functions to enable quick location of a special segment of the recording. The seek function may be found on the digital auto receiver.

Secam—The 625 line color system used in France.

sensitivity—The degree of input signal in RF or audio signal.

sensor light—Lamp bulb indicating the unit is ready to operate. A dew sensor light in the camcorder indicates when moisture is inside the head area.

separation—The degree the right and left channels are apart. Speakers placed close together may sound like a small degree of separation.

servo—A control circuit that regulates a constant speed for the rotating drum or motors inside the VCR, disc player, or camcorder.

shotgun mic—A highly directional microphone used to pick up audio at a great distance.

sine wave—Fundamental wave used in testing audio and video consumer products.

skewing—Bent visual distortion of the upper portion of the picture caused by rapid fluctuating of signals on the tape. Also, the angled motion of the tape.

SLP—Super long play. The slowest speed found in VHS, VCR, and camcorders.

SN—Signal-to-noise ratio. The comparison of good signal with unwanted signal. The audio amplifier with a high signal-to-noise ratio produces noiseless sound.

snow—Black and white specks found on the television screen. Weak or poor reception.

software—The videocassette is referred to as software. The VCR is referred to as hardware.

SP—Standard play. A two-hour T-120 VHS tape rotates at SP speed.

speed—The rate (usually in inches per second) the tape passes the tape head.

splice—Cementing two pieces of tape together. Sometimes used in editing material on the tape.

stereo—Two separate channels of audio. The stereo amplifier has left and right audio channels.

sync—Synchronizing signals. Sync pulses are found in the television set or monitor to keep the picture from going sideways (horizontally) or up and down (vertically).

tape—A narrow plastic coated material with oxide compounds possessing magnetic qualities. Both audio and video are recorded on the tape.

tape head—A coil with a magnetic core which makes and takes off magnetic impressions of audio and video on the tape. The tape rubs against the tape head. The erase tape head erases the previous recording.

THD—Total harmonic distortion.

timer—The timer on the VCR sets the clock for the exact time you want a program to be recorded. The timer can also be set to turn off after recording.

tint—Referred to as the hue control. The tint control of a television receiver varies the color of a person's face.

tracking—Audio and video tracks on the recording tape. The tape head may be adjusted for normal tracking of the tape.

tracking control—A control that slightly changes the alignment of the tape head so it will accurately align with the video tracks on the tape.

transistor—A semiconductor device which operates somewhat like a tube. Many transistors are found in ICs.

tuner—The front end of the VCR, radio or television set which picks up and tunes in each station.

TVRO—Television receive only. A satellite dish antenna.

uhf—Ultra high frequency. The stations found on the television set from channels 14 to 83. A special antenna is needed to pick up the uhf channels.

U loading—The loading pattern of the tape in the Beta system.

VCR—Videocassette recorder.

vhf—Very high frequency. The vhf channels of the television set are from 2 through 13.

VHS—Video home system. The most popular video format developed by JVC.

VHS-C—A small cartridge using the VHS format. The VHS-C cassette must be placed in an adapter to play in the VCR.

videodisc—A flat video disc to record audio and video information.

videodisc player—A unit which plays the videodisc through the television set, like a VCR.

Vidicon—The early popular video pickup tube found in commercial and home cameras.

VIR—Vertical internal reference. A system used in some television receivers for automatic hue control.

white balance—The primary video colors, red, blue, and green must be blended correctly to produce white.

white balance control—This control sets the colors for the camera.

zoom—A wide angle lens that can take a picture from far away. Manual or motorized power zooming are found in the camcorder. Often, the consumer home video cameras have a zoom ratio of 3:1 and 6:1.

Appendix C:
List of Manufacturers

AIWA
35 Oxford Drive
Monnachie, NJ 07074

Cannon
One Cannon Plaza
Lake Success, NY 11042

Chinon
43 Fadem Road
Springfield, NJ 07081

Curtis Mathis
1411 Greenway Drive
Irving, TX 75038

Elmo
70 New Hyde Park
New Hyde Park, NY 11040

Fisher
21314 Lassen Street
Box 2329
Chatsworth, CA 91311

General Electric
Box 1976
Indianapolis, IN 46206

Goldstar
1050 Wall Street
Lyndhorst, NJ 07071

Hitachi
401 West Artesia Blvd
Compton, CA 90220

Instant Replay
2951 South Bay Shore Drive
Coconut Grove, FL 33133

J. C. Penney
1301 Avenue of the Americas
New York, NY 10019

JVC
41 Stater Drive
Elmwood Park, NJ 07407

Kodak
343 State Street
Rochester, NY 14650

Kyocera
411 Sette Drive
Paramus, NJ 07652

Magnavox
Box 6950
Knoxville, TN 37914

Minolta
101 Williams Drive
Ramsey, NJ 07446

Mitsubishi
5757 Plaza Drive
Box 6007
Cypress, CA 90630

NEC
1255 Mechael Drive
Wooddale, IL 60191

Nikon
623 Stewart Avenue
Garden City, NY 11530

Olympus
Crossways Park
Woodbury, NY 11797

Panasonic
One Panasonic Way
Secaucus, NJ 07094

Pentax
35 Muerness Drive East
Englewood, CO 80112

Philco
P.O. Box 6950
Knoxville, TN 37914

Quasar
1325 Pratt Blvd.
Elk Grove Village, IL 60007

Realistic
Radio Shack
1700 Tandy Center
Fort Worth, TX 76102

RCA
600 North Sherman Drive
Indianapolis, IN 46201

RICOH
5 Dedrick Place
West Caldwell, NJ 07006

Sanyo
1200 West Artesia Blvd.
Compton, CA 90220

Sears
Sears Tower
Chicago, IL 60684

Sharp
Sharp Plaza
Mahwah, NH 07430

Sony
Soney Drive
Park Ridge, NJ 07656

Sylvania
P.O. Box 6950
Knoxville, TN 37914

Teknika
353 Route 46 West
Fairfield, NJ 07470

Toshiba
82 Totowa Road
Wayne, NJ 07470

Vivitar
1630 Stewart Street
Santa Monica, CA 90406

Zenith
1000 Milwaukee Avenue
Glenview, IL 60025

Index

Other Bestsellers of Related Interest

TROUBLESHOOTING AND REPAIRING VCRs—
Gordon McComb

It's estimated that 50% of all American households today have at least one VCR. *Newsweek* magazine reports that most service operations charge a minimum of $40 just to look at a machine, and in some areas there's a minimum repair charge of $95 *plus the cost of any parts.* Now this time- and money-saving sourcebook gives you complete schematics and step-by-step details on general upkeep and repair of home VCRs—from the simple cleaning and lubricating of parts, to troubleshooting power and circuitry problems. 336 pages, 300 illustrations. Book No. 2960, $19.95 paperback, $27.95 hardcover

TROUBLESHOOTING AND REPAIRING SOLID-STATE TVs—Homer L. Davidson

Packed with case study examples, photos of solid state circuits, and circuit diagrams. You'll learn how to troubleshoot and repair all the most recent solid-state TV circuitry used by the major manufacturers of all brands and models of TVs. This workbench reference is filled with tips and practical information that will get you right to the problem! 448 pages, 516 illustration. Book No. 2707, $19.95 paperback, $26.05 hardcover

THE CET STUDY GUIDE—2nd Edition—Sam Wilson

Written by the Director of CET Testing for ISCET (International Society of Certified Electronics Technicians), Sam Wilson, this completely up-to-date and practical guide gives you a comprehensive review of all topics covered in the Associate and Journeyman exams. Example questions help you pinpoint your own strengths and weaknesses. Most important, the author provides the answers to all the questions and offers valuable hints on how you can avoid careless errors when you take the actual CET exams. 336 pages, 179 illustrations. Book No. 2941, $18.95 paperback, $21.95 hardcover

TROUBLESHOOTING AND REPAIRING COMPACT DISC PLAYERS—Homer L. Davidson

Here's all the expert guidance you need to maintain and repair your CD player! Repairs can be a very costly propostion. With this book, you can learn to troubleshoot and repair this complicated electronic unit yourself, saving money and time. Homer Davidson guides you through CD players, showing each section, circuit, and component and explains how they all work together. 368 pages, 429 illustration. Book 3107, $21.95 paperback, $26.95 hardcover

THE CET EXAM BOOK—2nd Edition—Ron Crow and Dick Glass

An excellent source for update or review, this book includes information on practical mathematics, capacitance and inductance, oscillators and demodulators, meters, dependency logic notation, understanding microprocessors, electronics troubleshooting and more! Thoroughly practical, it is an essential handbook for preparing for the Associate CET test. 266 pages, 211 illustrations. Book No. 2950, $16.95 paperback, $21.95 hardcover

TROUBLESHOOTING AND REPAIRING THE NEW PERSONAL COMPUTERS—Art Margolis

A treasury of time- and money-saving tips and techniques that show personal computer owners and service technicians how to troubleshoot and repair today's new 8- and 16-bit computers (including IBM PC/XT/AT and compatibles, the Macintosh, the Amiga, the Commodores, and other popular brands). Margolis examines the symptom, describes the problem, and indicates which chips or circuits are most likely to be the source of the trouble. 416 pages, 351 illustrations. Book No. 2809, $21.95 paperback, $27.95 hardcover.

Look for These and Other TAB Books at Your Local BOOKSTORE

To Order Call Toll Free 1-800-822-8158

(in PA and AK call 717-794-2191)

or write to TAB BOOKS Inc., Blue Ridge Summit, PA 17294-0840.

For a catalog describing more than 1300 titles, write to TAB BOOKS Inc., Blue Ridge Summit, PA 17294-0840. Catalog is free with purchase; otherwise send $1.00 in check or money order made payable to TAB BOOKS Inc. (and receive $1.00 credit on your next purchase).

TROUBLESHOOTING AND REPAIRING SMALL HOME APPLIANCES—Bob Wood

Author Bob Wood pairs step-by-step pictures with detailed instructions on how to fix 43 of the most common electric appliances found in the home. Following the illustrations and directions provided, you'll be able to quickly disassemble practically any electrical device to get to the trouble source. Among those included are: drill, garbage disposal, can opener, grass trimmer, vacuum cleaner, blender, and much more! 256 pages, 473 illustrations. Book No. 2912, $14.95 paperback only

THE ILLUSTRATED HOME ELECTRONICS FIX-IT BOOK—2nd Edition—Homer L. Davidson

"Here is a book a do-it-yourselfer needs to be able to fix just about every piece of electronic equipment found in the home . . . packed with step-by-step illustrations . . ."
—*Hands-On-Electronics*

This revised edition of the bestselling home electronics fix-it handbook will save you time and aggravation and money! It is the only repair manual you will ever need to fix most household electronic equipment. 480 pages, 377 illustrations. Book No. 2883, $13.95 paperback, $16.95 hardcover

BUILD YOUR OWN 80386 IBM® COMPATIBLE AND SAVE A BUNDLE—Aubrey Pilgrim

Now you really can have the power of a PS/2-compatible microcomputer at just a fraction of the normal retail cost. Or, you can upgrade your present IBM compatible to include all of the up-to-date features of new 80386-based machines for even less! The secret? Assembling it yourself! All you need is a pair of pliers, a couple of screwdrivers, and the parts you can buy for hundreds of dollars less than what a complete, assembled machine would cost. 224 pages, 83 illustrations. Book No. 3131, $19.95 paperback, $24.96 hardcover

TROUBLESHOOTING TECHNIQUES FOR MICROPROCESSOR-CONTROLLED VIDEO EQUIPMENT—Bob Goodman

With this excellent introduction to servicing these "electronic brains" used in everything from color TVs and remote control systems to video cassette recorders and disc players, almost anyone can learn how to get to the heart of most any problem and solve it skillfully and confidently. Includes dozens of handy hints and tips on the types of problems that most often occur in microprocessors and the easiest way to deal with them. 352 pages, 232 illustrations. Book No. 2758, $24.95 paperback only